IMAGES
of America

DANVILLE

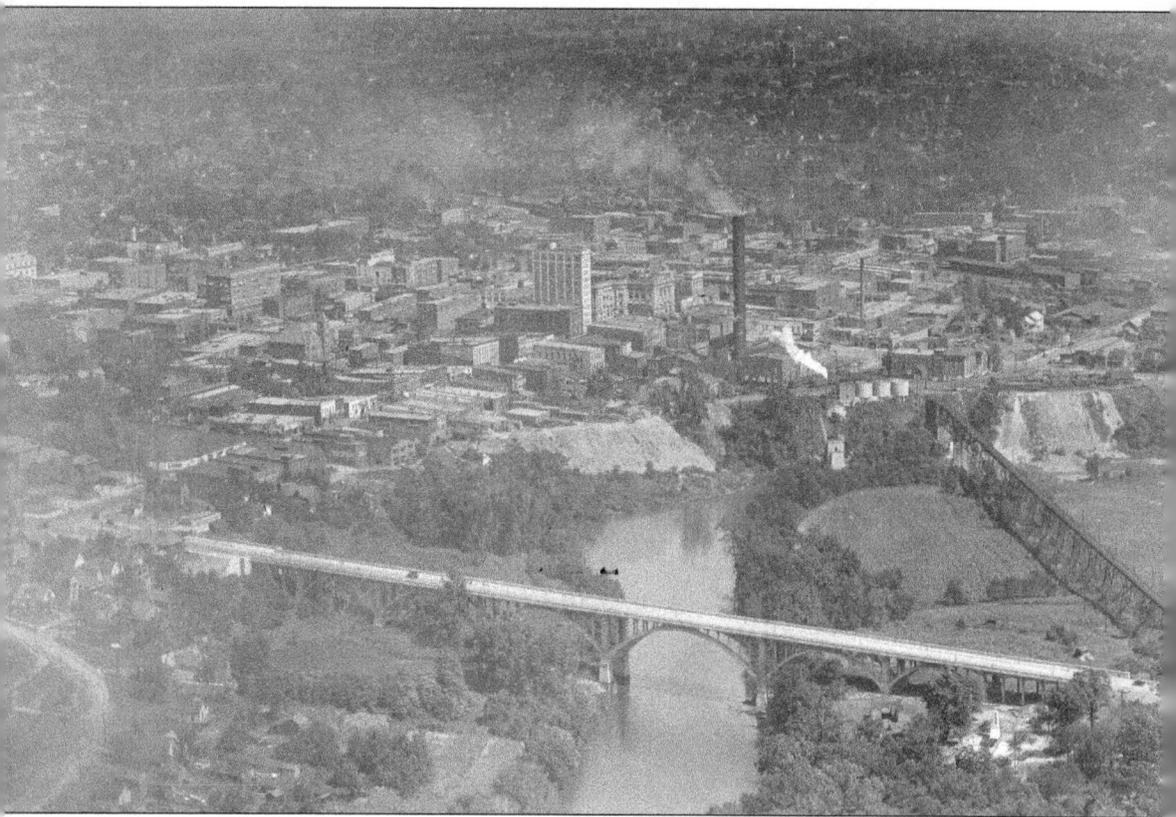

This aerial view of Danville from the southwest, taken around 1923, shows the old Memorial Bridge as well as the Illinois Traction Bridge. While the power plant smokestack can be seen in the center, there is no Lauhoff Grain Company downtown and no Hotel Wolford to the north. (Courtesy of the Vermilion County Museum.)

ON THE COVER: The four-horse team of the Beard Ice Company, seen in a 1932 photograph, was used for shows. It made the fairs often, as well as delivered ice. (Courtesy of the Vermilion County Museum.)

IMAGES
of America
DANVILLE

Vermilion County Museum Society

ARCADIA
PUBLISHING

Published by Arcadia Publishing
Charleston, South Carolina

Library of Congress Control Number: 2013947827

For all general information, please contact Arcadia Publishing:
Telephone 843-853-2070
Fax 843-853-0044
E-mail sales@arcadiapublishing.com
For customer service and orders:
Toll-Free 1-888-313-2665

Visit us on the Internet at www.arcadiapublishing.com

CONTENTS

ACKNOWLEDGMENTS

The publication of this book would not have been possible without the extensive archives available at the Vermilion County Museum. The board and staff of the museum would like to thank all the members, visitors, businesses, organizations, and volunteers who have worked diligently through the years to help the society collect and maintain both its photographic archives and its vertical information files. This book is the result of their preservation efforts.

Unless otherwise noted, images are courtesy of the Vermilion County Museum.

INTRODUCTION

In December 1952, David J. Twomey, managing secretary of the Danville Chamber of Commerce, documented early Danville business history in an article entitled "Danville Industrial Story." A few of the comments made then still pertain to Danville today. The most important and electrifying statement came at the beginning and still holds true today: "Cities do not grow and prosper by chance. They are the result of the vision, sacrifices, and efforts of its citizens."

During its last 100 years, Danville has survived many economic crises, and it has risen to the forefront of business and industry through adaptation to what buyers want and need. When coal mining and brick manufacturing decreased in the 1920s and 1950s, respectively, some of the major sources of employment disappeared. But Danville's leaders were pioneering a new method of community development. The Danville Plan was born to entice new industries to the area.

Diversity was the name of the game. Small industrial establishments were induced to locate in Danville. This expanded not only the industrial base, but also allowed local businesses to grow. Jelly candy and drag-line buckets, bobby pins and lift trucks, photographs and automobile castings, dresses, jackets, fertilizers, electrical products, hoists, and dog foods all began to flow out of Danville to local consumers and to the four corners of the world. At the start of the program, Danville had 14 plants employing about 1,500 individuals; by 1963, there were 150 plants employing more than 16,000 people.

In recent times, Danville has faced another economic crisis. Many of the industries of the 1950s and 1960s have closed, moved south, or merged with other entities. But the same spirit of determination still exists, similar to that of the 1920s. As many times as bridges and malls have been built and demolished, the population and economy have shifted and changed. However, the Danville of today still offers a chance for that pioneering spirit. It is a place to grow, a town set among fertile fields that is rich in natural and human resources.

In compiling this book, the Vermilion County Museum Society wanted to give the reader a glimpse into the last century with photographs and slides that have been incorporated into the museum's archives in the last 10 years. Many of these images have added to the museum's historical holdings, especially those from the 1930s through the 1970s. Whenever possible, an attempt has been made to utilize views that have not been printed in previous museum publications. In order to tell a more complete story, some new views have been taken to augment certain chapters. In many cases, the main hindrance was having too many photographs to draw upon, although, in some areas, there were not enough. Images of America: *Danville* provides only glimpses of the past; it is merely a sampling of the people, places, institutions, and events that have helped shape Danville's history.

Looking into the future, this book reminds the reader of the need to keep a visual history of the city. There are still gaps in history to fill, as well as the present to be recorded. Photographic treasures are still to be found in dusty attics and basements, in scrapbooks and personal libraries. Whether in a printed book or in a digital edition, history is constantly being written; in the sharing, it is kept alive.

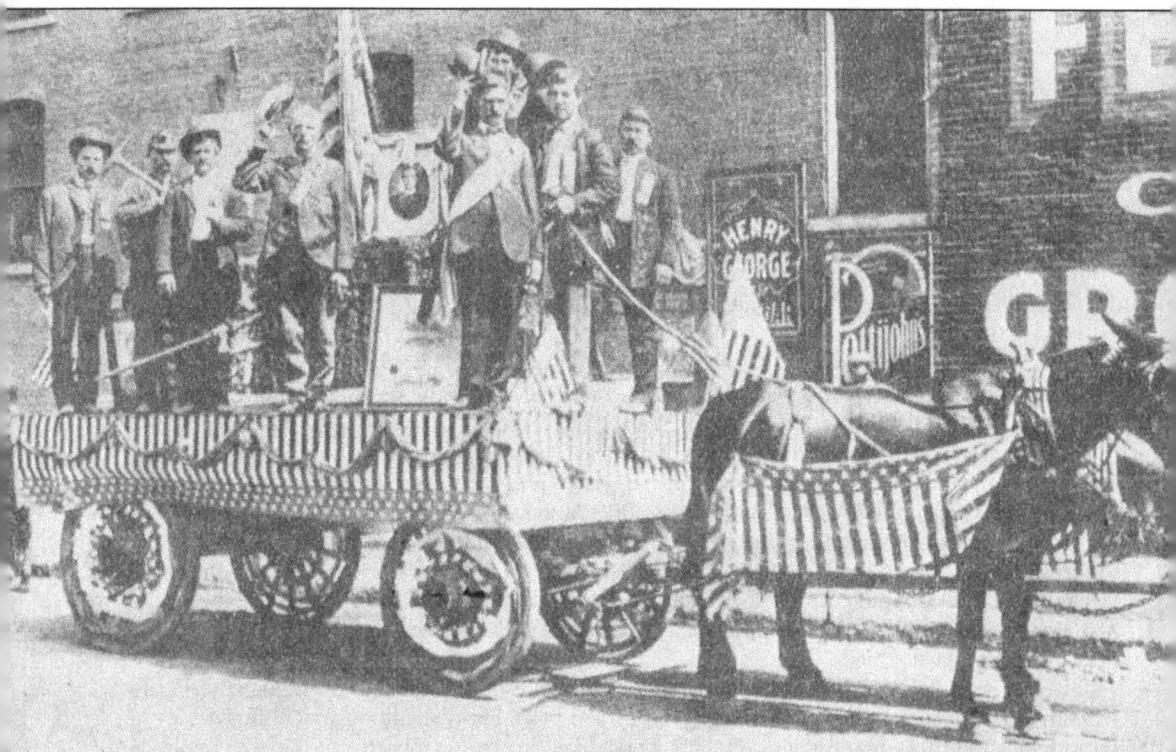

The first Labor Day parade in Danville was held in 1898. This photograph, taken at that first parade, during the year of the Spanish-American War, shows men on a mule-drawn wagon. They are, from left to right, Dan Shouse; an unidentified man with a pick; William Hamilton; unidentified; Jim Smith, district president of the United Mine Workers Association; two unidentified; and John B. Strain. There is a large chunk of coal in the wagon, topped by the American flag. The photograph was taken at the northeast corner of Walnut and Main Streets.

One

IT'S OFF TO WORK WE GO

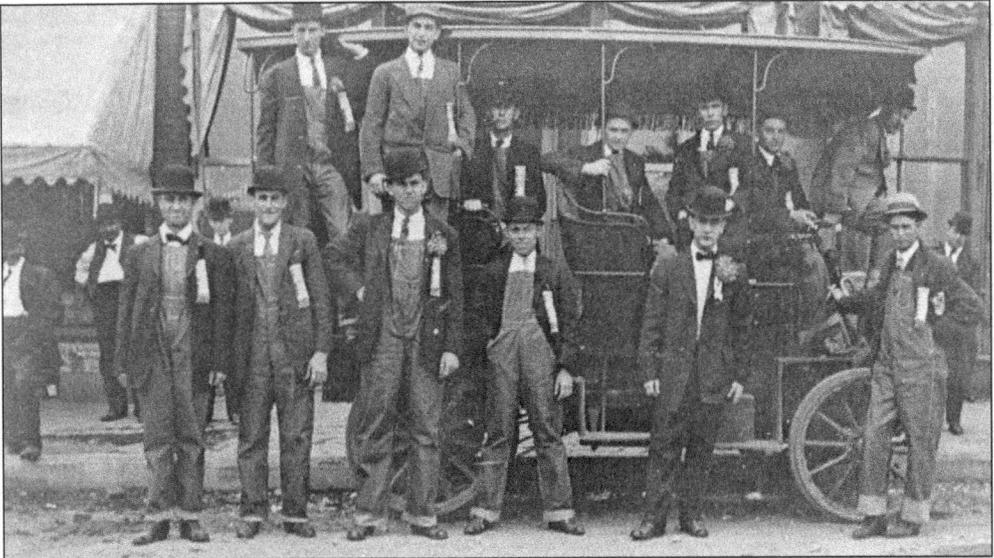

Plumbers Union Local 293 poses with a car at the 1909 Labor Day parade. For years, workers from the area have participated in Danville's parade with decorated floats. Beginning at Harrison Street, the parade usually heads south on North Vermilion Street. Prizes are awarded for the best entries in the parade.

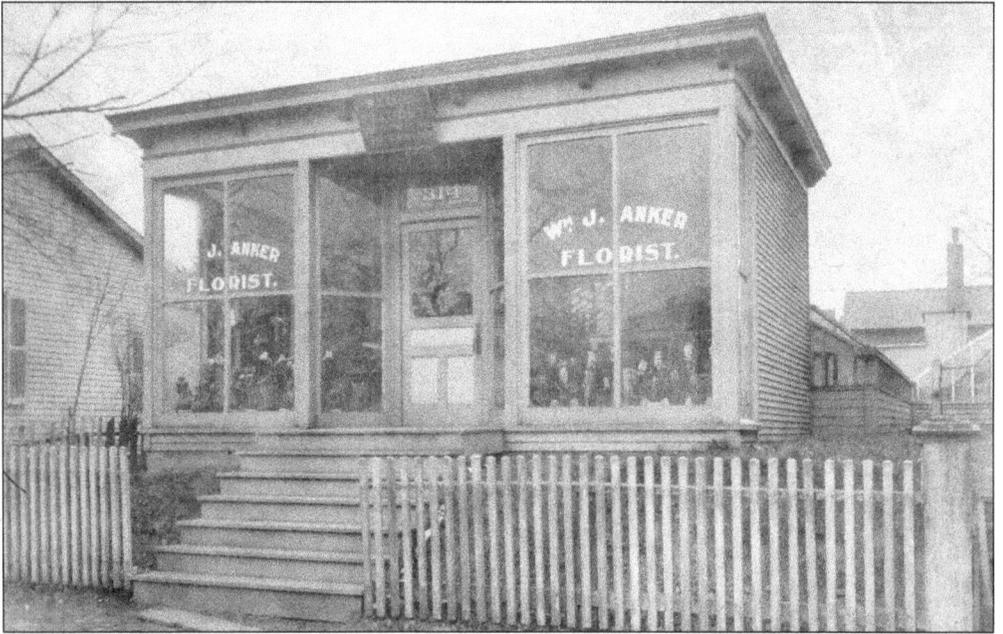

William J. Anker was 16 when he entered the flower industry. In 1887, he built this shop and greenhouse at 314 Jackson Street, where he raised and sold flowers. After moving three times, the shop finally settled into its present-day location, at 421 North Hazel Street. Anker also ordered flowers from Chicago via postcard or telegraph. When telephones came into use, flowers ordered by 10:00 a.m. would arrive by the Wabash evening train.

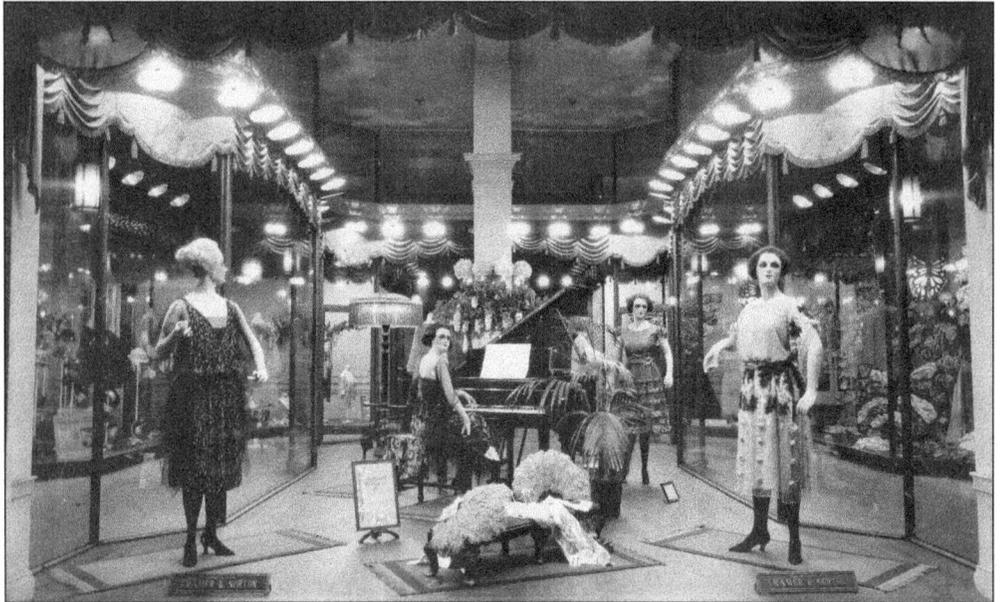

This photograph shows the display window in the Cramer & Norton store. The store was listed as a dry goods store and sold suits, cloaks, ladies' ready-to-wear clothes, and millinery. It was situated at 12–14 East Main Street in the early 1920s. Its advertising slogan was "Watch Us Grow—The Store for All the People." The sign in the foreground states that the display is "Suggestive Apparel for Easter Parties."

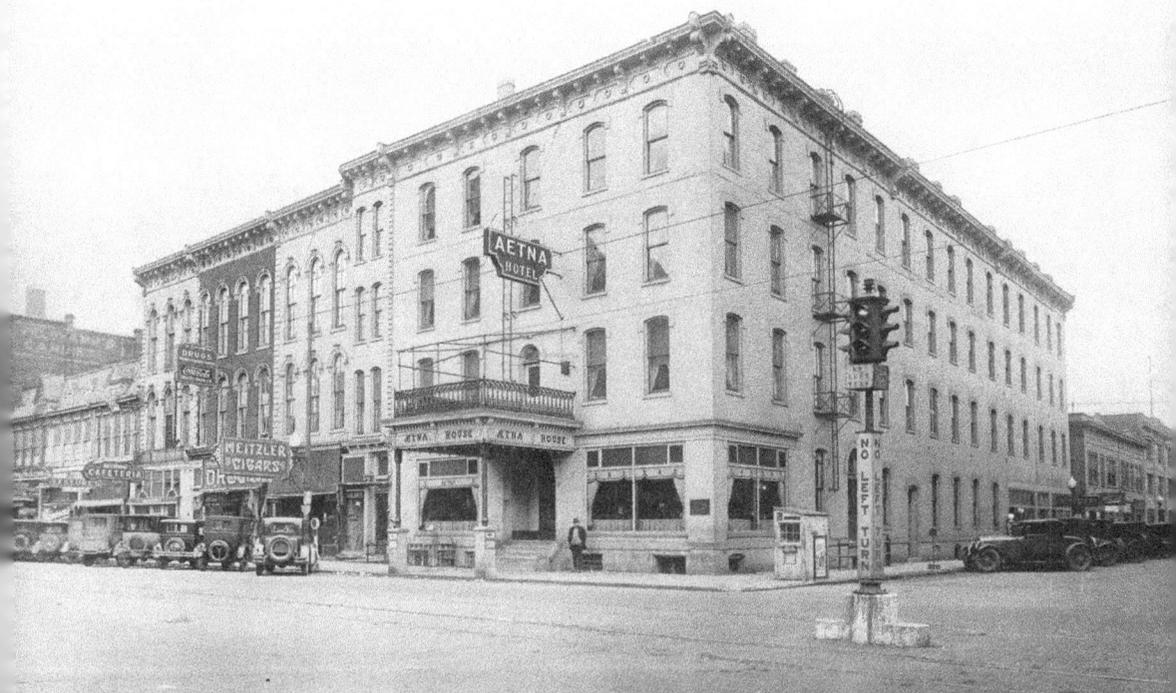

The Aetna Hotel was built on the southwest corner of Vermilion and North Streets in 1865, just after the Civil War ended. In 1888, the roof of the two-story brick building was removed and two more floors were added. Several years later, the building was extended about 30 feet to the alley. It was one of the finest hotels in the city and played host to many notables, including William F. "Buffalo Bill" Cody and future president Franklin D. Roosevelt, when he was a candidate for vice president in 1920. The building was razed in the 1930s to make room for a Walgreens. Of special note are the streetcar tracks in the center of the intersection and the traffic signal in the center of the street. Thompson's Restaurant (left), five doors south of the hotel, was known for its cafeteria-style service, with guests eating at their famous one-armed chairs.

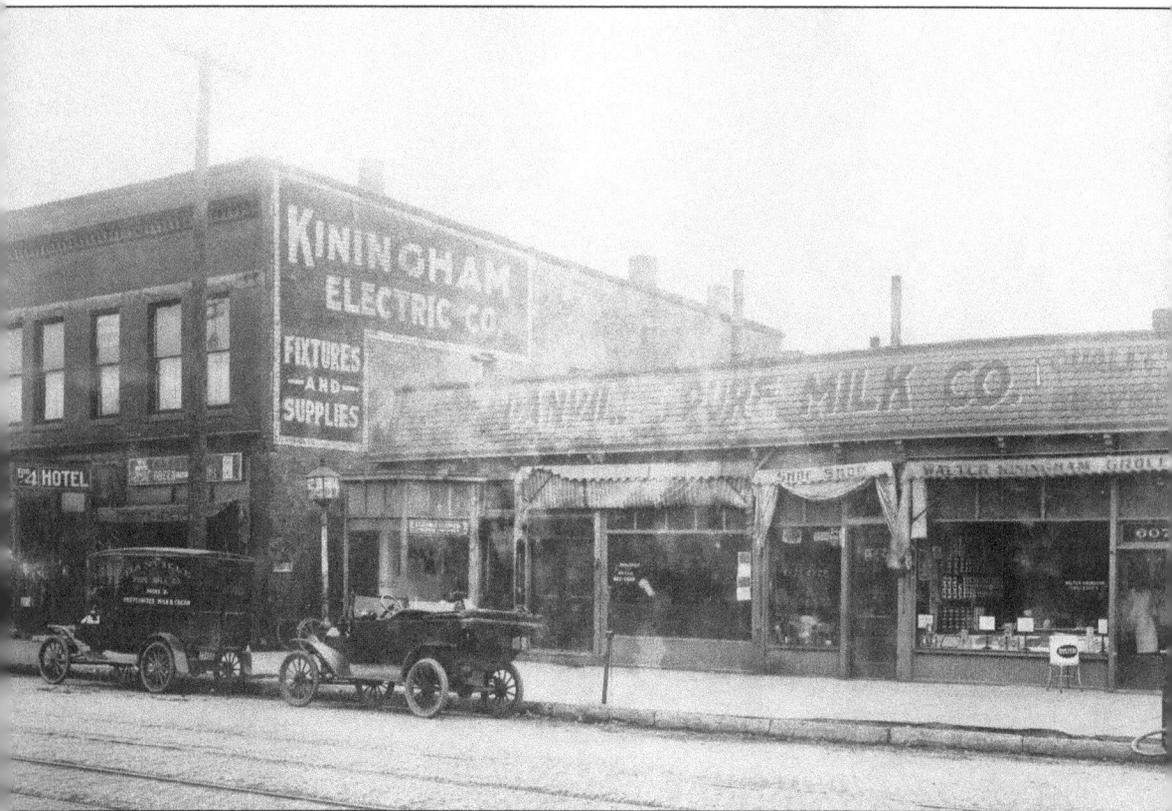

At the beginning of the 1900s, traveling by automobile on dirt roads was very hazardous, especially in bad weather. In an effort to encourage automobile travel, the American Automobile Association lobbied for new road construction. The Dixie Highway was designed to promote travel between Chicago and Miami. By 1927, nearly 5,786 miles of roadway on the Dixie Highway had been improved. In Danville, this highway ran from North Vermilion Street down to Main Street and then east on Main to the Indiana state line. This photograph of Dixie Highway, taken in the 600 block of North Vermilion Street, shows businesses in the early 1900s. They are, from left to right, the Big 4 Hotel, Reid Bros. Groceries, a dry cleaners, Danville Pure Milk Company (a wholesale and retail milk company whose delivery wagon is parked on the street), Samuel H. Dahlquist Shoe Store, and Walter Kiningham Groceries.

This 1920s photograph shows the interior of the Main Restaurant, at 6 West Main Street, which was owned and operated by George E. Ames. This was a prime location, situated between the Illinois Traction System's streetcar station and the Plaza Hotel, and across the street from the courthouse. This building was used alternately as a saloon and a restaurant.

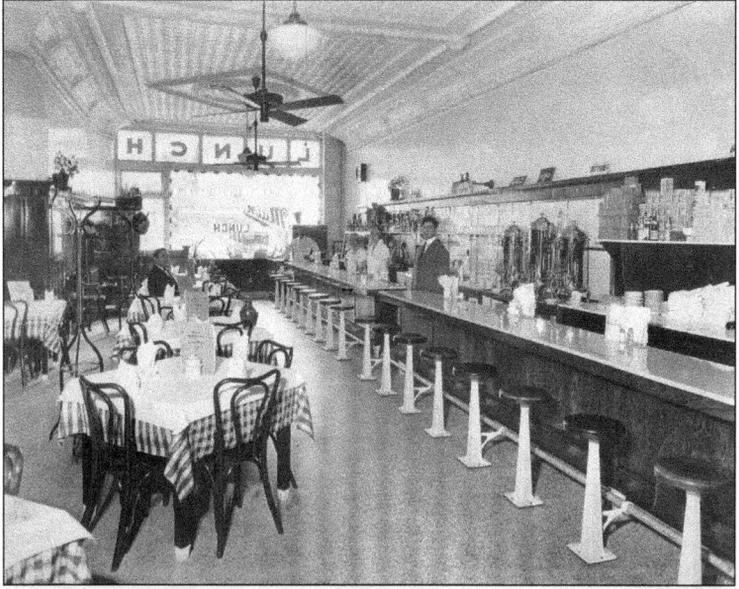

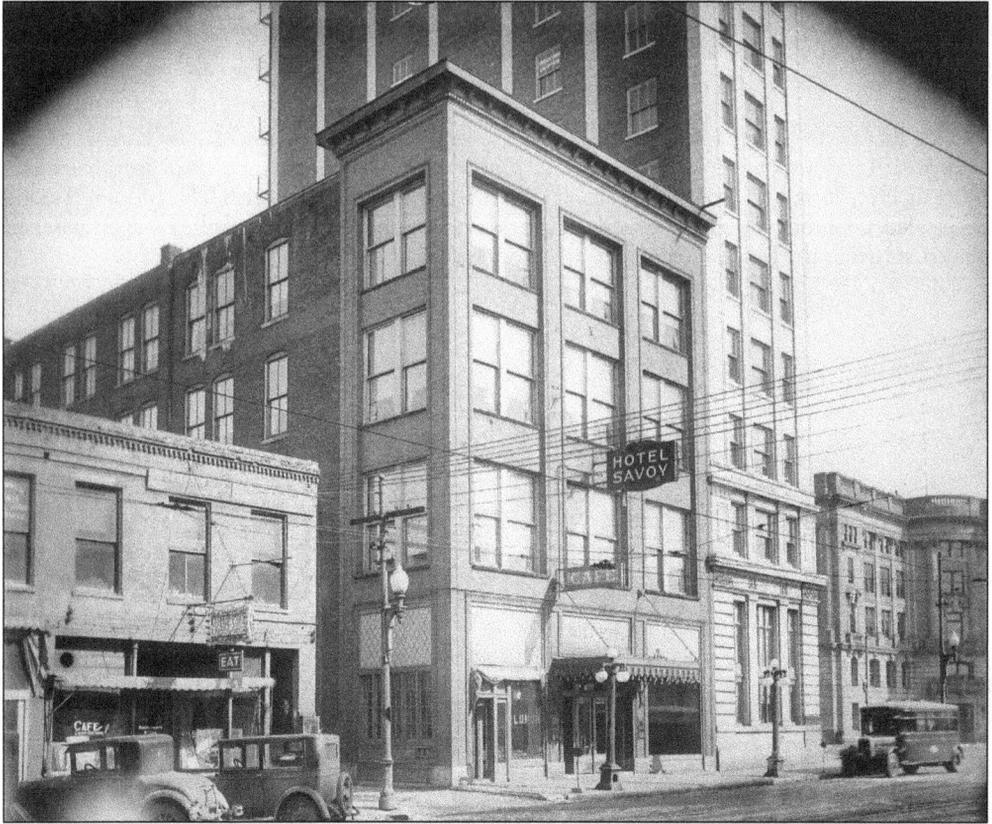

The Hotel Savoy, built in 1913, was located at 11–13 West Main Street. This 1930 photograph shows the hotel sandwiched between Westside Pocket Billiards, on the left, and Bresee Towers, on the right. The hotel later became known as the Milner Hotel. In the early 1960s, the building was razed for the new First National Bank building.

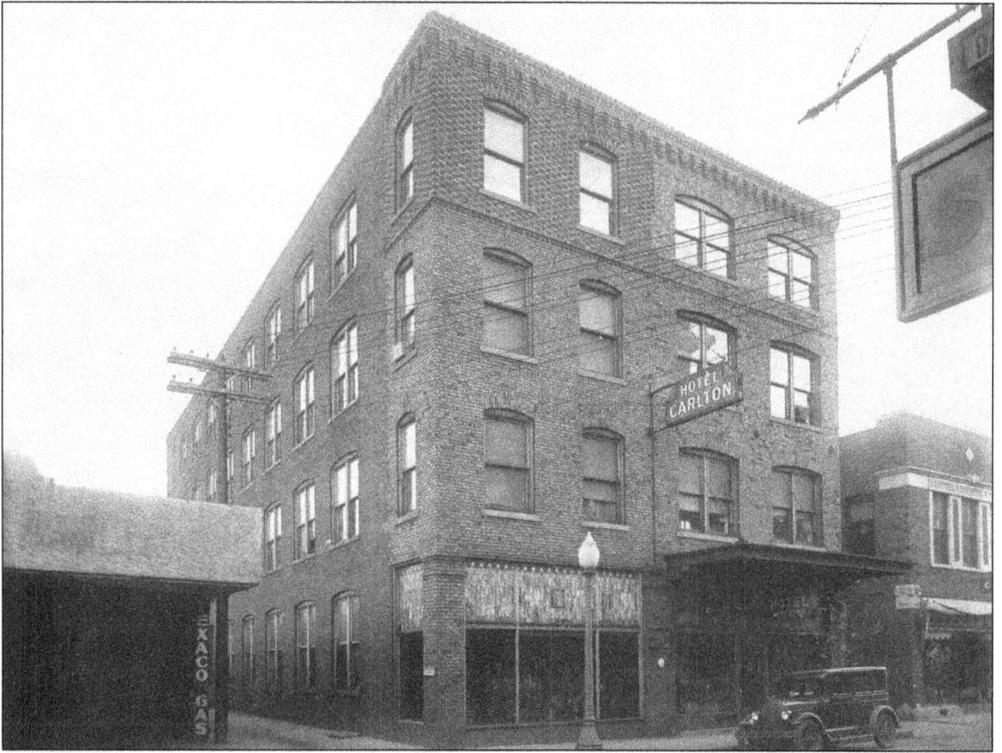

Built in 1915 as a rooming house, the Hotel Carlton, at 9–11 West Harrison Street, became a hotel in 1925. It had no elevator, but rooms were $1, or $2 for a room with a bathroom. Among others, federal jurors, show people working at the Fischer Theater, and Danville Dodgers baseball players stayed at the hotel. It closed in 1958 and was razed in 1965.

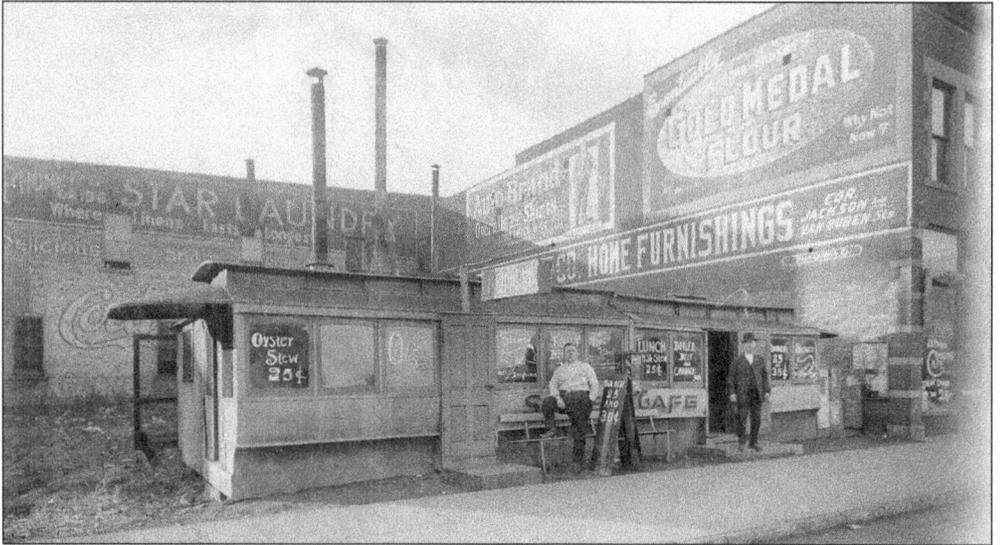

This early Danville scene, on Washington Avenue just north of Main Street, shows a café serving oyster and fish stew for 25¢; stewed rabbit with dumplings, boiled beef, and cabbage for 30¢; and stewed rabbit for 35¢. Star Laundry is visible behind the café, and the Wabash Café can be seen to the right. No wasted space here—every wall and window was used for advertising.

14

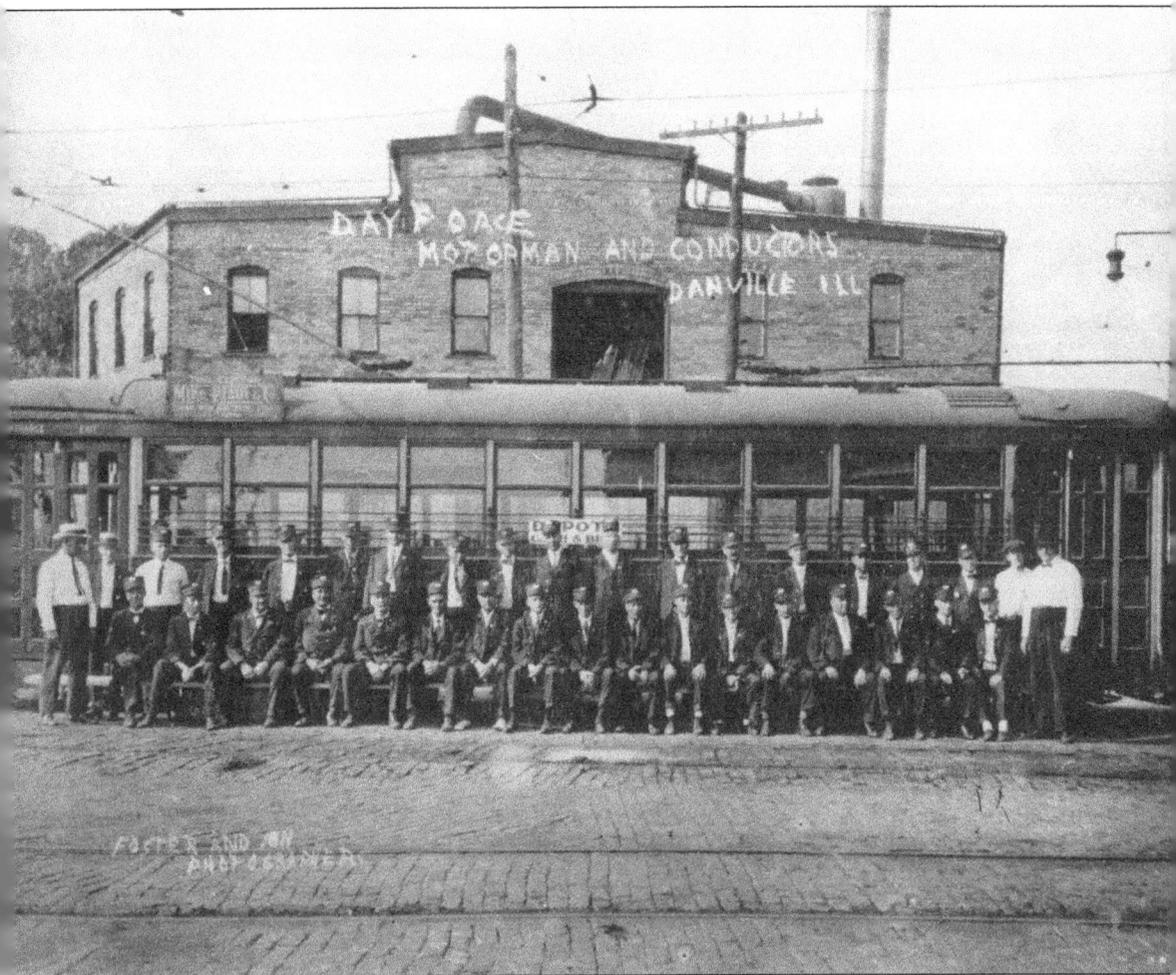

This 1921 photograph shows the day force of the Illinois Traction System's motormen and conductors in front of one of the streetcars. Fast-moving streetcars, faster-moving automobiles, and slow-moving pedestrians made for a bad mix when operating streetcars. From 1902 to 1936, at least 14 people died after being run over or struck by streetcars. Five others and one horse died in car or buggy collisions. In 1902, Carey B. Hall, hired to operate a streetcar, was warned to keep the car on the rails or lose his job. On his second day, Hall, traveling down West Fairchild Street, discovered he was unable to slow down because of the frost-slickened rails. Approaching the end of the line at Logan Avenue, he bailed out of the car just before it jumped the tracks and rolled down the hill at Lake View Memorial Hospital. True to their word, the company fired Hall for his inability to control the streetcar. Hall went on to become an accountant at Danville Transfer & Storage, and then the president of the company in 1912.

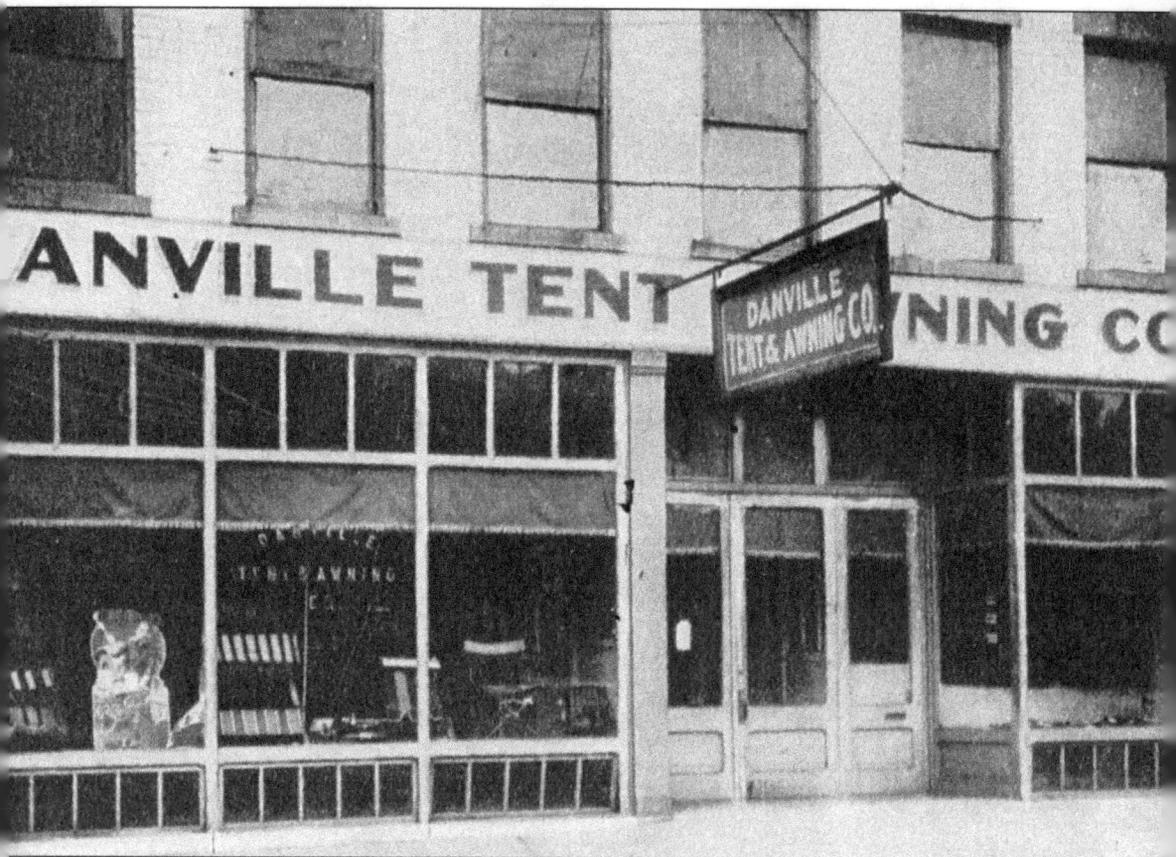

Danville Tent & Awning began in 1895 in the home of Thomas J. Wodetzki in Lincoln, Illinois. Wodetzki learned the trade working for a firm in Joplin, Missouri, that made white Conestoga wagon covers. Six years later, in 1902, he opened his Danville business at 523 East Main Street. In 1966, the firm had a factory at 248–250 West Main Street and a showroom at 219 West Main. Demands for its products came from all over the United States. The company provided weather protection for homes and stores as well as the agricultural, industrial, transportation, and recreational businesses. In the mid-1960s, the company added filter bags, used by millers of grain, to its line. After expansion in the 1960s, the awning business was dropped from its product line. The company continued to make its tents from heavy grades of cotton until the 1970s, when it switched to vinyl-coated nylon, which was cheaper, stronger, longer lasting, and fade resistant. Later, the firm moved to 1706 Warrington Avenue. A fourth-generation family-operated business, it is now known as American Pavilion.

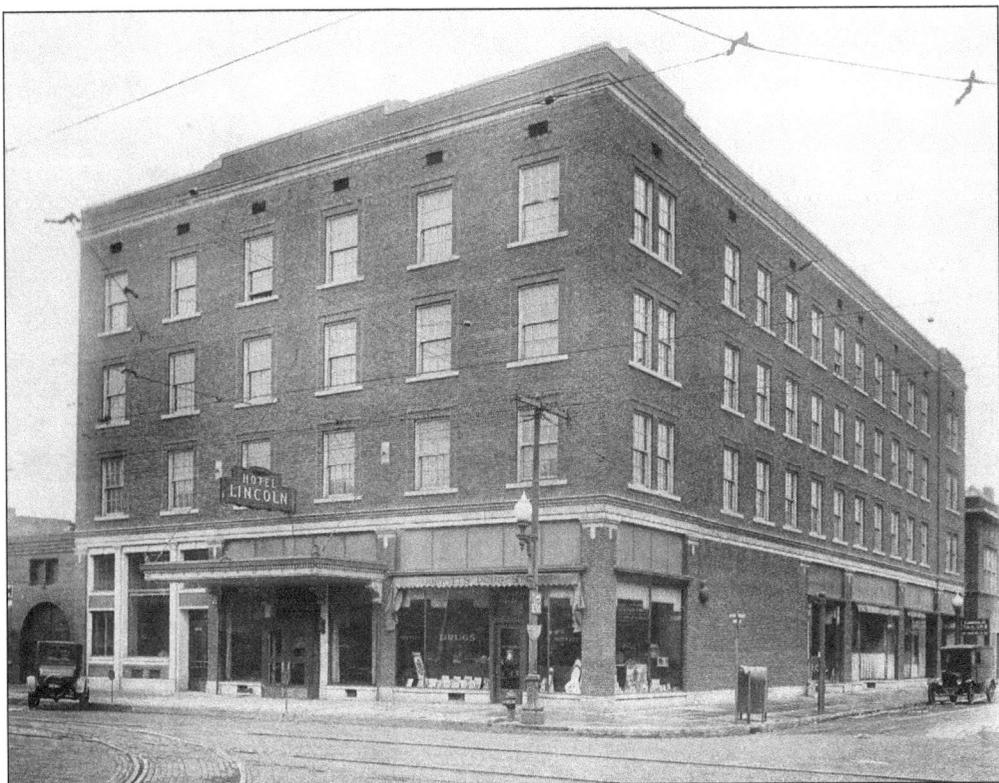

Hotel Grier-Lincoln, built in 1935 at 101–103 West Main Street, was situated just east of the site of the old McCormick House Hotel. It was first known as the Centennial, and then the Arlington. The hotel listed the Oak Room, the Beefeater Room, and 24-hour coffee shop among its amenities. Its 100 rooms had tile baths and showers, and the building was protected by an automatic sprinkler system. The hotel closed in 1974.

The Saratoga Hotel was located at 8 South Hazel Street. Seen here around 1930, the hotel was situated between the Perry Jumps Grocery, on the left, and the Fred Medaris Barber Shop, on the right. The hotel manager at this time was Barney Shydlavsko. Note the outside seating for the Saratoga Café.

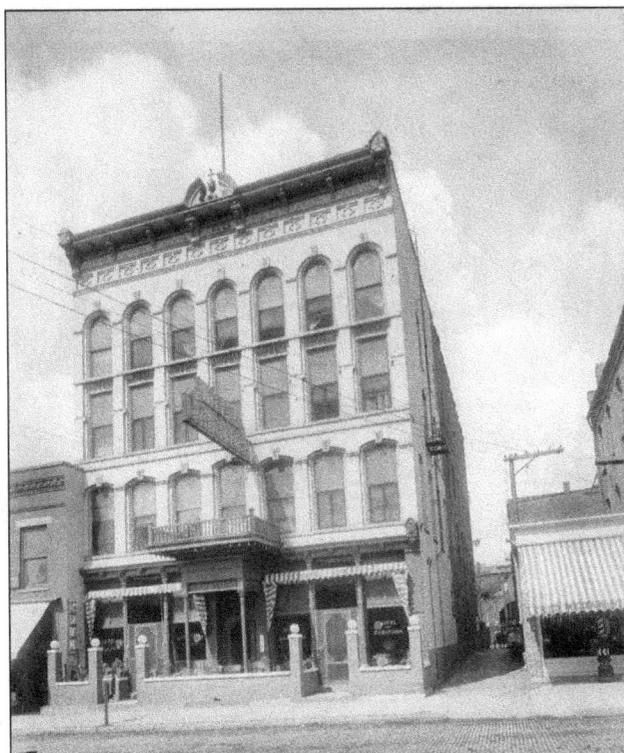

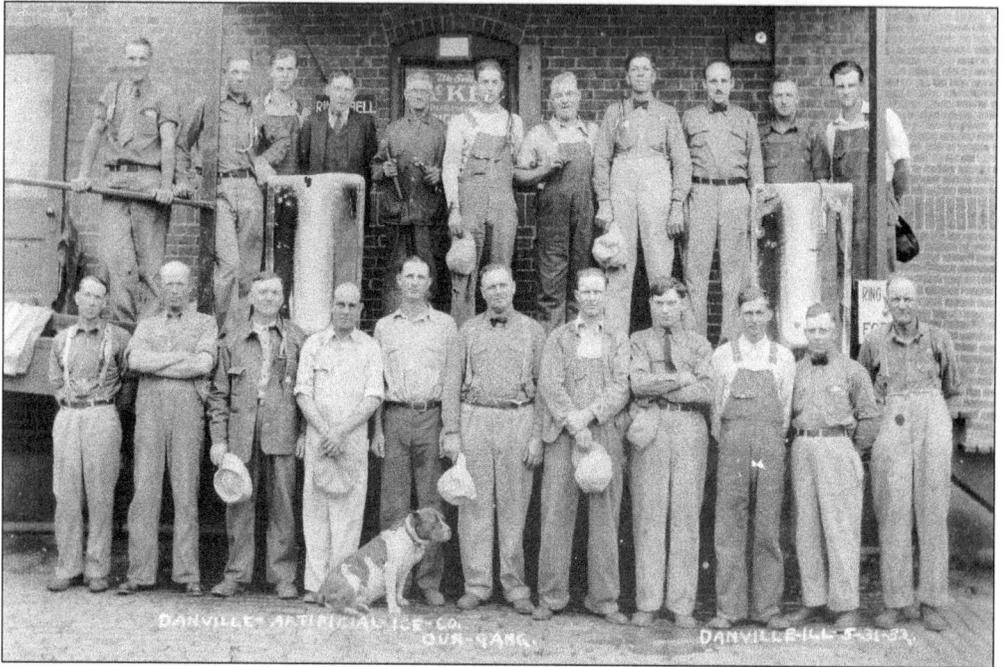

Danville Artificial Ice Company was located at 733 East Cleveland Street. The dog in the foreground of this 1932 employee photograph was Lady. The company was a dealer, manufacturer, and wholesaler of ice in the area. It was in competition with Beard Ice Company and Crystal Ice & Fuel Company. By 1940, the company was no longer in existence.

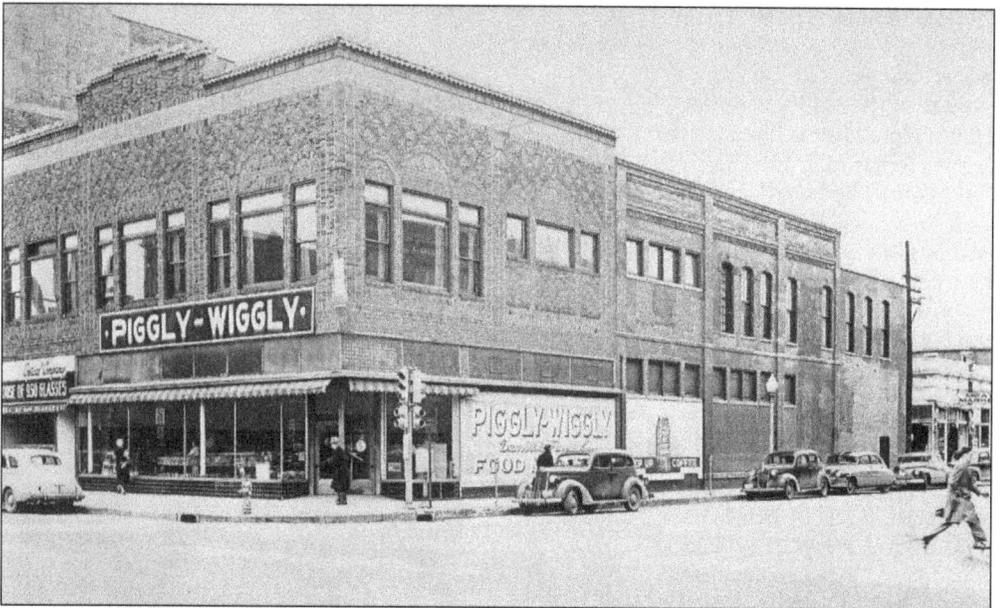

This photograph shows the Piggly-Wiggly grocery store at 23 East Main Street. This chain was started in Memphis, Tennessee, in 1916 and came to Danville in about 1919. The early self-serve store eventually had five locations in the city. It was one of the first to provide shopping carts for its customers. It also standardized product placement within its stores so that each location was set up the same.

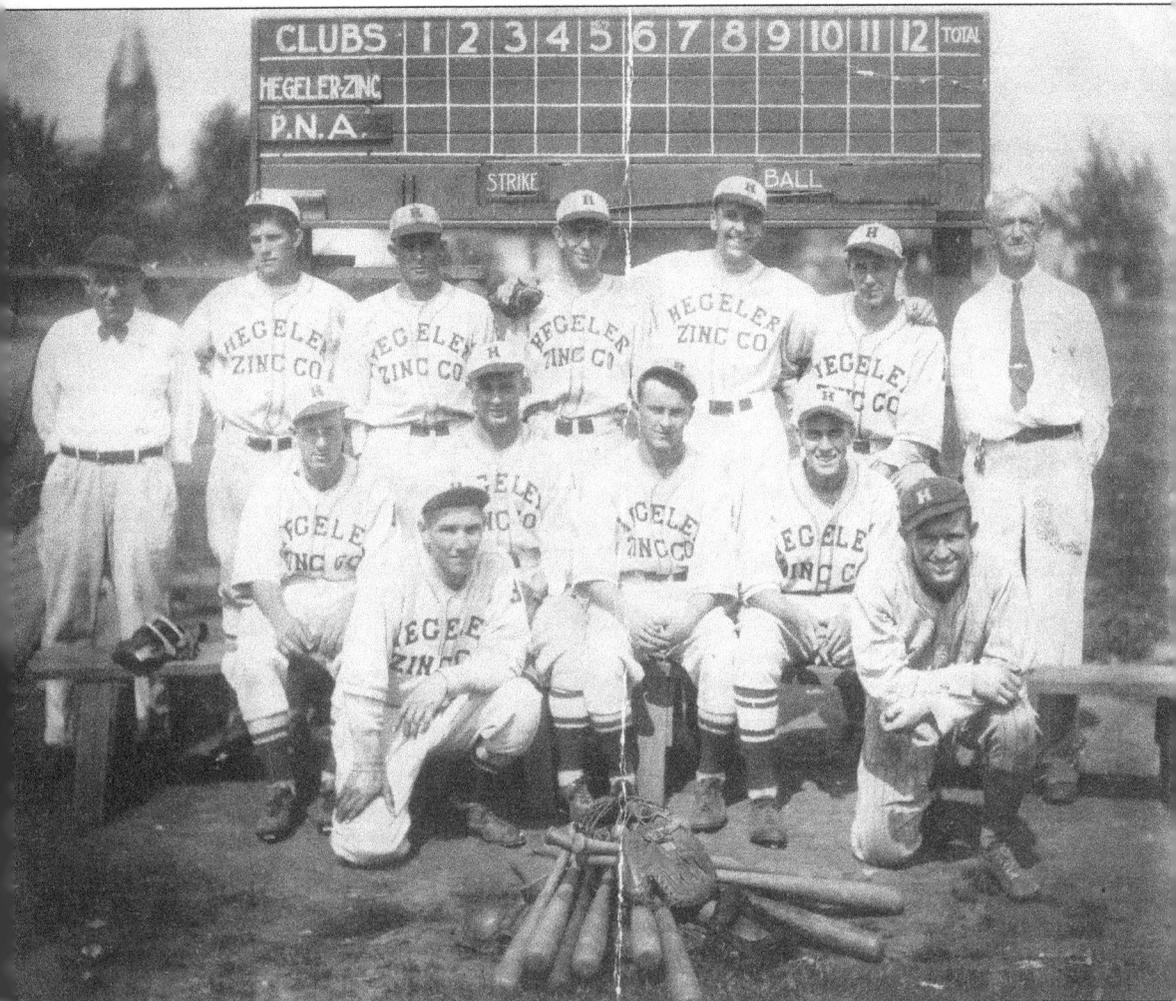

Julius and Herman Hegeler started Hegeler Zinc Company southwest of Danville in 1906. The zinc, purchased from a mine in Joplin, Missouri, was transported to Danville via the Chicago & Eastern Illinois and Big Four Railroads. In 1924, a rolling mill was added, and sheet zinc was used for making canning lids and other products. In 1937, a power plant was added, and Julius Hegeler built and patented a large and efficient kiln used throughout the world in zinc smelting. Peak production periods were during World Wars I and II. Smelting operations were suspended in 1947. In 1954, the business was sold to the National Distillers & Chemical Corporation. After the sale of the company, operations in Danville were closed. The Hegeler Zinc Company grounds later became the location of the Peterson Filling & Packaging Company, which was started by two of Julius Hegeler's grandsons, Edward C. Hegeler III and Julius W. Hegeler II, along with Harry and Robert Peterson. A favorite pastime of some company employees is shown in this photograph of the Hegeler Twilight Baseball Team.

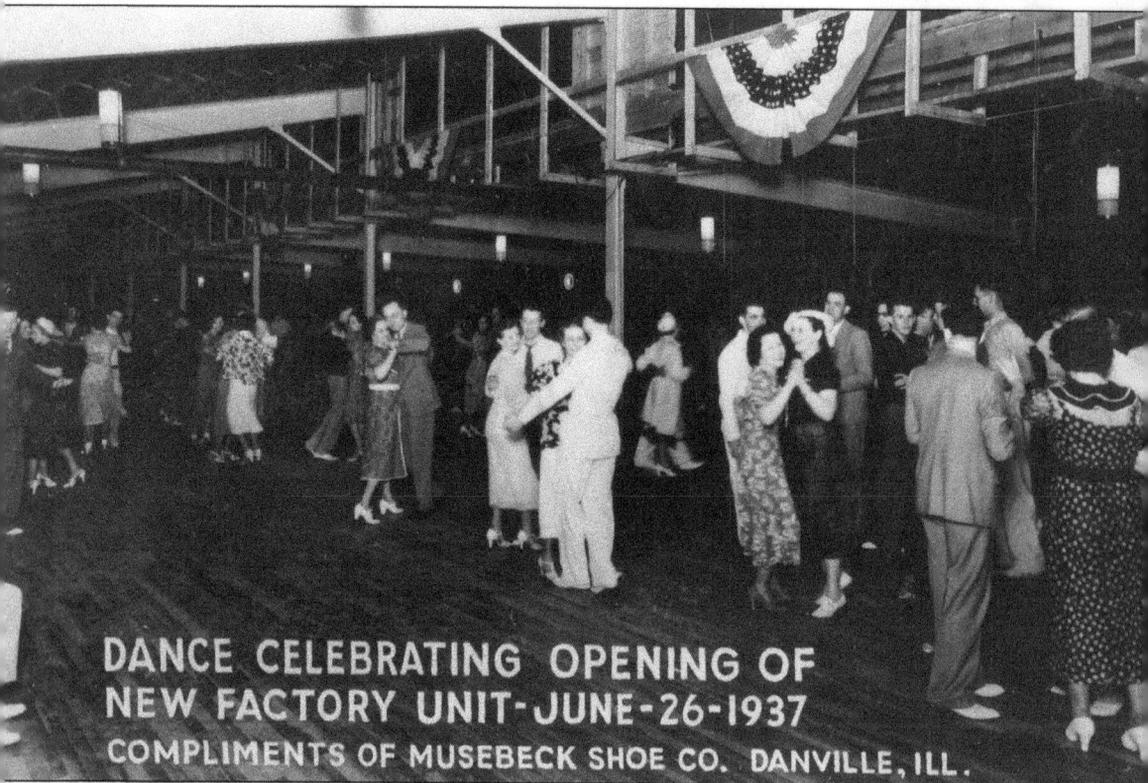

DANCE CELEBRATING OPENING OF
NEW FACTORY UNIT-JUNE-26-1937
COMPLIMENTS OF MUSEBECK SHOE CO. DANVILLE, ILL.

George E. Musebeck began working in a shoe factory at the age of 15. An industrious young lad, he learned to operate all of the various machines in the plant. For 10 years, he worked for the United Shoe Machinery Company, where he installed new equipment and taught people how to operate the machines. For his last three years with United Shoe, Musebeck was placed in charge of laying out shoe factories. Having learned all aspects of the business, he decided to open his own shoe factory at a time when some may have thought the industry overcrowded. Musebeck felt that service had become second place to style. He saw an opportunity to make a good service shoe, well made and classically styled, that would appeal to all men in general. Production began at his newly built plant, at 200 Commerce Street in Danville, in late 1927. Musebeck's business prospered, as evidenced by this 1937 postcard showing a dance celebrating the opening of a new factory unit. The plant was closed in the mid-1940s.

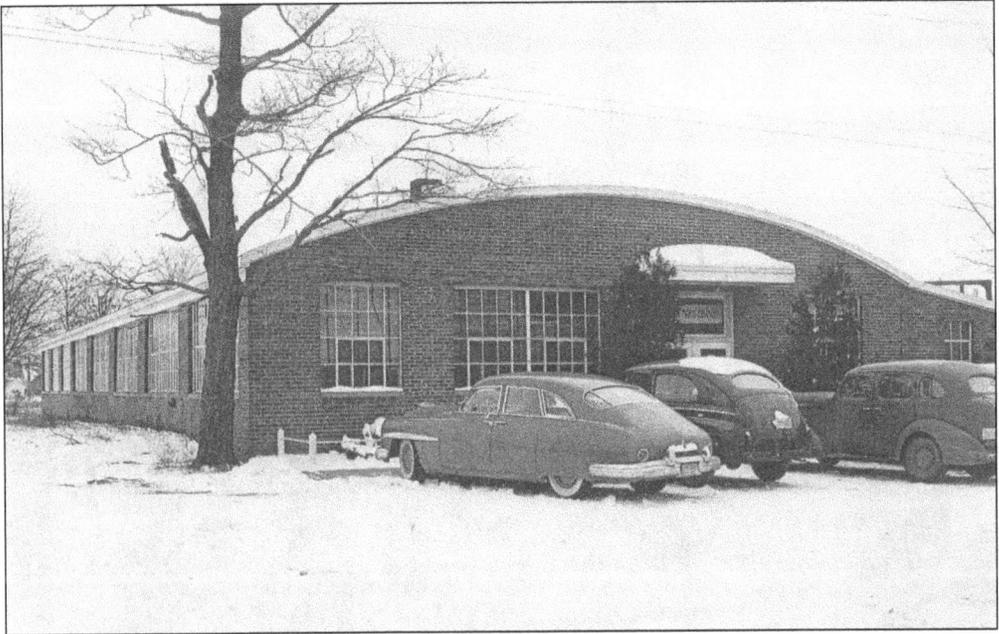

The Grogan Photo Service Company was known from coast to coast. In 1938, it opened a factory at 1107 Bahls Street in Danville, which allowed it to mass-produce pictures on short notice. The company was able to produce 15,000 photographic postal cards in one day. The highlight of the plant's history occurred during World War II, when it produced approximately 80,000 to 100,000 photographs per day for the US government. The photograph above shows the exterior of the Quonset hut–type building that was the company's home. The interior of the company's sorting room is seen below.

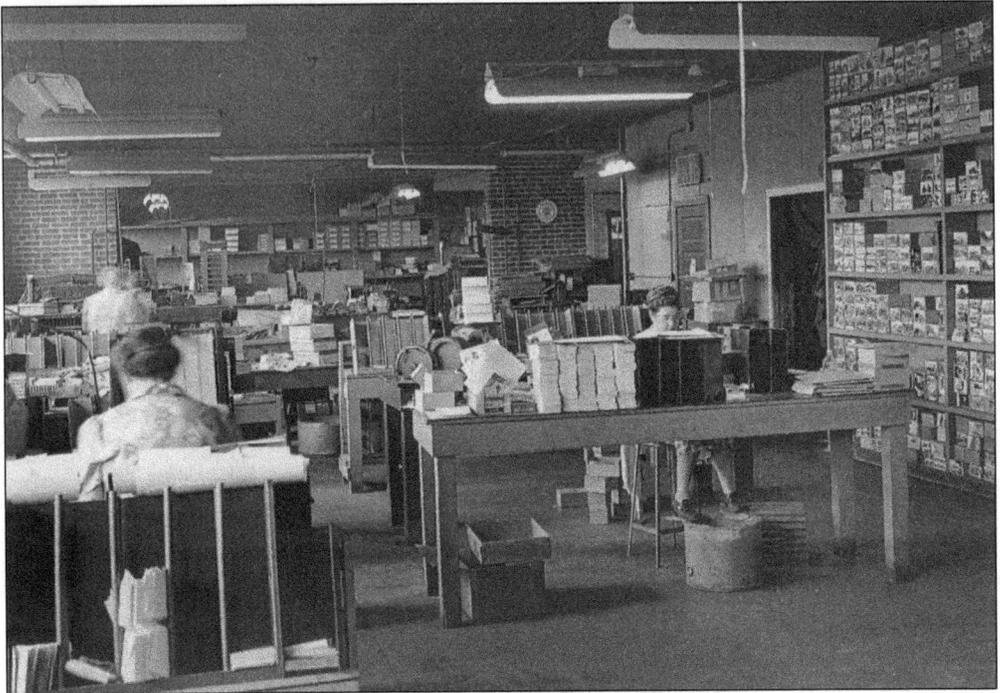

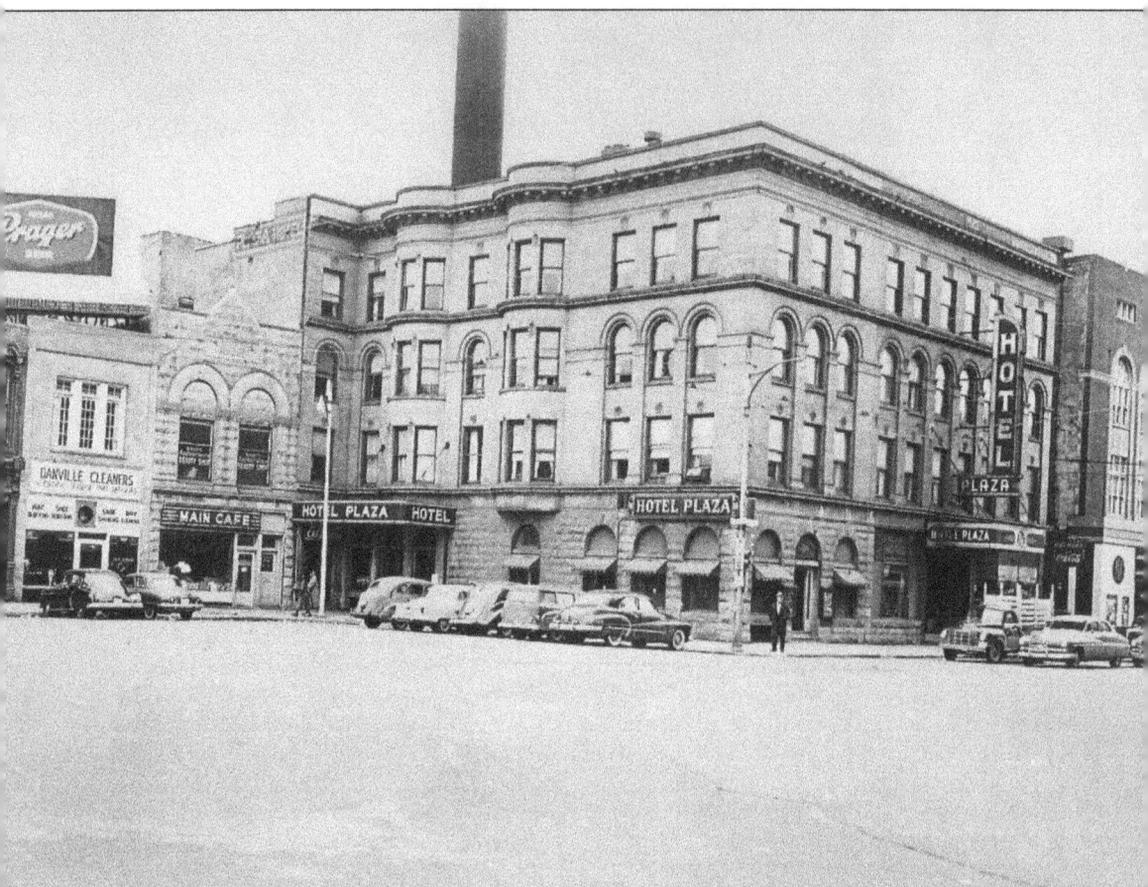

The Hotel Plaza was on the southwest corner of the public square, in the former Lincoln Hall building. The structure was first built in 1859 by W.W.R. Woodbury, a pioneer doctor and pharmacist, and named Lincoln Hall after Woodbury's friend Abraham Lincoln, who practiced law in Danville. It housed the Woodbury Book & Drug Company on the first floor, offices on the second floor, and a ballroom on the third. In the 1890s, the building became a hotel and the front of it was removed for a face-lift to put on a more modern appearance. It continued to be remodeled and expanded into an L-shaped building, with four separate structures built at various times before 1900. After renovations in the early 1900s, it was regarded as the best hotel in Illinois outside of Chicago. The dining room was "fabulous," with a ballroom to the rear, closed off by an iron gate. The reading room was furnished with Italian pieces. It had 115 rooms, covering 60,000 square feet. It was razed in December 1970 as part of the urban renewal program.

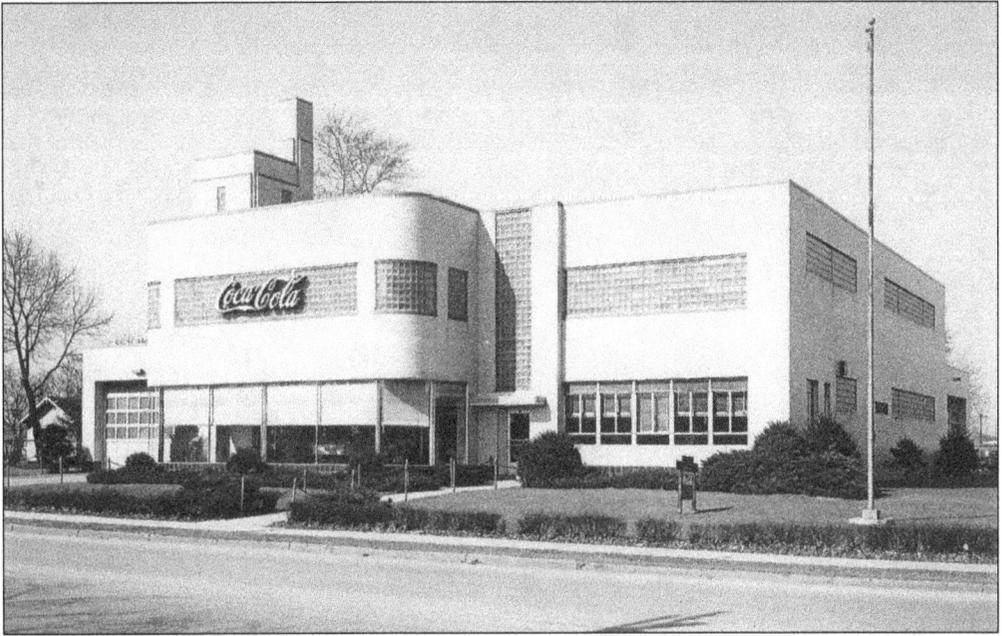

Coca-Cola was bottled in Danville beginning in 1904 at Dudenhofer Coca-Cola, located at 110–112 South Street. In 1929, the name was changed to Danville Coca-Cola. In 1941, Danville Coca-Cola was relocated to its final site, at 1405–1411 East Main Street. Many "firsts" were introduced in Danville, including the first distinctive bottle, the first carton, the first cooler, and the first coin-operated cooler.

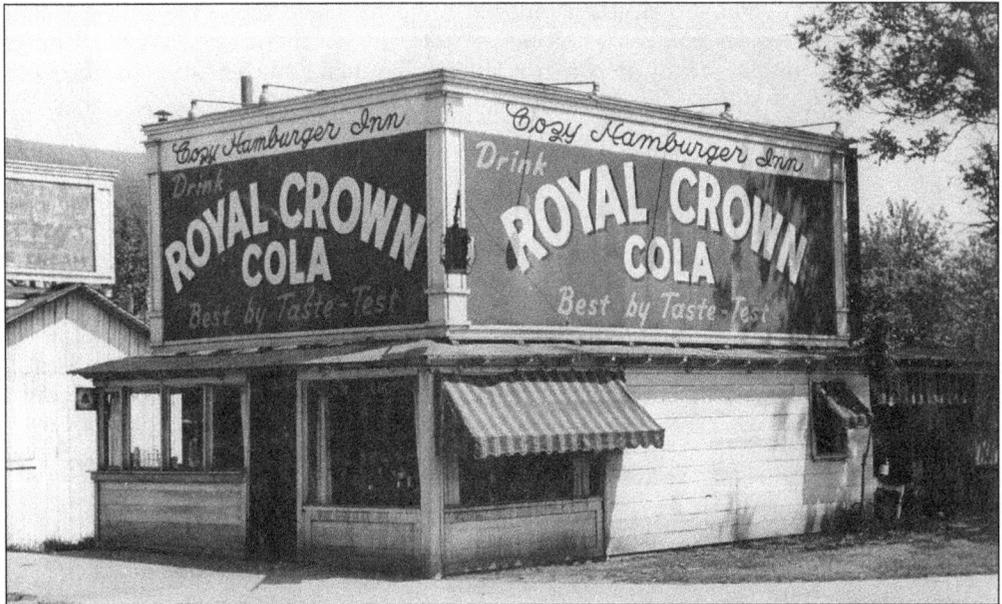

Ina M. France, owner of the Cozy Hamburger Inn, at 312 West Main Street, served hamburgers from 1943 to 1945. Previously, the building was the John Snyder Restaurant. Notice the advertisement for Royal Crown Cola at the top of the building. In the background is an advertisement for Scotty's Sandwich Shop, which served Cherry's ice cream, a local favorite. The building was torn down in 1955.

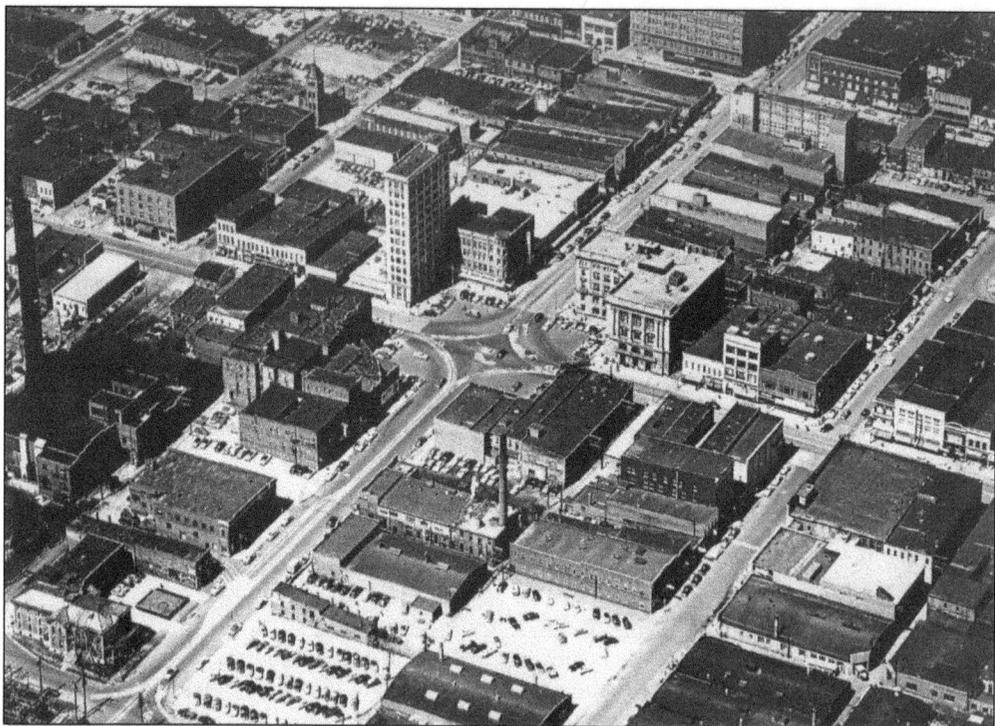

This aerial view of downtown Danville shows the public square, with the diamond-shaped median in the center of Main and Vermilion Streets containing a flagpole. When Vermilion still went south from Main, in 1949, the businesses in the first block south were, among others, the Danville News Agency, the Black Cat Liquor Store, the Hotel Pearson, National Printers & Stationers, the Illinois Power Company, the Illinois Terminal Railroad Company, the Cozy Hotel, and the county jail.

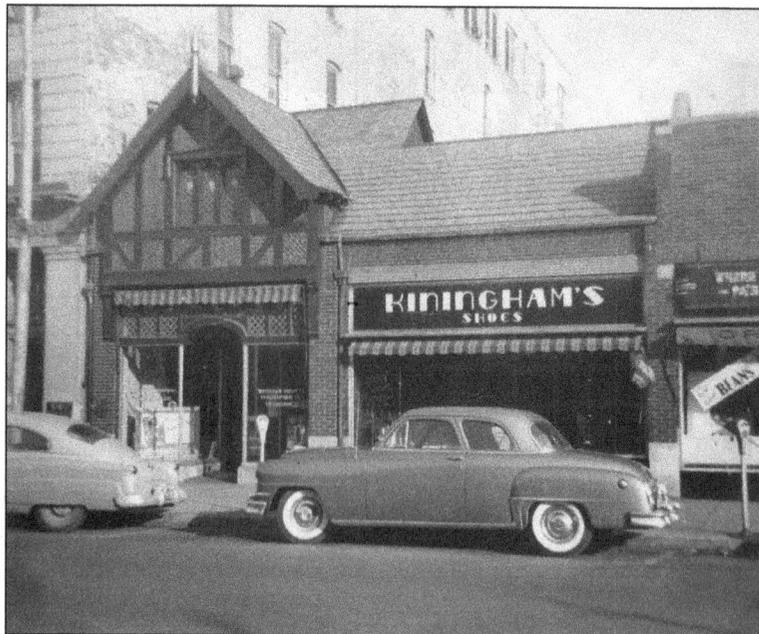

Shown is the central downtown district of town in the 100 block of North Vermilion Street, on the east side of the street. Kiningham's Shoes was located at 135 North Vermilion. To the right of Kiningham's is the Grab-It-Here, and Webster-Heskett Mauerman Inc. Insurance and the Adams Building are to the left.

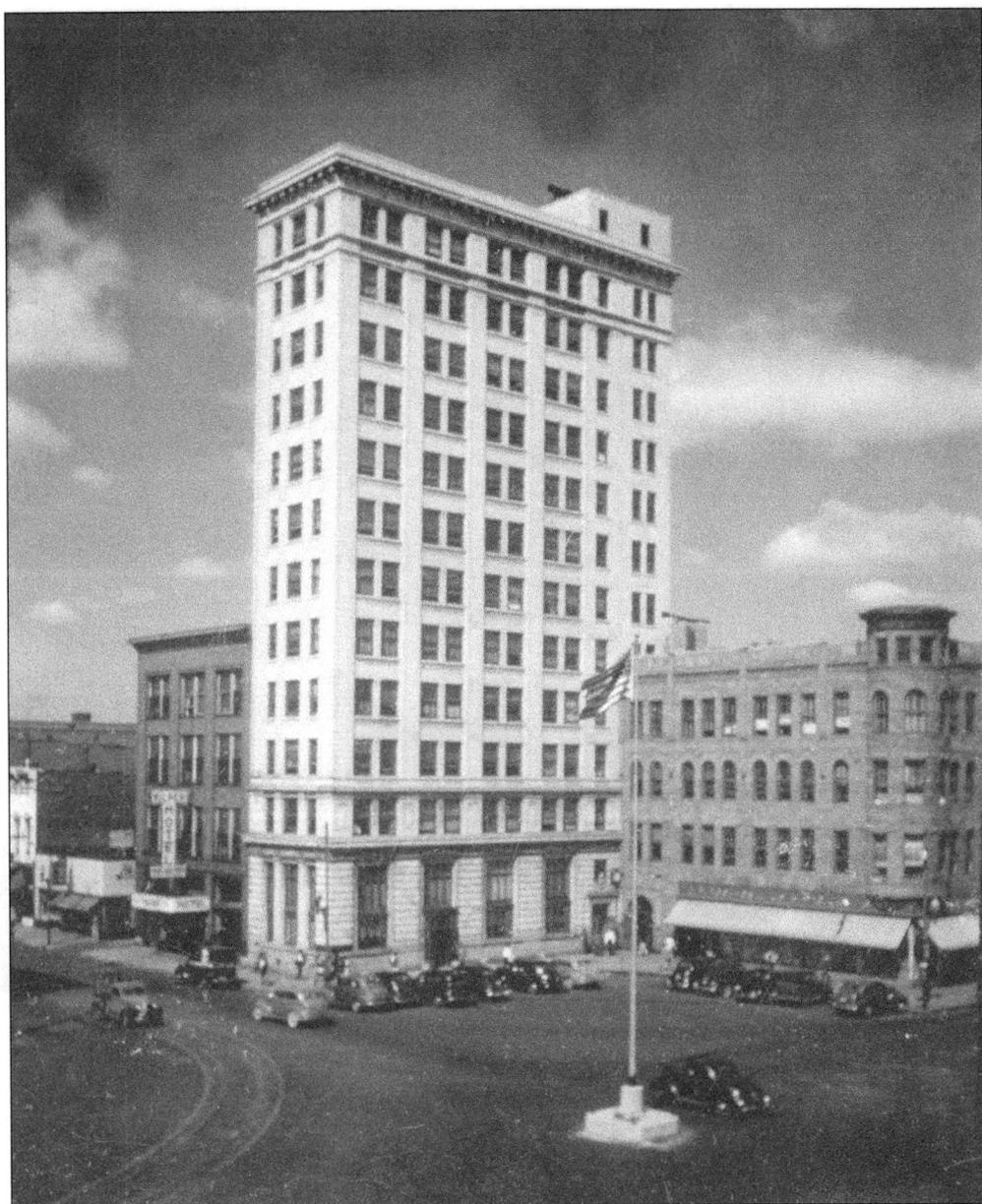

Bresee Tower, located at 4 North Vermilion Street, is Danville's first "skyscraper." The building was constructed as a two-story structure in 1869, housing the First National Bank on the first floor and offices above. It was expanded to four stories in 1879 and then to its present 12 floors in 1918. In 1961, when the bank moved next door, the building was purchased by Paul and H.R. Bresee of Champaign-Urbana. Paul Bresee utilized the building's height to broadcast programming on WIAI 99.1 FM, a contemporary country music radio station. In 1993, the building and the radio station were purchased by Key Broadcasting, a management company under the holding company First Corbin Financial. A plaque on the exterior of the building reads, "Abraham Lincoln occupied offices in a building on this site while practicing law in the Eighth Judicial District from 1847 to 1859." The building was closed in 2005, and deterioration of its terra-cotta exterior has been a recent concern.

Armand "Dutch" Stella, along with two of his brothers and a sister, started Stella's Bakery in 1931 at 113 South Hazel Street. In addition to selling baked goods in their own store, they also supplied Stella Bread to many other grocers and stores in the area. Dutch and his wife, Mildred, were married in 1935. Eventually, Stella pulled his wife and another brother into the family business. In 1958, Dutch and Mildred Stella were planning to move to Florida when a beer distributor told him that a Westville liquor store was for sale. Dutch sold the bakery and bought the liquor store, which he operated for three years until 1961, when he opened Stella's Beverages, Inc., at 536 East Main Street in Danville. Dutch and Mildred retired in 1982 and sold Stella's Beverages to JB Enterprises. My Brothers Liquor Store is in business at 536 East Main Street today.

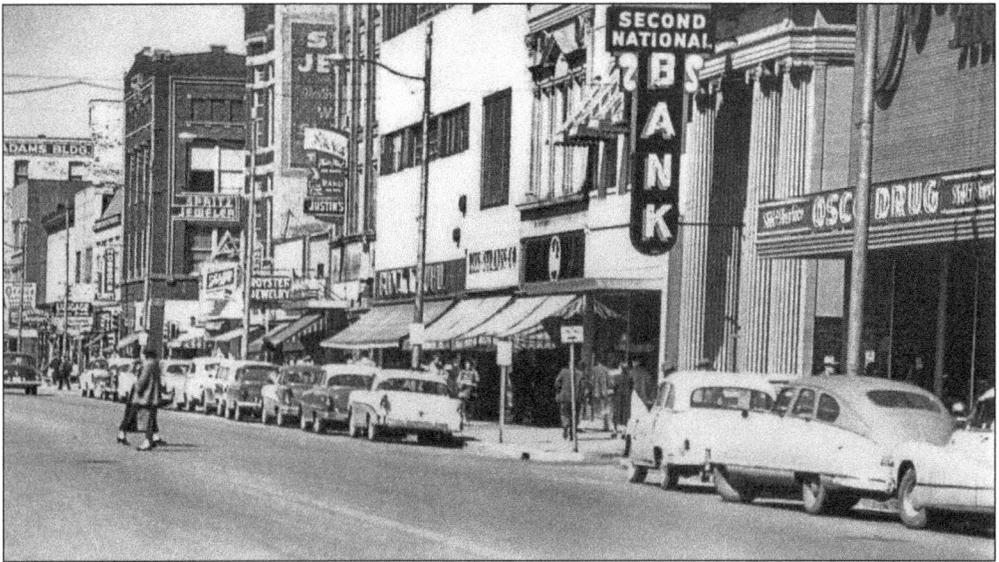

This photograph shows the east side of the unit block of North Vermilion Street heading north. Some of the prominent businesses that occupied the area were, from right to left, Osco Drug, Second National Bank, Bill Vogt men's clothing, Ries-Strauss Company men's clothing, the Block & Kuhl department store, the Baum Building, Justin's Shoe Company, Royster's Jewelry, Spritz Jeweler, the Dale Building, Mosser's Shoes, and the Adams Building.

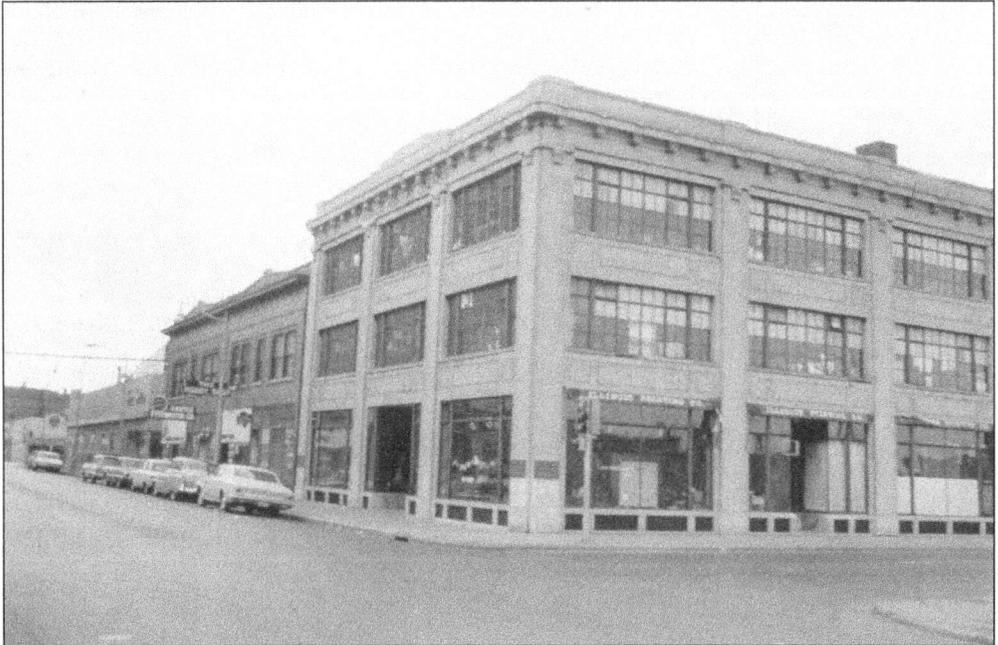

The Illinois Printing Company was organized in 1874 by a group of prominent Danville individuals: William Jewell, Joseph H. Woodmansee, and George Flynn. The original building, on the southeast corner of Vermilion and North Streets, was destroyed by fire in 1914. The company then built the structure shown here at 28 West North Street, where it operated until 1974. Currently, Vermilion Advantage and the Danville Area Economic Development Corporation are located here.

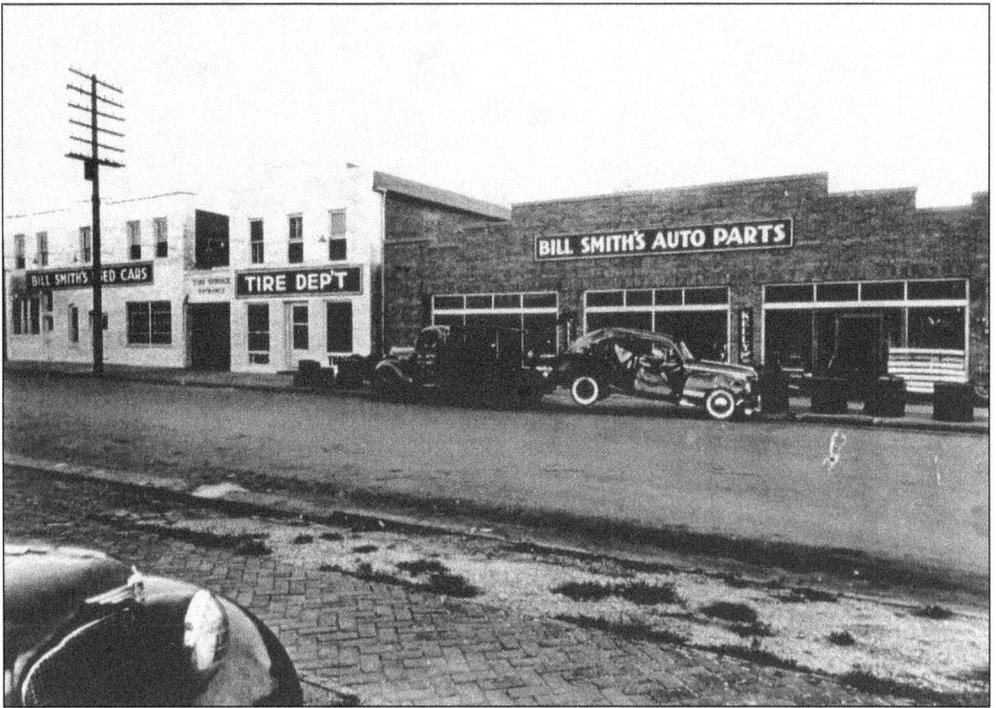

Bill Smith Auto Parts (above), at 102 South Street, and Fagen Auto Parts (below), at 40 South Hazel Street, are two of the many auto part suppliers that have operated in Danville over the years. Bill Smith bought a building previously owned by the Danville Used Car Exchange in the early 1940s. Fagen Auto Parts opened in the early 1930s at a location that was previously a restaurant. These two businesses were in the same general area, south of Main Street and just west of Vermilion Street. This area was reworked during urban renewal in the 1970s. Both auto parts dealers are still in business today but at different locations. Bill Smith moved to 400 Ash Street, and Fagen moved to 3202 North Vermilion Street.

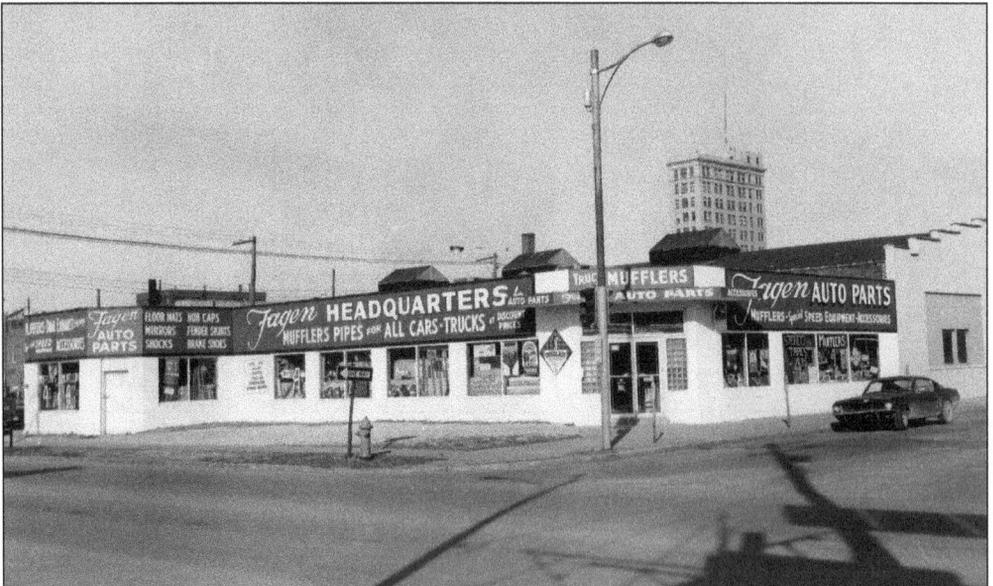

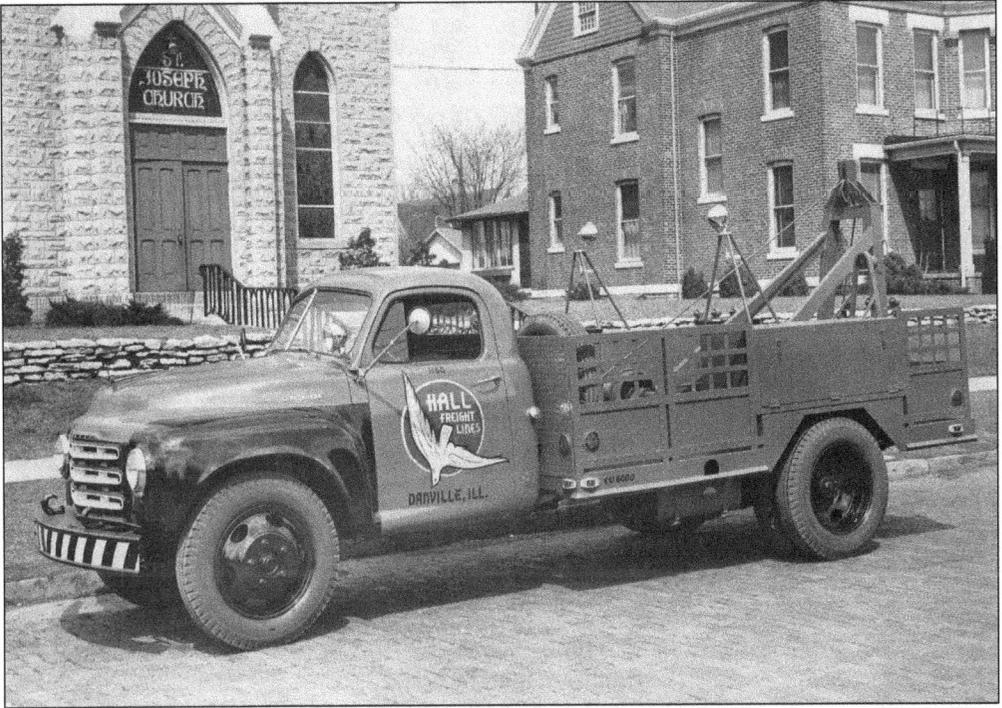

Danville Transfer & Storage was one of the earliest transfer lines in Danville, with a stable of 55 teams of horses housed in two barns in the city. In 1910, the company hauled one slab of stone weighing 18 tons for the construction of the new post office at Harrison and Vermilion Streets. In 1914, Carey B. Hall became president of the company, located at 12–18 College Street. In 1927, the company purchased its first motorized truck; in 1928, it retired its last team of horses. In 1936, the name was changed to Hall Freight Lines. The emblem on their trucks represents the company motto, "Direct as the Bird Flies." By 1959, the company served 221 towns in Illinois directly from all Hall terminal points. The photograph above shows one of the earlier trucks in front of the old St. Joseph Church.

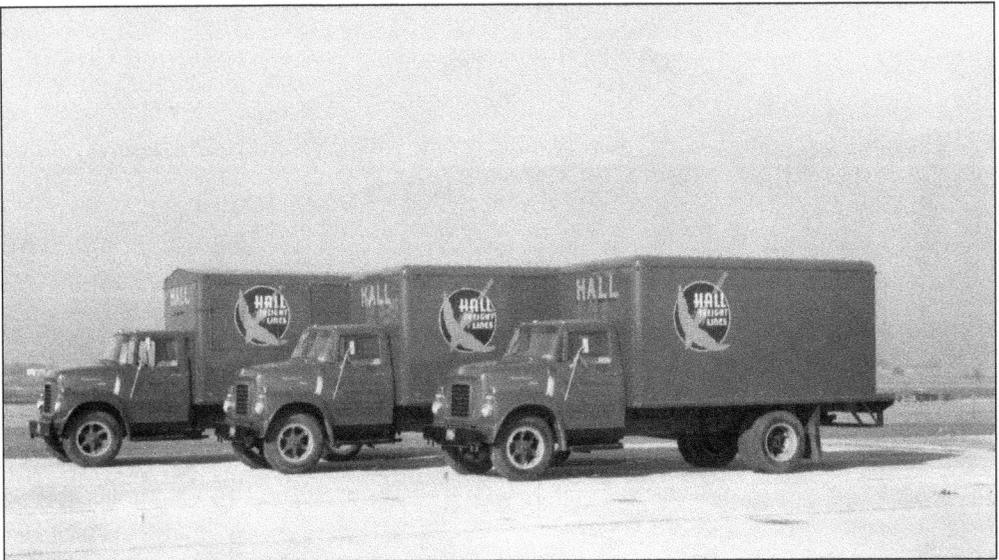

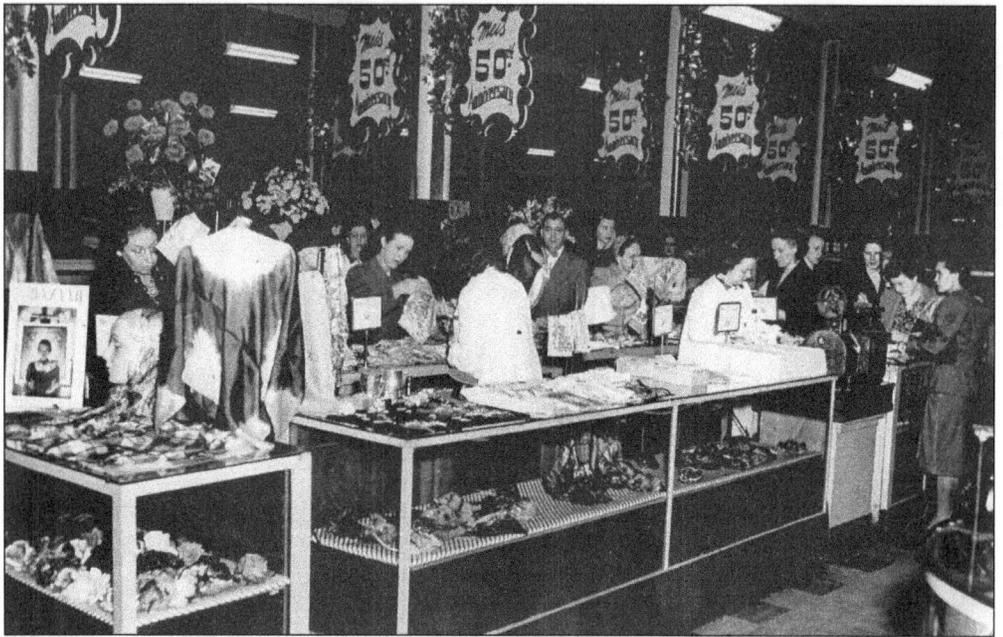

The 1947 photograph above shows Meis Bros., at 102 East Main Street, during its 50th anniversary. The Meis-Baer Store opened on September 6, 1897. In 1901, Alphonse and Joseph Meis bought out all other interests and renamed the store Meis Bros. Between 1905 and 1907, adjacent buildings were acquired, and they were incorporated into one store in 1918, the first major move to become a modern department store. Joseph Meis retired in 1918, after which Alphonse built Meis Bros. into a leading store in the area. Meis Bros. was famous for its Dollar Day and Moonlight Madness sales. Of special interest were the Christmas window displays with movable figures to delight the children. Dick Van Dyke once worked as a salesman in the shoe department. The store was purchased by H.P. Wasson & Company in 1964 and later by Goldblatt Brothers, Inc., of Chicago.

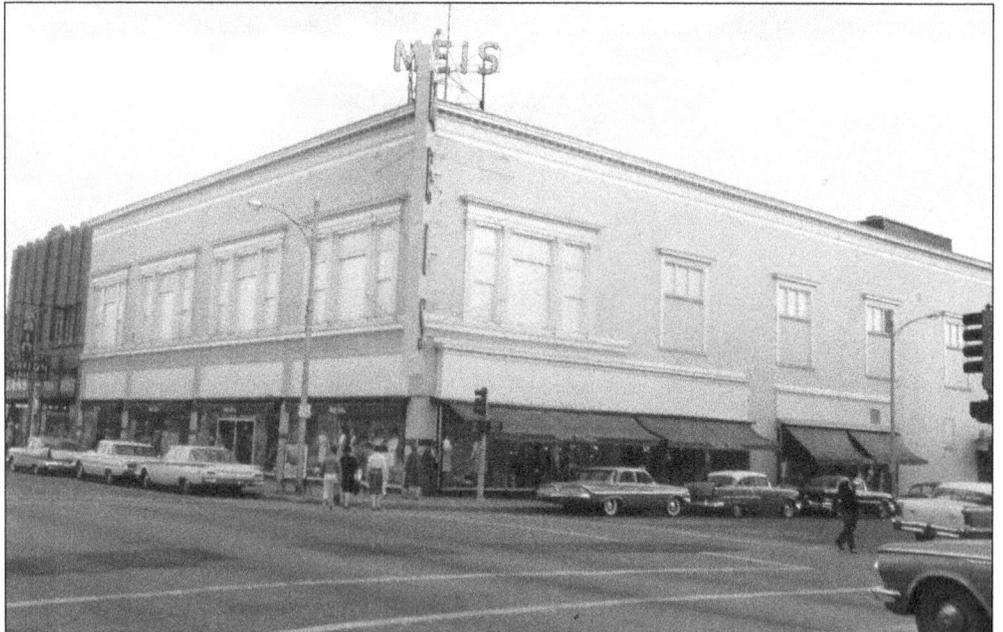

The Chamber of Commerce of Danville represented the leading mercantile, banking, manufacturing, and professional interests of the city. In 1899, at the organization's inception, Danville, with a population of 25,000, was the sixth-largest city in Illinois. It had vast coal resources and was a leading producer of bricks. The main lines of the Chicago & Eastern Illinois Railroad, the Wabash Railroad, and the Peoria & Eastern and Cairo divisions of the Big Four Railways intersected the city, providing optimal access to shipping for manufacturers. In 1948, the managing secretary at the time, David J. Twomey, noted that since 1930, a total of 34 new plants, employing over 5,000 people, had invested in the Danville community. Renamed the Danville Area Chamber of Commerce in 1982 to stress regional concerns over city concerns, it is now known as Vermilion Advantage. The organization continues to promote the area and represent business and manufacturing interests in the county.

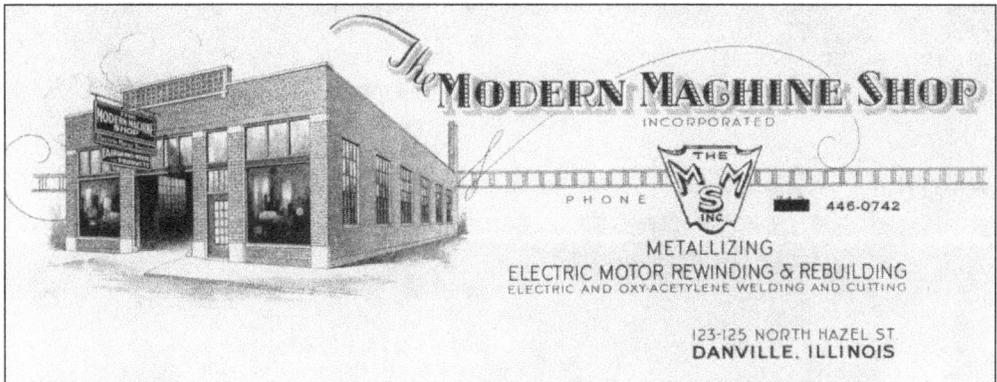

Modern Machine Shop, located at 123–125 North Hazel Street, was incorporated in the early 1920s under the leadership of John Abbie Miller and Clarence Carter. It specialized in metallizing, electric motor rewinding and rebuilding, and electric and oxyacetylene welding and cutting. The business was a mainstay of the downtown Danville area until it closed in 2010.

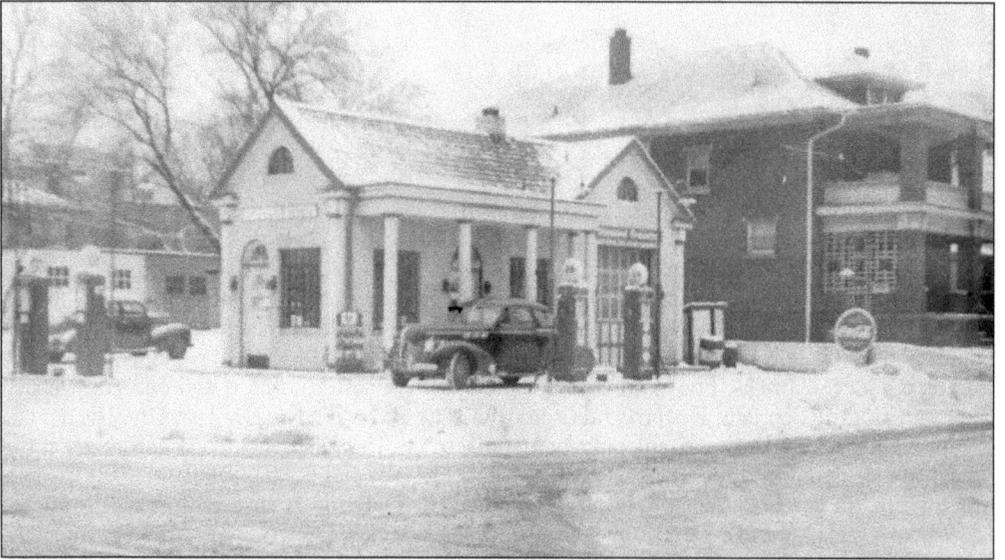

This late-1940s photograph shows one of many gas stations in Danville. The Crandall DX service filling station, on the northeast corner of Harrison and North Gilbert Streets, was situated just south of Washington School, barely visible on the far left. The station was owned by Hosea G. Crandall. While the station and Washington School no longer exist, the house to the right is still standing.

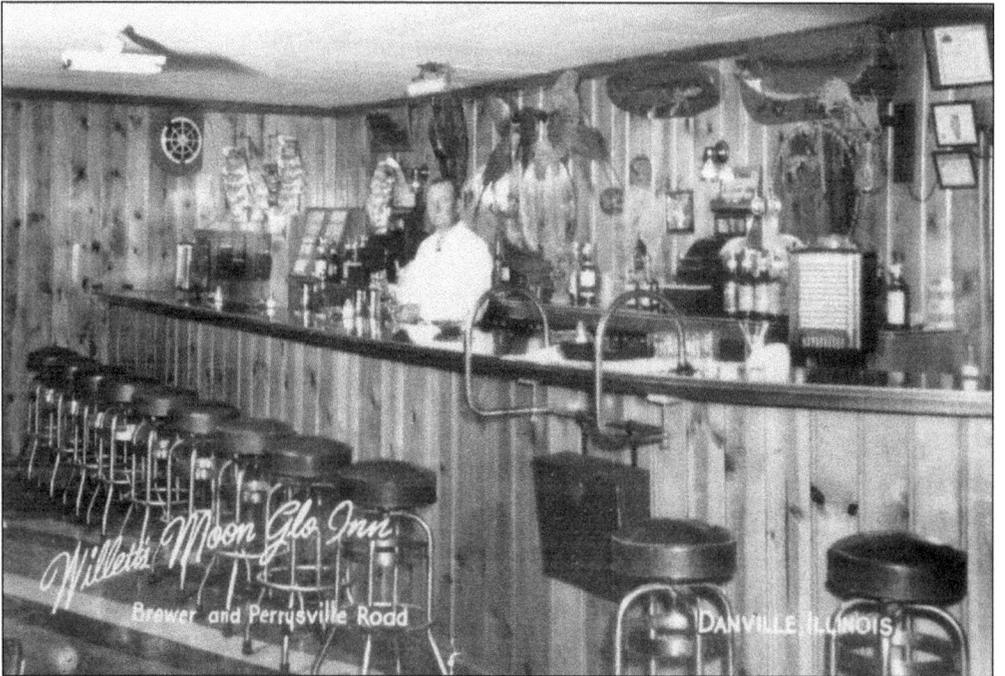

The Moon Glo Inn, at the corner of Brewer and Perrysville Roads, has been famous for its Moon Burgers since the 1980s. Opened in 1948 by William Willett, the former father-in-law of Dick Van Dyke, it has been a favorite watering hole on the southeastern side of Danville for many years. The inn was purchased by Eugene Adams in 1962 and is now operated by his son Phil.

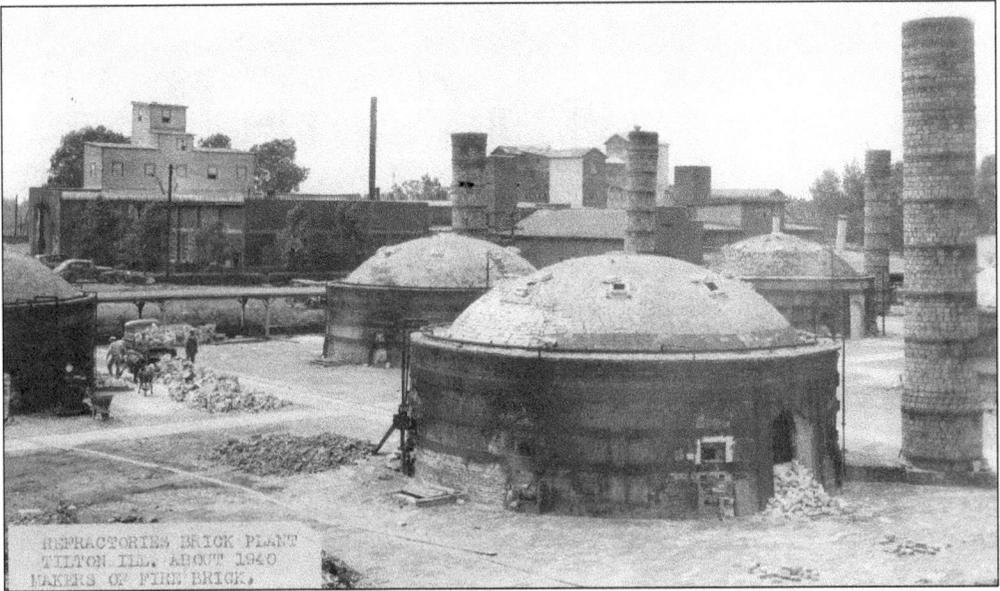

REFRACTORIES BRICK PLANT
TILTON, ILL, ABOUT 1940
MAKERS OF FIRE BRICK,

There were five brick companies located in Danville and the surrounding areas from 1900 to 1973: Acme Brick Company, Advance Industrial Supply Company, Danville Brick Company, General Refractories Company, and Western Brick Company. General Refractories (above), located at the General Motors Tilton site, bought out American Refractories Company in 1923. It specialized in firebrick, which was used to line furnaces and kilns. Western Brick Company (below), situated on 120 acres of land in Vermilion Heights, opened in 1901. The founders initially chose Danville as the company site because of the city's three railroads and the area's large amount of coal, which was needed to operate the kilns. Production started with 20,000 bricks a day, increasing within 20 years to 350,000 bricks a day, making Western Brick the largest brick plant in the world by 1920. The plant was closed in 1973.

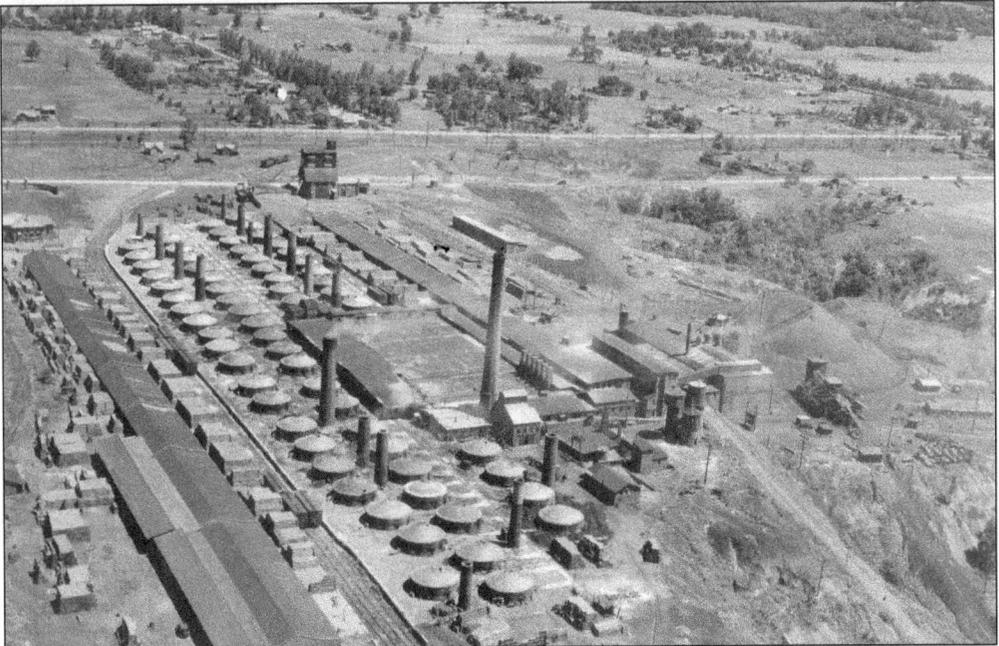

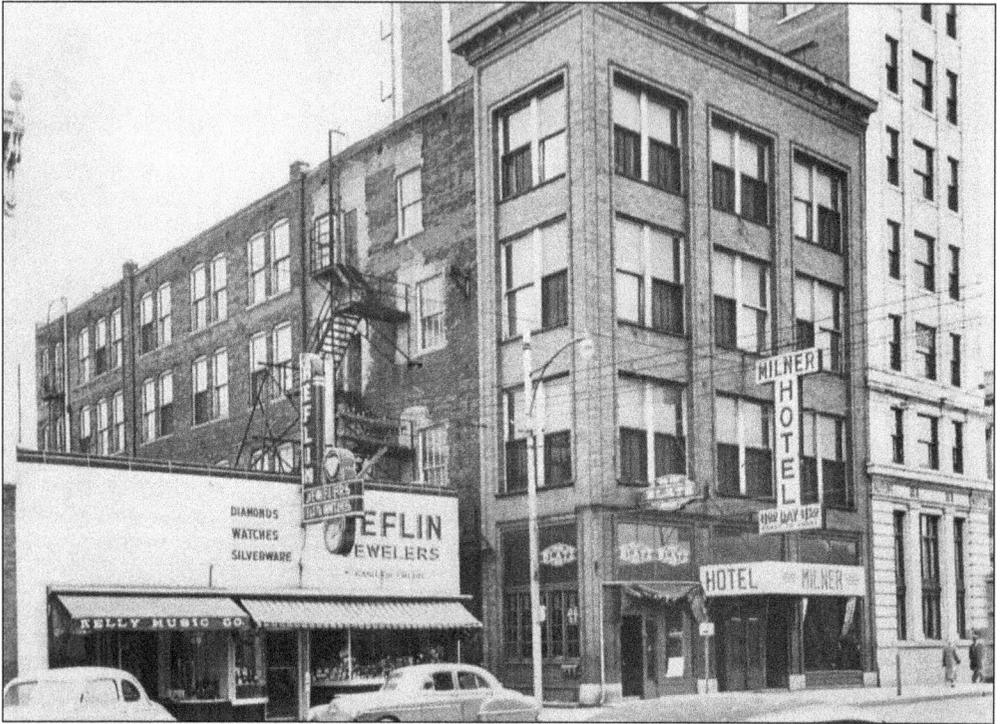

The unit block of West Main Street has changed a lot over the years. These two photographs show this location about 20 years apart. The 1940s image above shows, from right to left, beginning at 2 West Main Street, Bresee Towers, the Milner Hotel (the former Savoy Hotel), Heflin Jewelers, and Kelly Music Company. Taken in 1968, the photograph below continues the unit block with Vermilion County Abstract (right), at 23 West Main Street, and the Spiegel Mail Order Store. After this photograph was taken, these buildings were razed for the expansion of First National Bank. The Spiegel Store was inside a building once owned by Charles A. Fera, a real estate investor, restaurateur, and grocer who accumulated and then platted land south of Spring Hill Cemetery. Kingdom Street was named after one of his thoroughbred horses.

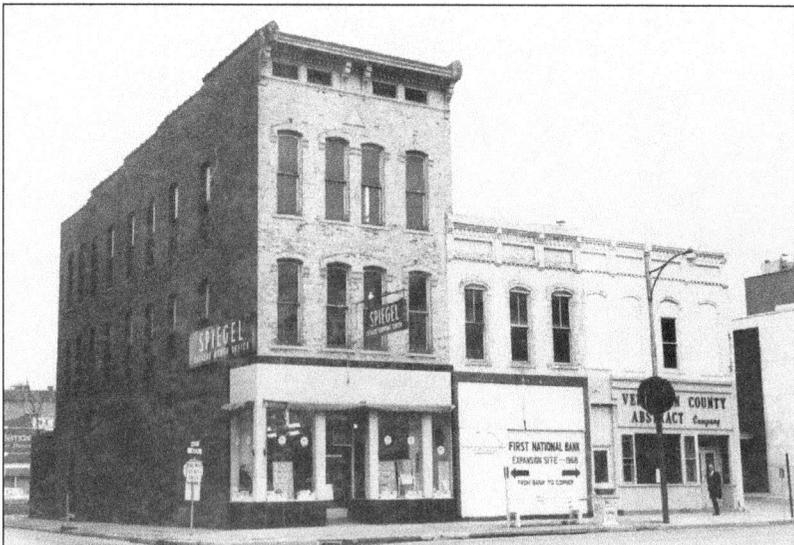

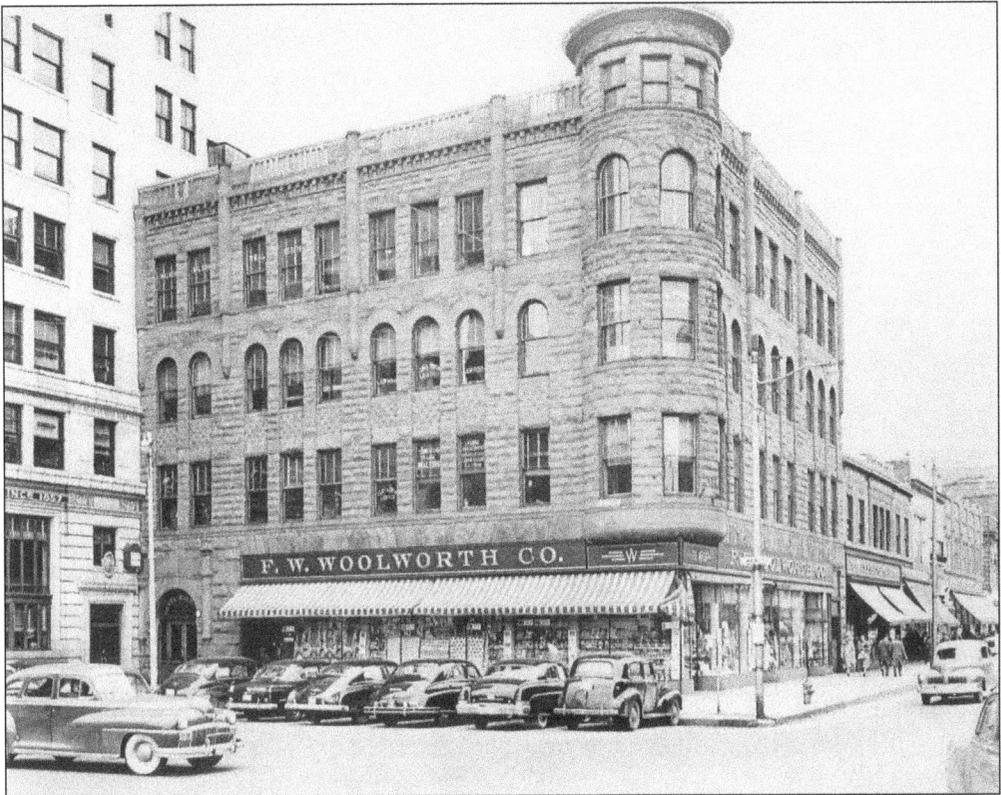

F.W. Woolworth in Danville was established in 1909 on the ground floor of the Daniel Building, at 8 North Vermilion Street. The red sandstone building was an icon on that corner. Its long lunch counter was a popular stop for noonday shoppers. At the time of its closing in 1978, it was the oldest department store in Danville.

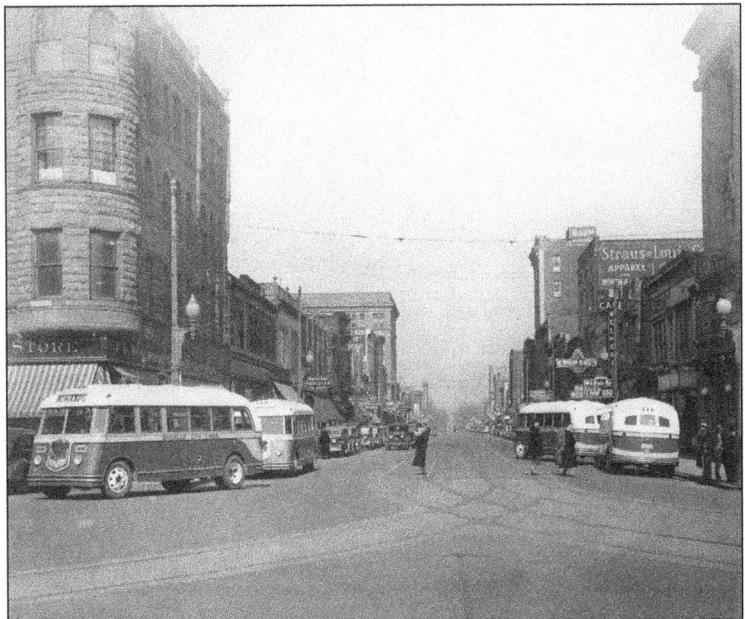

Danville City Lines buses bring people to shop and conduct business in this early-1950s photograph of the central business district. Note the rails down the middle of the street from the former streetcar lines. Clearly identifiable on the left are F.W. Woolworth, S.S. Kresge, and Parisian Women's Clothing. On the right are a corner of the courthouse, Café Belmont, Mandarin Café, and Straus & Louis Clothing Store.

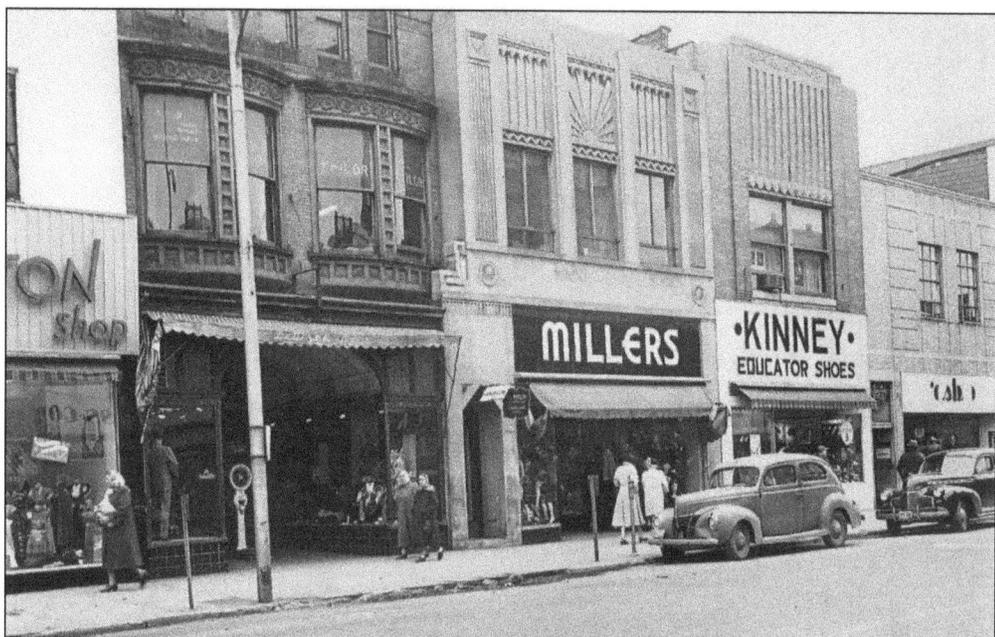

This photograph shows Danville's flourishing central business district in the late 1940s. Beginning at 32 North Vermilion Street are, from left to right, the Cotton Shop, Deutsch Brothers Men's Clothing (above which are a justice of the peace, a massage parlor, and Deutsch Brothers Tailor Shop), Millers Women's Clothing, the Kinney Shoe Store, the offices of dentist John P. Honey, and the Fashion Women's Clothing.

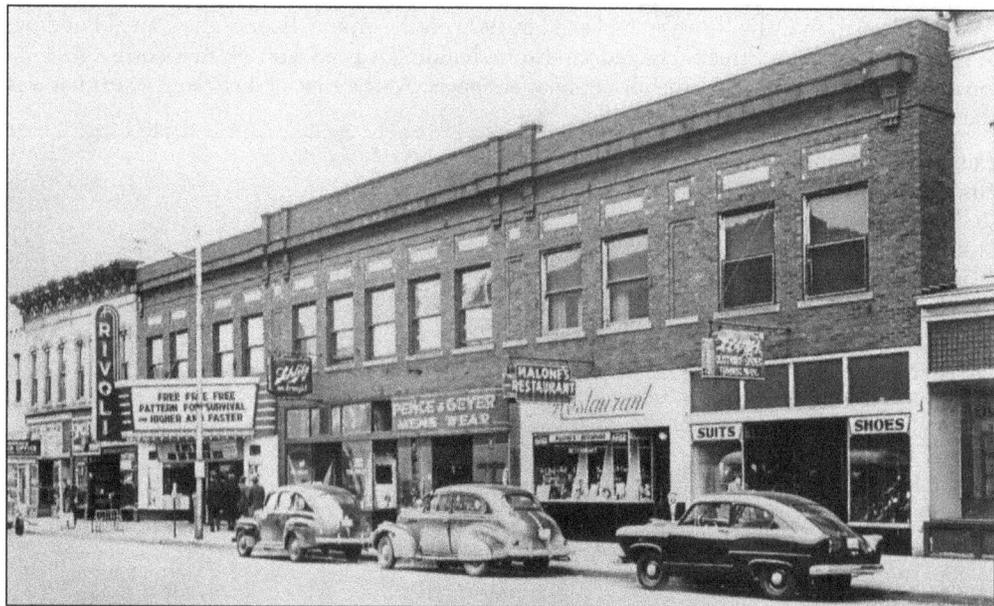

This photograph from around 1950 shows the south side of East Main Street. From right to left, starting at 122 East Main Street, are Levy's Men's Clothing Store, Malone's Restaurant, Pence & Geyer Men's Wear, the Kienast Tavern, the Rivoli Theatre, Shields Dry Cleaners, Singleton Shoe Repair, the offices of pawnbroker Abraham Gordon, and the barbershop of Robert Arp. The theater was previously known as the Tivoli, and it first opened as the Central Theatre in 1913.

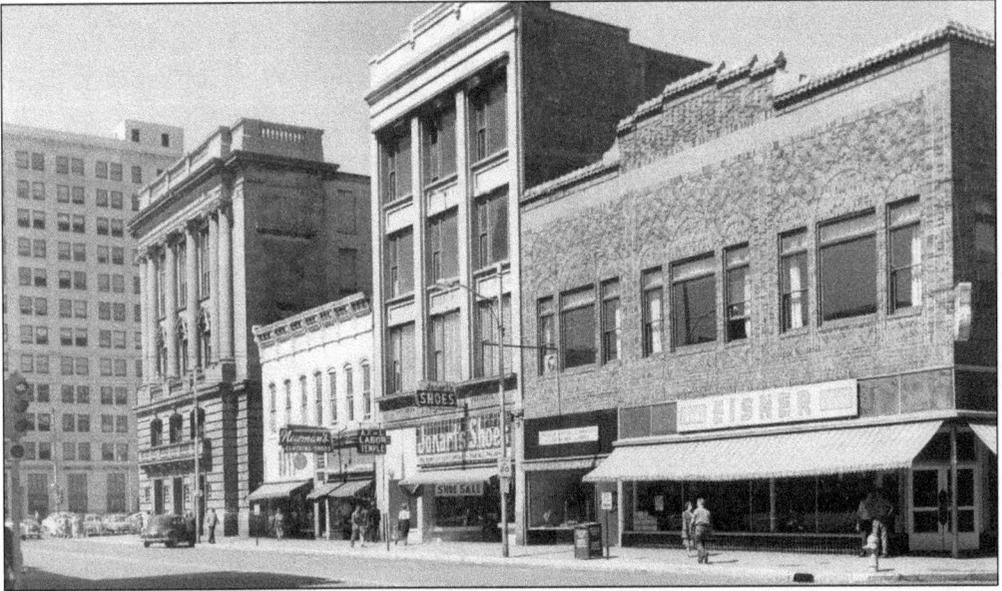

These businesses were in a prime location, just east of the public square in the unit block of East Main Street in the late 1940s. Beginning at 15 East Main Street, from left to right, are Newman's Clothing Store, the American Federation of Labor Union's Labor Temple, Jonart's Shoes, the Herald Optical Company House of 950 Glasses, and Eisner Grocery Company.

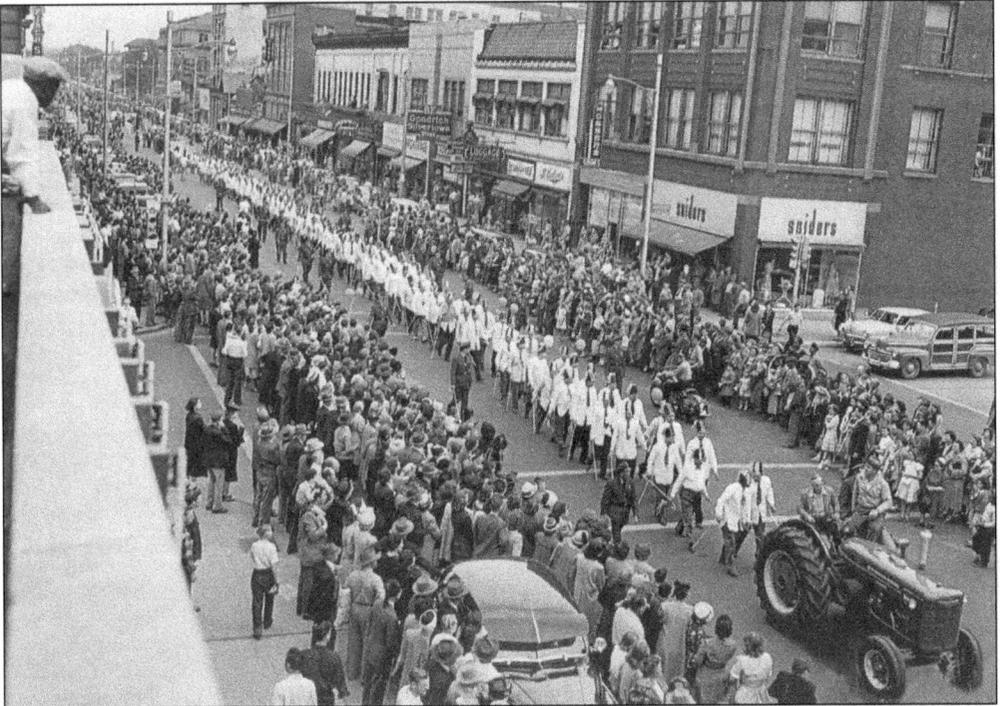

Masses of spectators line the street in this 1949 photograph of a parade marching south on North Vermilion Street. Shriners walk behind a tractor. Sniders (right) is located on the northeast corner of Vermilion and North Streets in the Dale Building. The man peering over the ledge on the left is probably perched on top of the Walgreens' roof.

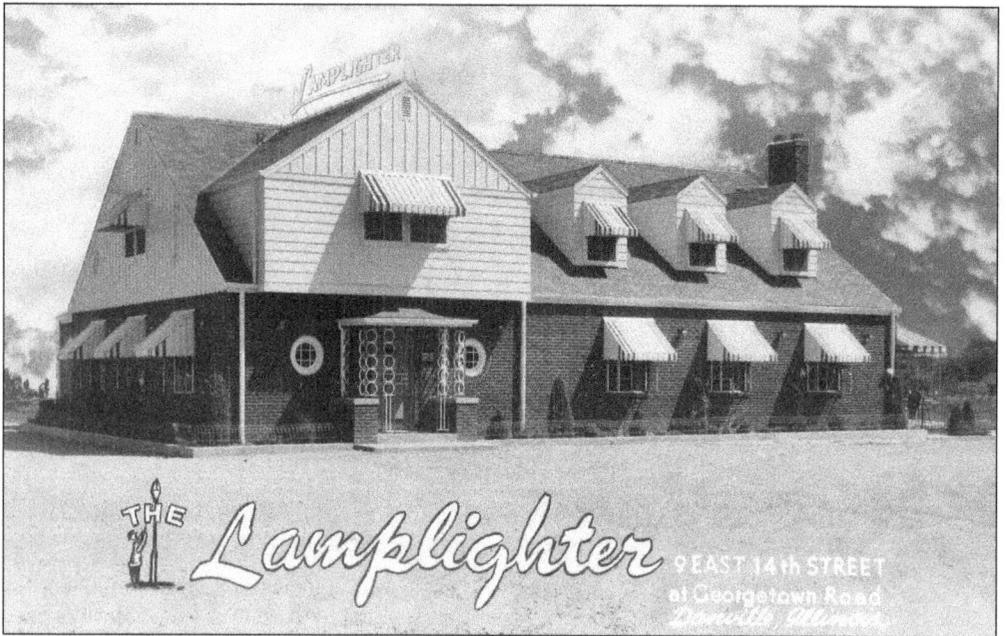

The Lamplighter was "Danvilleland's Finest Cocktail Lounge and Bar," according to the advertisement on the back of this postcard. This tavern was opened in 1949 by Frank I. Major and Warren O. White at 9 East Fourteenth Street, on the corner of Georgetown Road. In its heyday, it operated more as a supper club, hosting entertainment every evening, as well as on Sunday afternoon and evening.

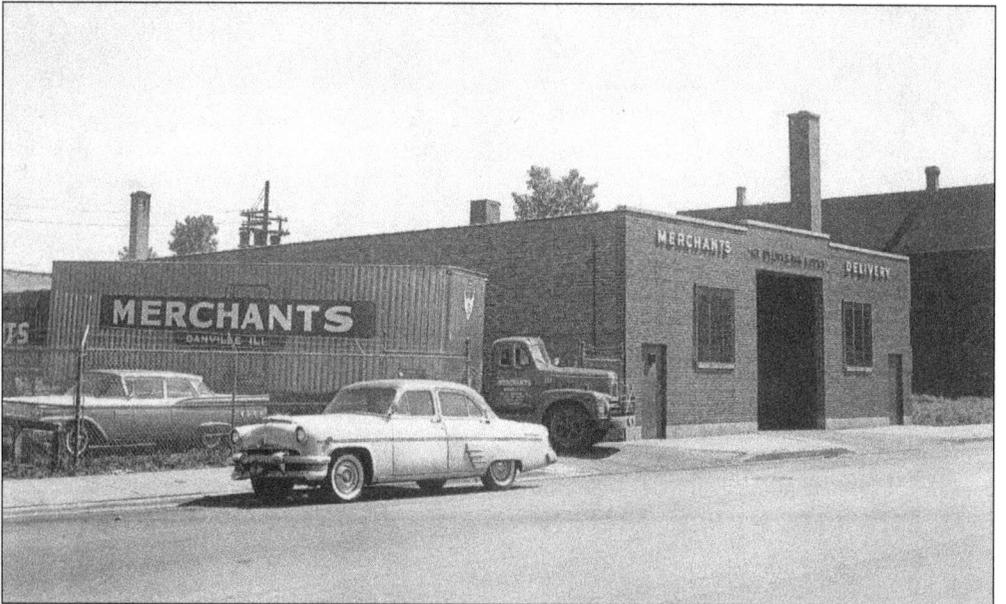

This 1950s photograph shows Merchants Delivery Service, at 115 Wabash Court. The company's motto, "We Deliver the Goods," is mounted above the door. In 1924, more than 30 Danville merchants were using the company to deliver their goods with Merchants' prompt three-times-a-day service. With a complete fleet of vehicles, the company later delivered daily within a 50-mile radius and also maintained a Chicago terminal for additional demands.

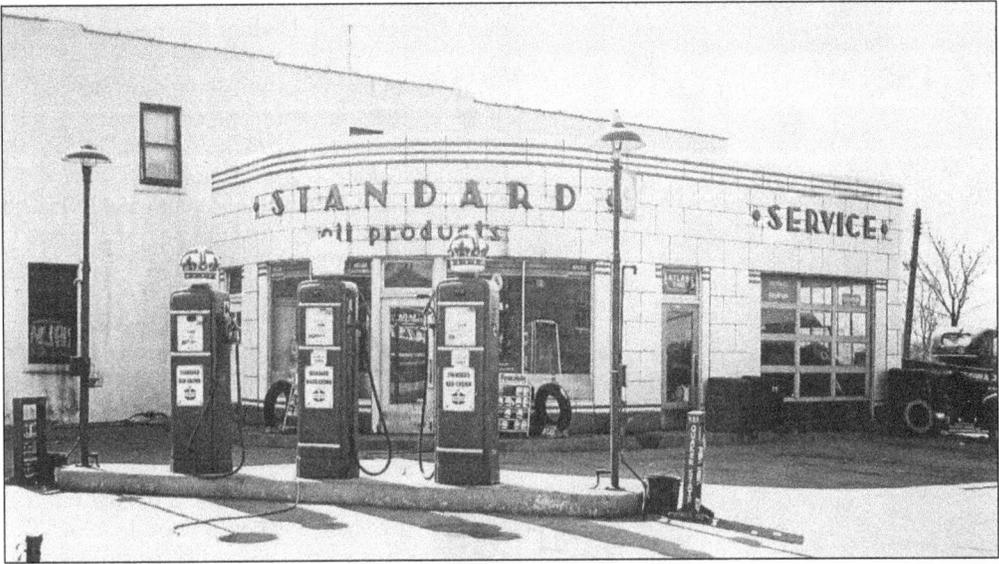

Standard Oil Company opened filling stations in Danville in the early 1930s and 1940s. The station seen here was built in 1930, on the site of the former United Electric Coal Company grocery, at 210 North Logan Avenue. The city directory lists it as being at "Logan Avenue corner Bridge," indicating its placement next to the bridge that provided entrance to the city from the old state route.

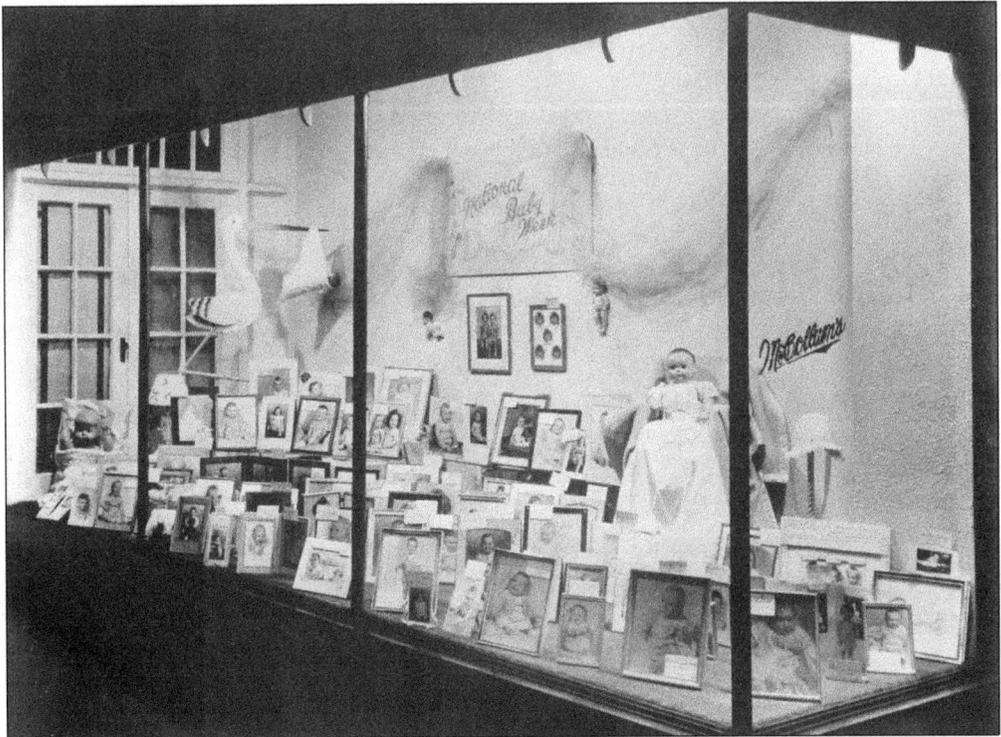

In the early 1950s, McCollum's was a children's clothing store at 105 North Vermilion Street. This photograph, taken by the Grogan Photo Company, shows the window filled with pictures of local children whose families shopped at the store in celebration of National Baby Week.

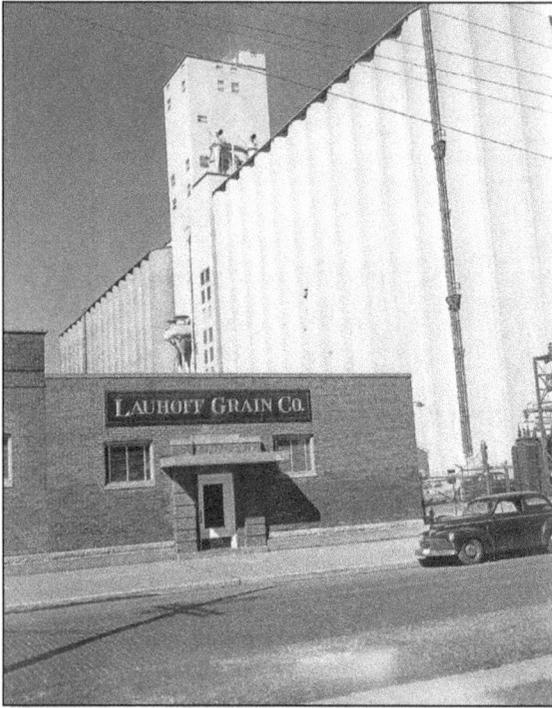

Howard J. Lauhoff purchased the Fecker Brewing Company in 1942 for a grain milling company. During the renovation and conversion from brewery to dry corn mill, a major fire virtually destroyed the plant. After rebuilding in 1946, the business was incorporated as Lauhoff Grain Company. In 1952, a soybean crushing and oil extraction facility was constructed at the Danville site, and soybean processing started the following year. The Danville facility is the largest dry corn mill in the United States and one of the largest soybean processing plants in the world. Lauhoff Grain Company functioned as a privately held corporation in which Howard J. Lauhoff had controlling interest until his sudden death in 1978. On January 3, 1979, the company was acquired by the Bunge Corporation of New York. It is still in operation today under the name Bunge Milling, Inc.

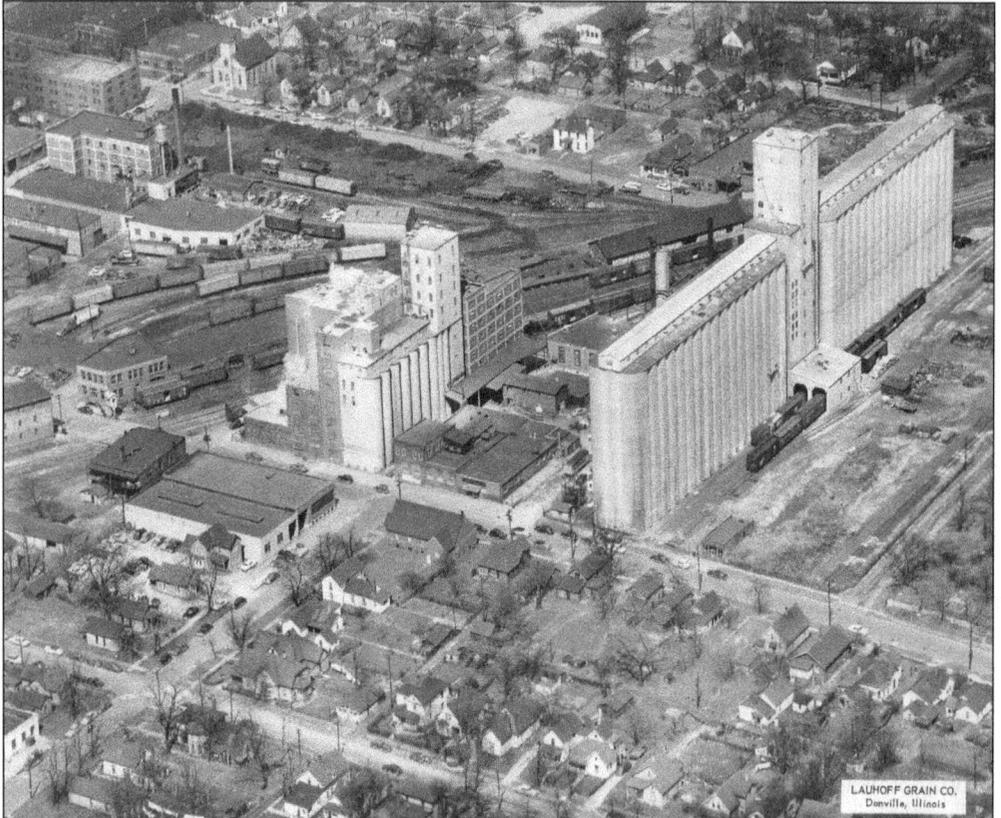

LAUHOFF GRAIN CO.
Danville, Illinois

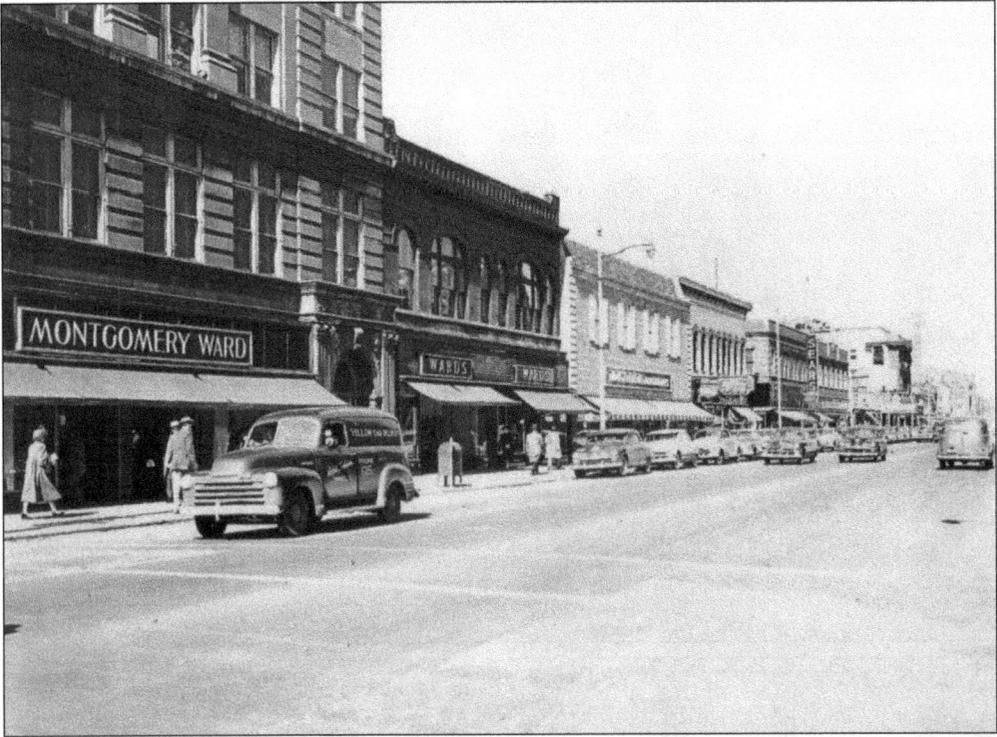

A corner of the Temple Building is visible, showing the west side of the 100 block of North Vermilion Street. Here, in the 1950s, Montgomery Ward occupied the first floor and the building next door. To the north of Ward's is the Butler Brothers-Scott 5¢–$1 store, Bob's Bargain Shoes, the Plaster Drug Company, the Colony Shop women's clothing store, Sears, and, farther down the street, the Fischer Theater.

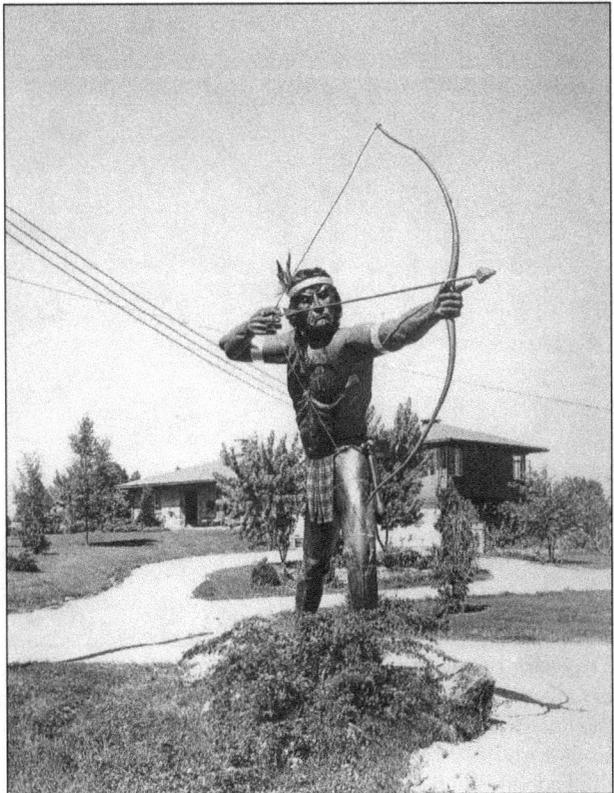

One of the most unique sites in Danville was the 18-foot-tall Native American statue at 3716 North Vermilion Street, outside of the Herb Drews Air Conditioning & Furnace Company. A Danville landmark since 1949, this eye-catching statue was moved to Curtis Orchard in Champaign in 1995.

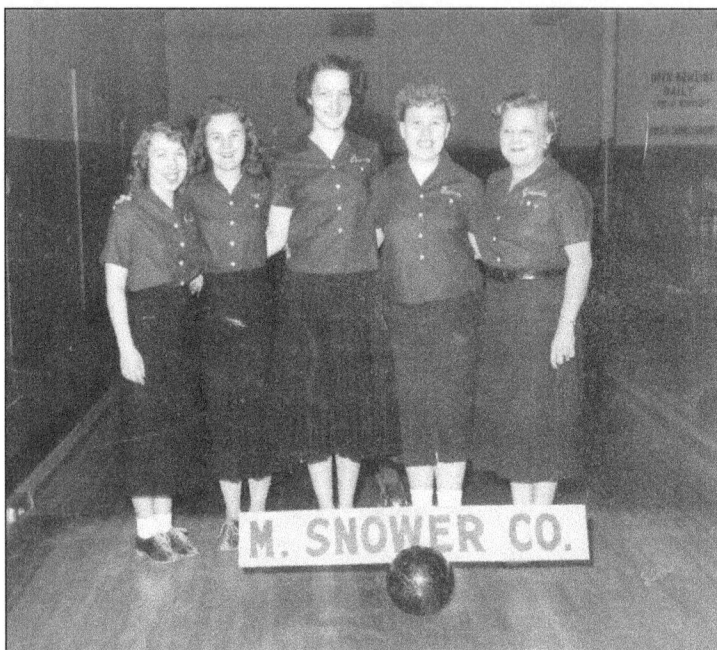

M. Snower & Company manufactured cotton dry goods, including women's dresses. It opened in 1950 at 222 West Main Street, the former site of a storage facility for Danville Tent & Awning. Isadore Katz was the company's manager. This photograph shows, from left to right, Carol Hickman, Pat Edwards, Sharon Rawland, Leona Richardson, and Juanita Laird participating in the company-sponsored bowling team.

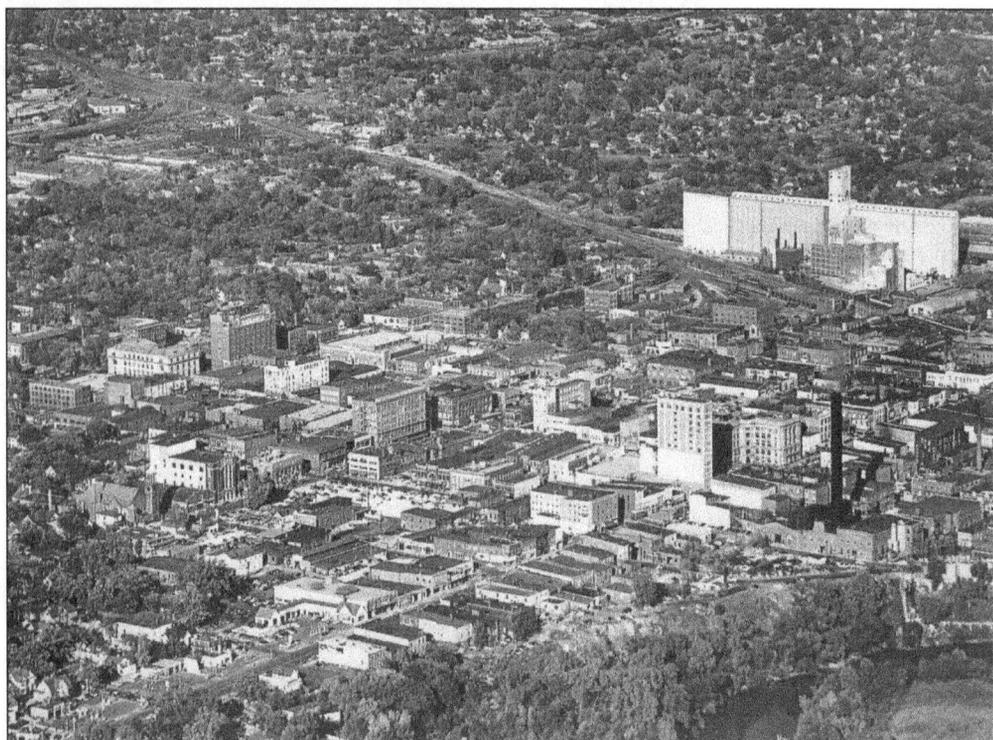

This aerial view of Danville, looking east from the Memorial Bridge, shows Lauhoff Grain Company (now Bunge Milling, Inc.) in the upper right, looming large near the downtown area. In the lower right, Danville's tallest building, Bresee Tower, provides definition to the city's skyline, along with the power plant's smokestack. To the north (left) is the Hotel Wolford, situated behind the Federal Building.

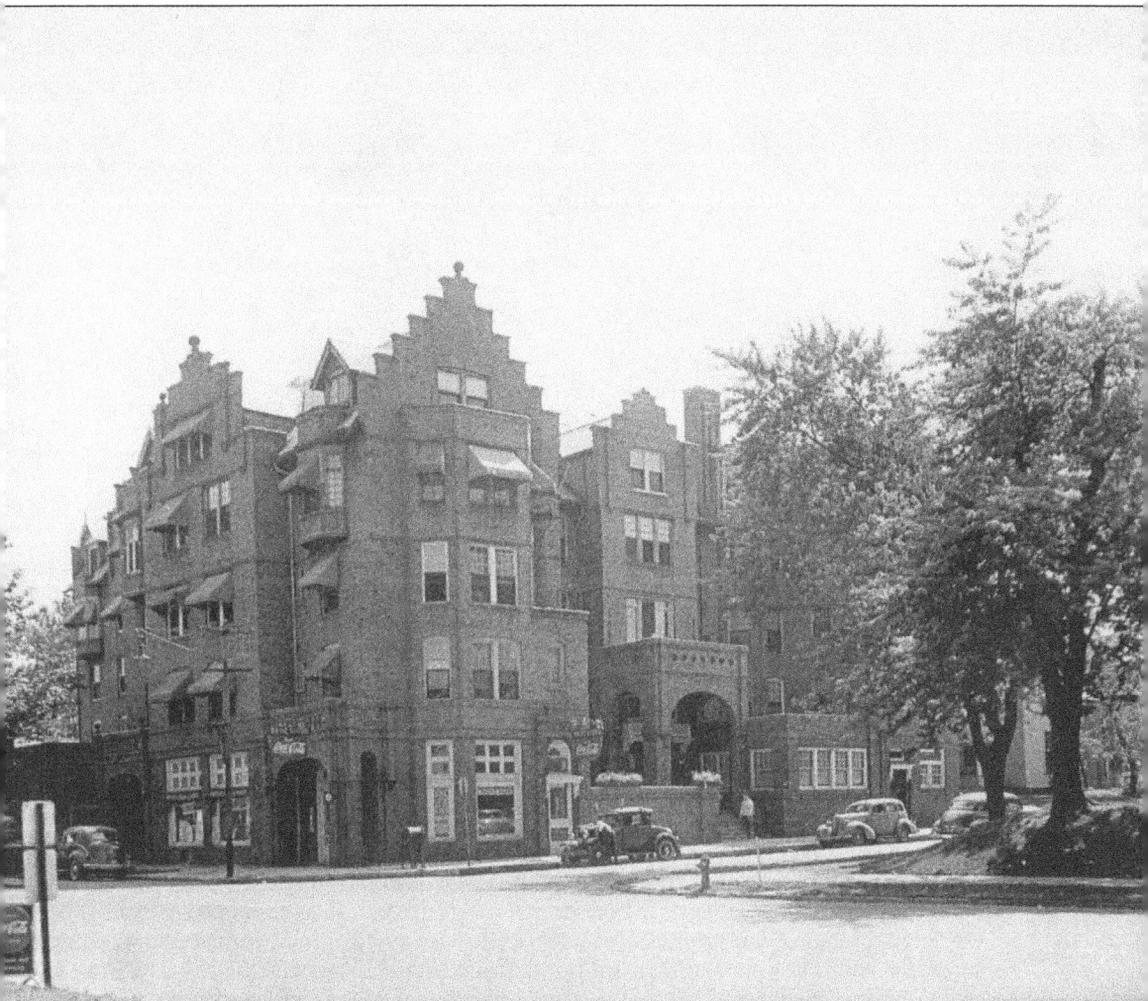

The Holland Apartments, originally called Dodge Flats, was built in 1906 by Gen. Anson Green Phelps Dodge, a local businessman and timber tycoon who once served in the Canadian Parliament. The building was patterned after a hotel that once stood in the Netherlands. Located at 324 North Vermilion Street, it is a wonderful example of the diverse style of architecture common to downtown Danville in the prosperous period between 1900 and 1920. Architect Charles M. Lewis once rented an apartment in this building, as well as other young professional lawyers, physicians, judges, and business owners. The 68-unit building also included four street-front retail stores and a large restaurant. In 1927, Dodge's daughter Julia had an addition built to the south side, designed to complement the original structure. By 1987, government inspectors declared the building unsafe and ordered it closed. In 1999, Crosspoint Human Services purchased the building in order to preserve the structure and provide affordable housing. The $7.2-million rehabilitation project used green technology to make the building more energy efficient and comfortable.

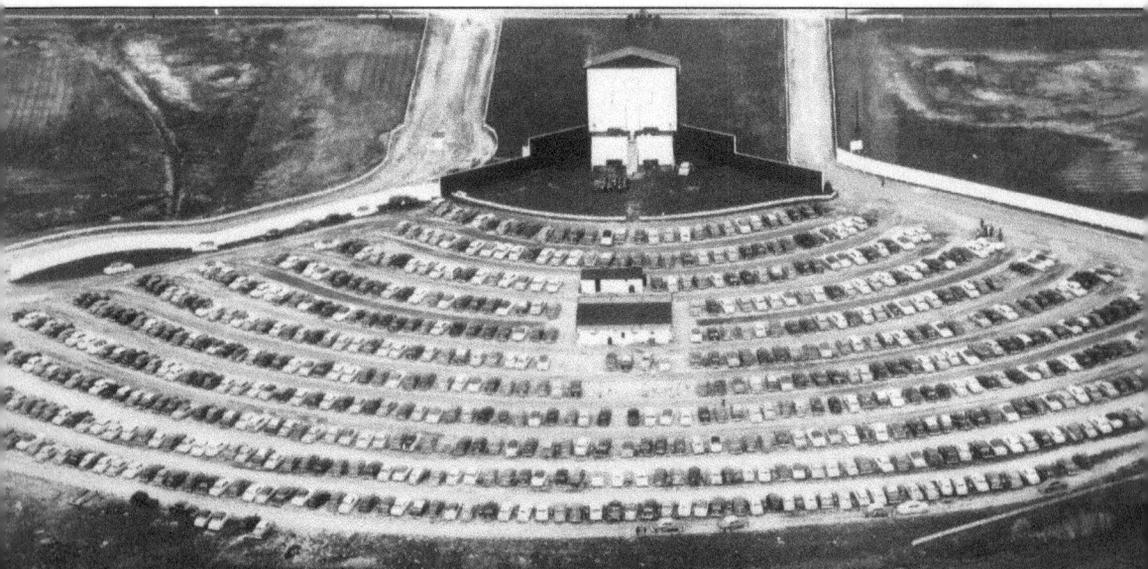

EASTER SUNRISE SERVICES
APRIL 18,1954
Immanuel and Trinity Lutheran Churches
DANVILLE, ILLINOIS

The Cascades Amusement Corporation of Bloomington, Indiana, invested approximately $150,000 to have the Dixie Drive-In Theater built on a 28-acre lot north of Liberty School on the east side of the old Dixie Highway. The 63-foot-high, 58-foot-wide concrete and steel tower was built to withstand windstorms of 90 miles per hour or more. The drive-in theater opened in April 1949 and was able to accommodate up to 800 automobiles. In addition to offering regular film showings, the Dixie also had "Dusk till Dawn" marathons, "Buck Night," and theme nights. The drive-in theater business reached it peak in the 1950s and 1960s, appealing to families, teenagers, and the middle-aged. Danville had three drive-ins at that time: the Dixie, the Illiana, and the Skyway. Changes in society and consumer preferences eventually led to the closure of drive-in theaters in the Danville area. The Dixie Drive-In tower was taken down in 1985.

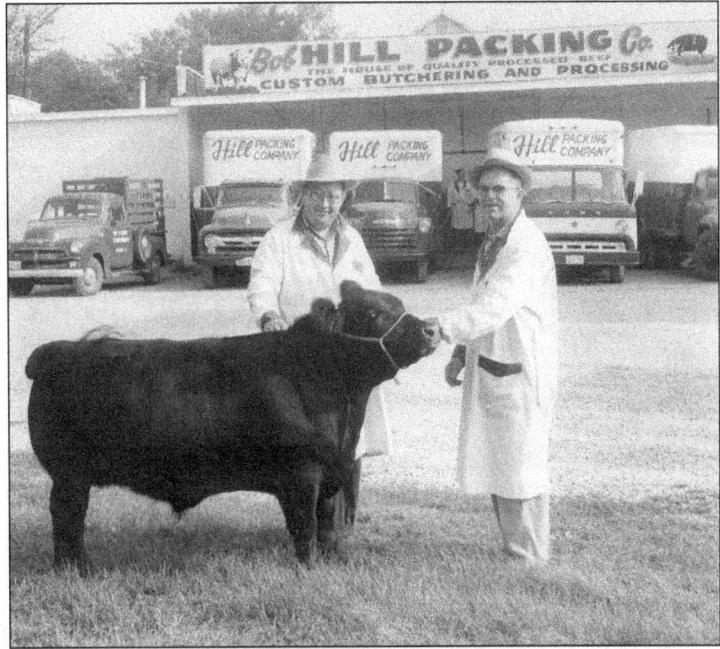

Bob Hill was a salesman at the Rose Packing Company before starting Hill Packing Company in 1955. Located at the corner of Perrysville Road and South Griffin Street, the company dressed beef and veal and did custom butchering. The business was purchased by A. Layden Enterprise in 1974 but continued to operate as Hill Packing until closing in 1985. Seen in front of the business is a 1958 4-H Club beef winner that was purchased by the Cork Plaza Restaurant.

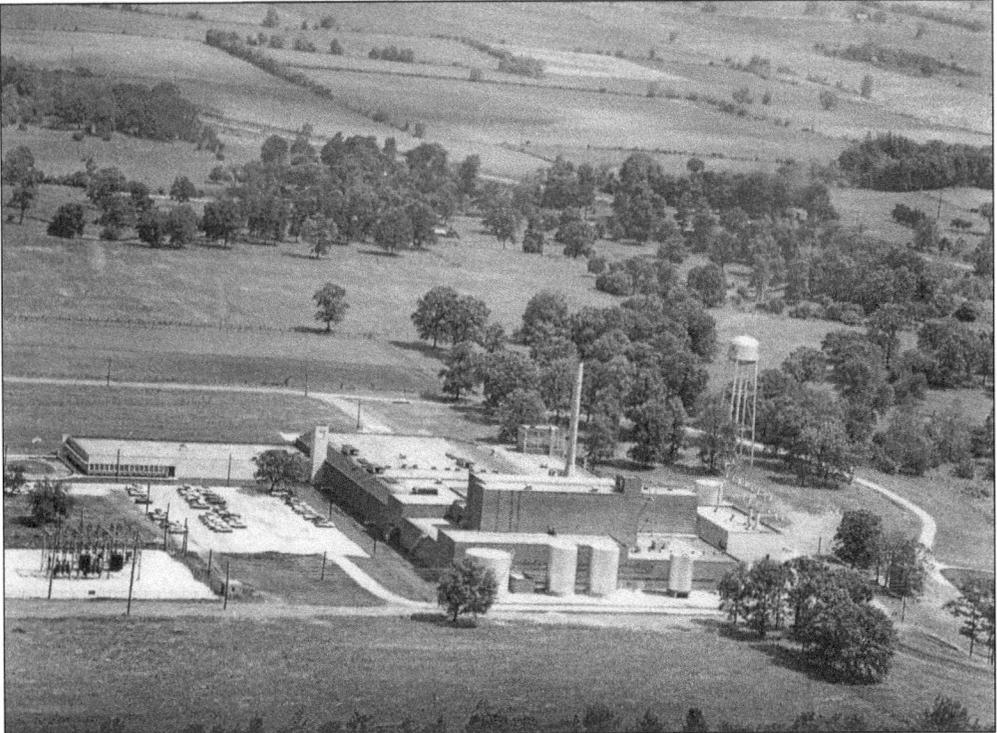

Tee-Pak, Inc., manufactured cellulose casings and plastic film packaging. The multimillion-dollar Danville plant, completed in 1957, was on a 37-acre site facing Michigan Avenue near Voorhees Street. Tee-Pak's Danville facility was designed to supplement the production of its Chicago plant. Tee-Pak built three additions after opening, allowing the plant to cover more than 300,000 square feet. In 2005, the Danville plant was purchased by Visofan USA, Inc.

After a study of more than 200 sites was completed in January 1945 by the Fort Wayne Works of General Electric, Danville was recommended as the most favorable site for a plant to manufacture fluorescent ballasts. This move was done in an effort by the company to streamline post–World War II production and to take advantage of available labor markets. An opening reception for the new Danville plant was given by the Danville Chamber of Commerce on June 24, 1947. The 1955 photograph below shows movie star and future president Ronald Reagan conversing with a General Electric plant employee in Danville. At the time, Reagan was the host and occasional star of *GE Theatre* and a spokesman for General Electric. By 1966, General Electric's Ballast Department, at 1430 East Fairchild Street, made the city of Danville the "ballast capital of the world." It was turning out more essential controls for fluorescent lamps than any facility on earth. Valmont Electric bought the Danville plant in 1987. Late in 1994, Valmont moved the production lines to Mexico, and the Danville plant was closed.

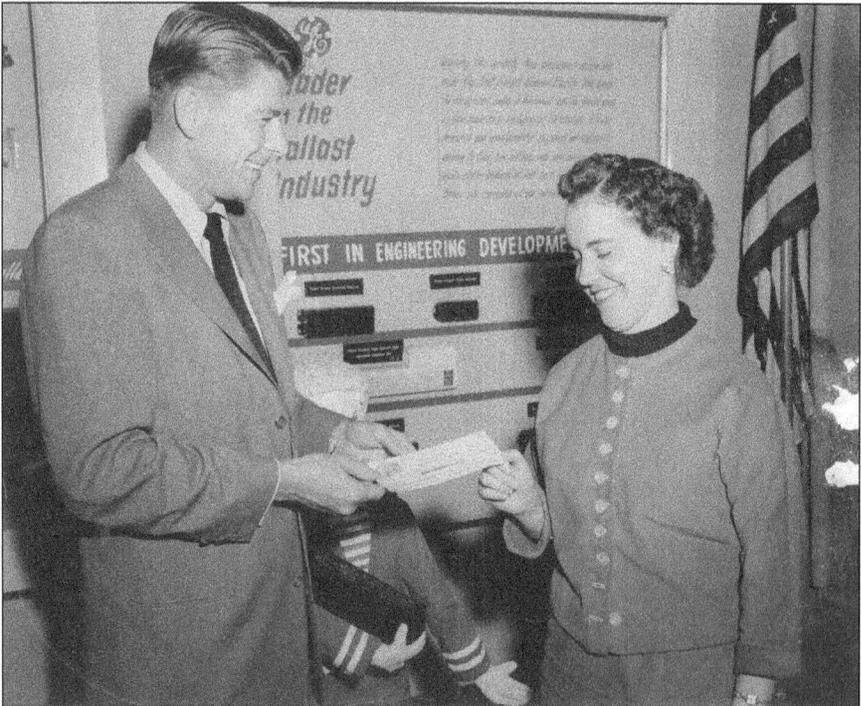

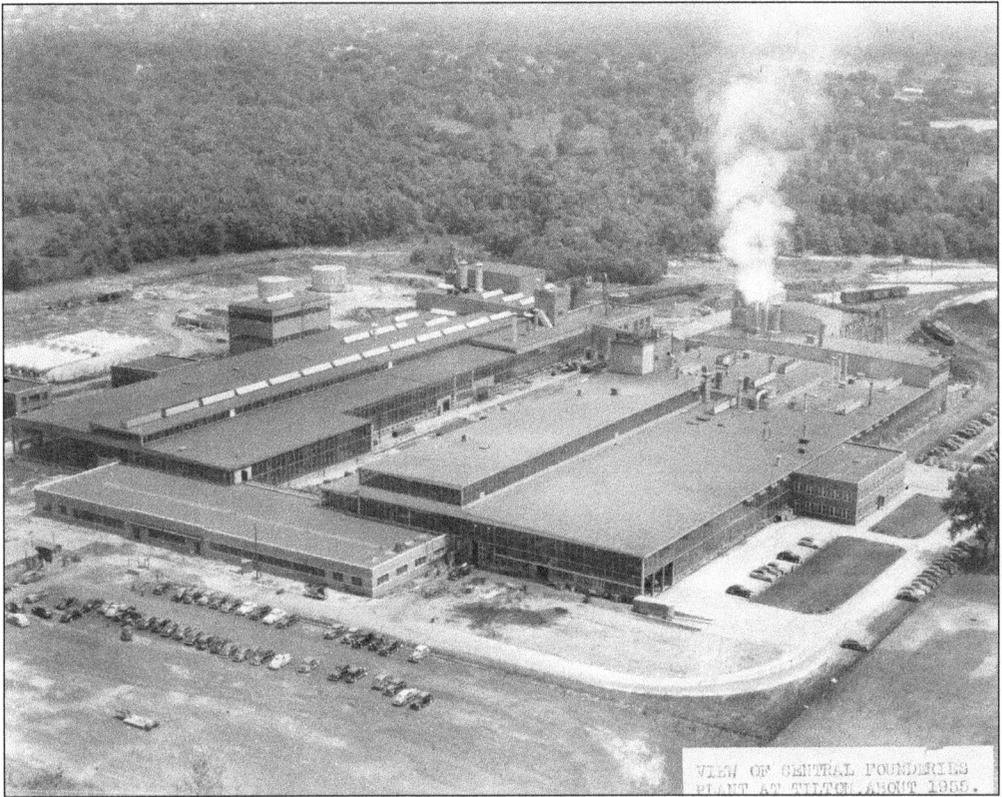

VIEW OF CENTRAL FOUNDRIES
PLANT AT TILTON ABOUT 1955.

In 1943, a defense plant was built by the US government in Tilton, Illinois, on the former site of the American Hemp Corporation and, prior to that, the Cornstalk Products Company. Operated by the Saginaw Malleable Iron Division of General Motors, the plant produced castings for heavy-duty military vehicles for the war effort. The defense plant was closed by the government after World War II but was purchased and reopened by General Motors in 1947 to produce light and medium automotive castings, including shock absorbers, fractional horsepower motors, end frames, and similar parts for the automotive industry. The plant expanded to become the largest industry in the area, and, by 1966, the 320-acre site had 500,000 square feet under roof. General Motors eventually closed the plant in 1996.

central foundry

DIVISION OF GENERAL MOTORS

DANVILLE PLANT

DANVILLE, ILLINOIS

Fred W. Amend began his company manufacturing marshmallows in Chicago in 1921, but he soon became interested in jelly candies. The Danville plant was constructed in the late 1920s and remained open until August 2003 as part of ConAgra Foods' Store Brands Division. The formula for all the candies was the same, with only the size, shape, and flavoring being different. In the years from 1931 to 1938, a total of 40,941,746 pounds of sugar, or an average of 64 train cars per year, was used to produce candy at the factory. This was in addition to the 36,681,081 pounds of corn syrup used, which equaled approximately 48 tank cars a year. In Danville, its most famous product, Chuckles, was shipped around the world. The advertising slogan for the candy was "Even the name says Fun." This photograph shows the exterior of the building, located south of the Chicago & Eastern Illinois Railroad tracks on North Griffin Street.

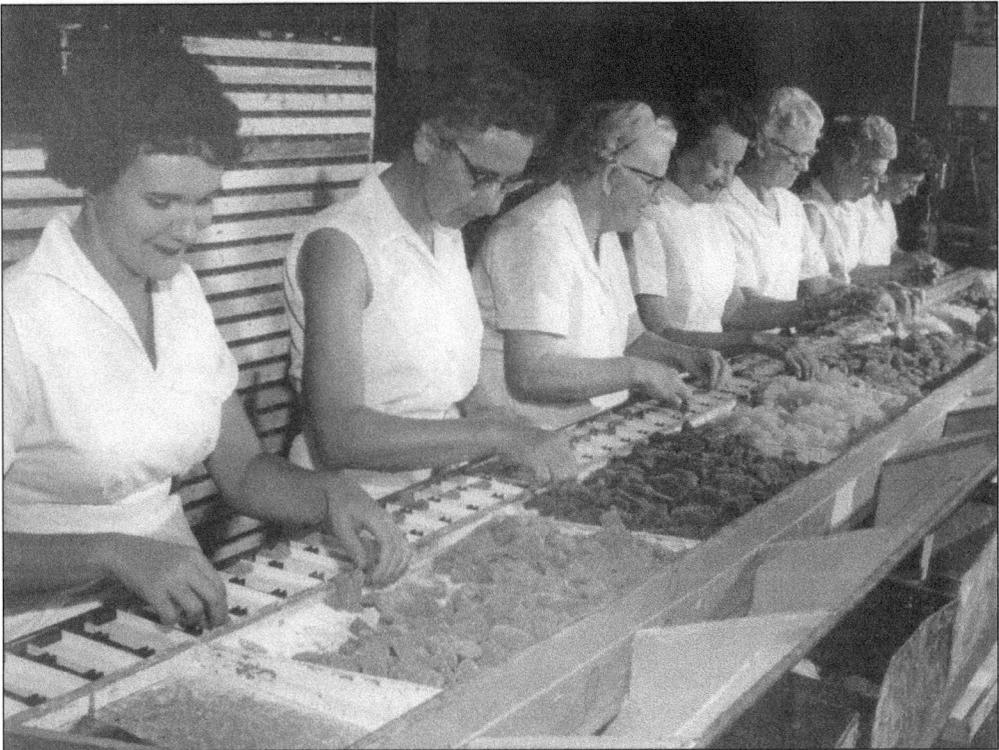

The ladies in this photograph are sorting and preparing the five-flavor bar candies for packaging. This was the second step after the freshly made candies had been scooped from a general bin and sorted into separate trays by color. Usually, the men worked back in the kitchen and the women packed the candy.

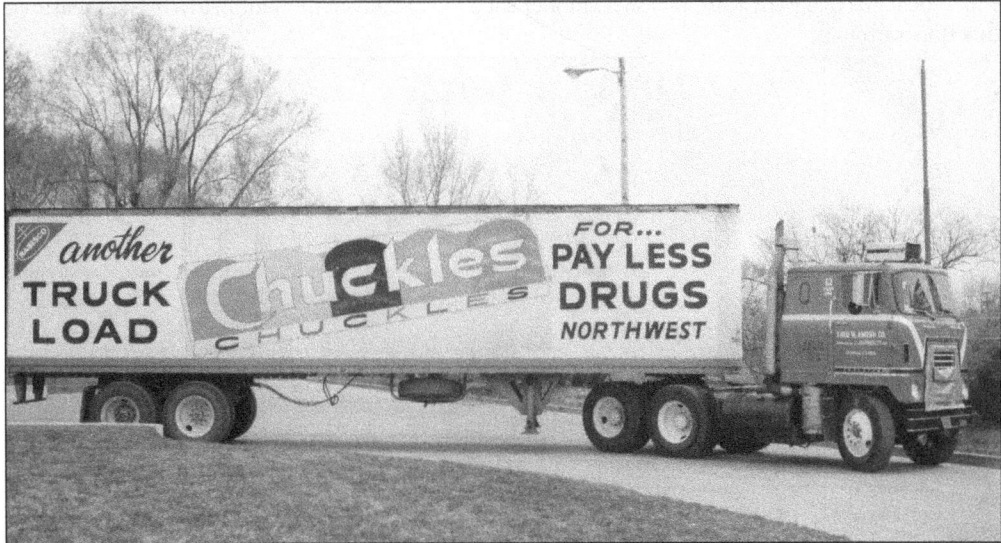

The delivery truck for the Fred W. Amend Company pulls out of the lot at 805 North Griffin Street. In 1971, Nabisco purchased the plant and the brand. This specific load of candy was destined for Pay Less Drugs. At one time, the candy could be found in the pockets of boys, in the hands of moviegoers, in Easter baskets, and in the lunch pails of adults.

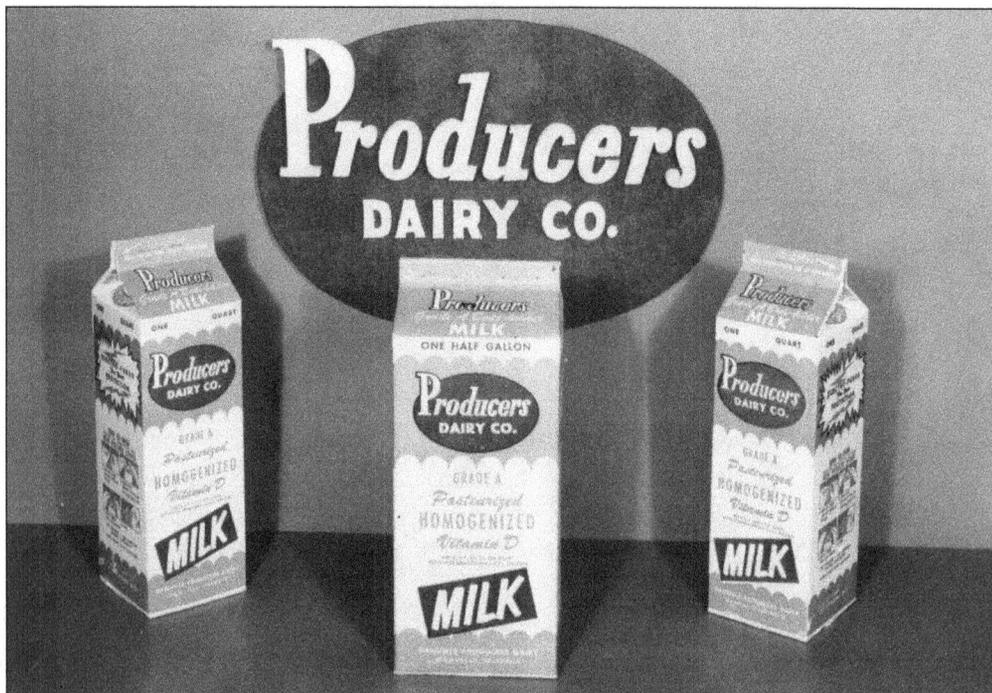

Producers Dairy Company began serving the Danville area in 1934. The company, a division of Prairie Farms Dairy, Inc., purchased approximately 25 million pounds of raw milk annually from area farmers. It was located at 408–410 West Fairchild Street, with a branch at 2009 East Main Street. Later, the main office was moved to 52 South College Street. In 1966, its milk products were available in handy glass or in plastic-coated cartons. Bob Metzen, who was from Danville, created the Producers Dairy cow illustration that was used on its products in the 1950s and 1960s. His daughter Karen was the model used for the advertisement below, which featured this illustration.

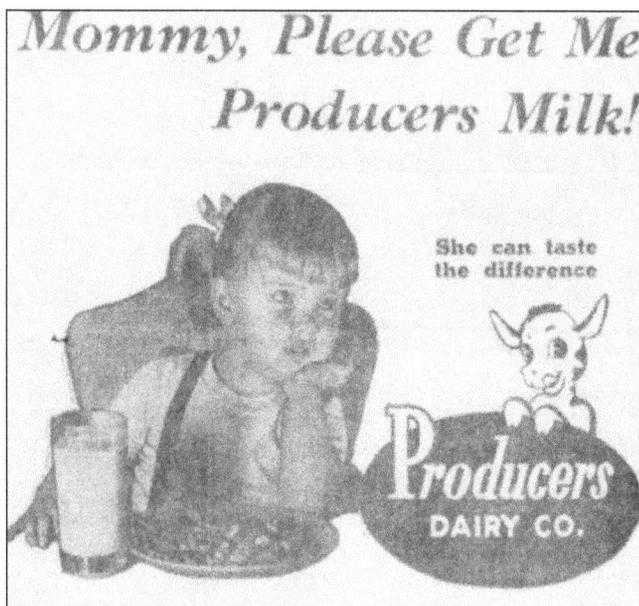

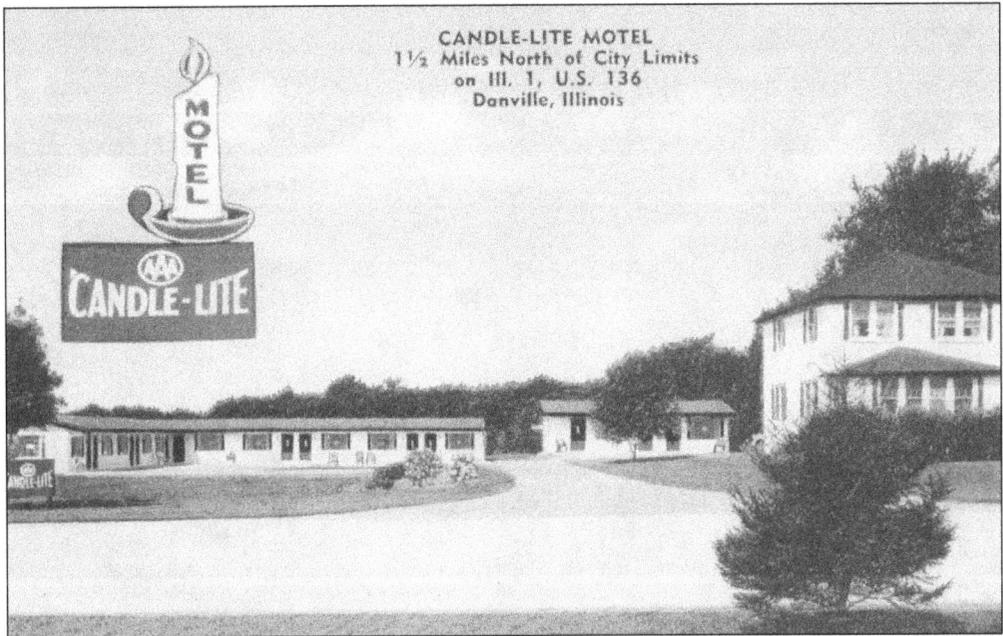

CANDLE-LITE MOTEL
1½ Miles North of City Limits
on Ill. 1, U.S. 136
Danville, Illinois

Harry S. Helck opened the Candle-Lite Motel at 3626 North Vermilion Street in 1962. The hotel was advertised as Danville's most modern, fireproof motel. It was part of the AAA-endorsed chain of motels. For years, the motel's unique candle-shaped sign continued to greet people driving into town on Route 1. The motel is still in business today under different ownership.

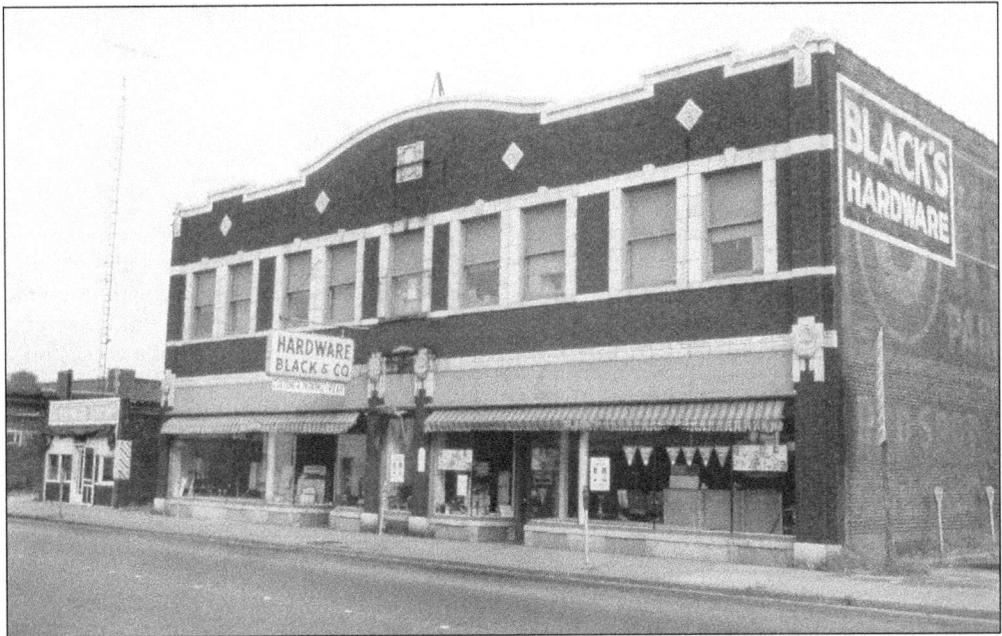

Black & Company, at 31 North Hazel Street, opened its doors in 1945 and offered hardware, industrial supplies, roofing material, paint, electrical equipment, and sporting goods to businesses as well as individual consumers. In the early 1970s, the company relocated to 620 North Gilbert Street and focused on becoming an industrial supplier for businesses and contractors. The company continues in business today at its location on Gilbert Street.

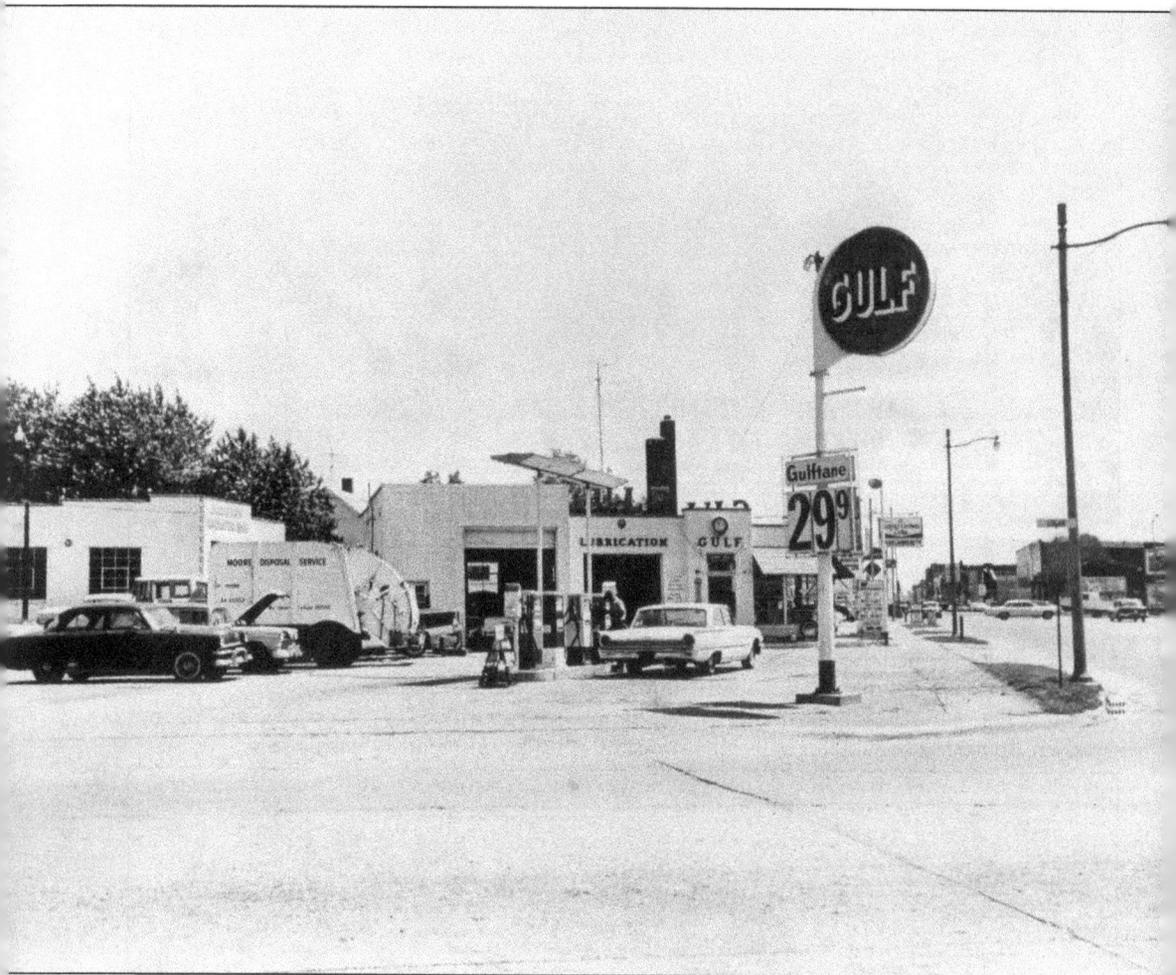

The Schafer brothers opened a Gulf Oil station in 1940 on the northeast corner of Logan Avenue and West Main Street. Owners John "Hans" and Frederick "Fritz" E. Schafer provided gas and repair service at this location for 50 years. By that time, automobiles came equipped with hydraulic brakes, electric starters, heaters and defrosters, hard tops, and tires that would run for several thousand miles. Motorists could even have their 1940 autos equipped with radios so they could listen to their favorite programs. In 1940, there were more than 90 full-service stations in the city of Danville competing for consumers' gasoline and service dollars. Gasoline stations also had to compete with the gas suppliers for consumer dollars. The suppliers would sell direct to consumers needing large quantities of fuel. This photograph shows the station in 1963. Note that the gas price was 29¢ per gallon. Hans Schafer was involved in the service station business until 1989.

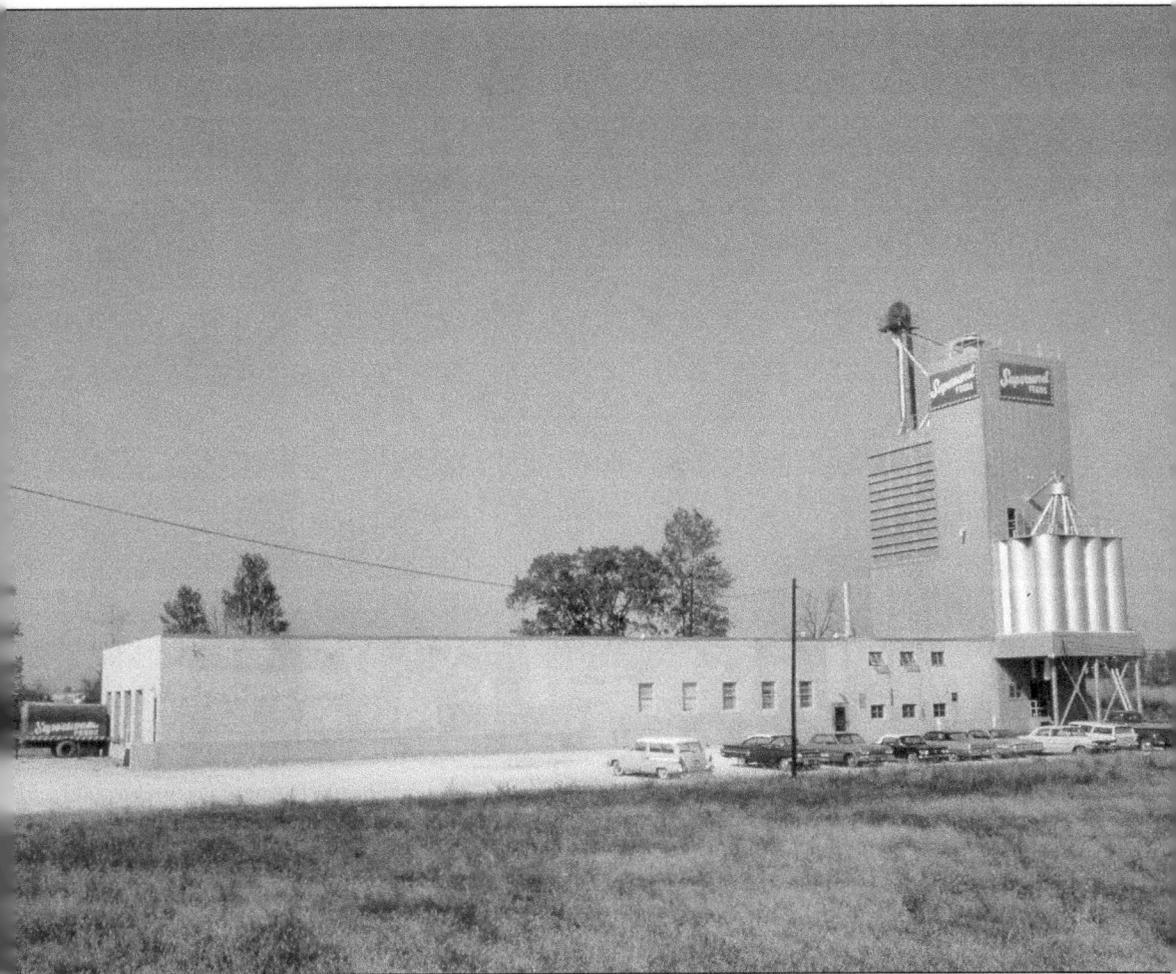

Supersweet Feeds, a division of the International Milling Company in Minnesota, made a selling point of delivering freshly manufactured feeds to customers within 24 hours of receiving an order. When sales growth in east central Illinois and western Indiana increased, it became increasingly difficult to fulfill this promise. Up to this point, area needs for Supersweet Feeds were met by the plants in Monmouth, Illinois, and Madison, Wisconsin. After investigating several potential sites for a new Midwest plant, the company chose Danville because of its progressive business climate. The new Danville plant was built on a nine-acre tract at 1223 East Voorhees Street. It began production in February 1963. It initially had the capacity to produce 168 tons of livestock feed in a 24-hour period. The Supersweet plant in Danville produced 50–60 varieties of livestock feed. The facility closed in 2004.

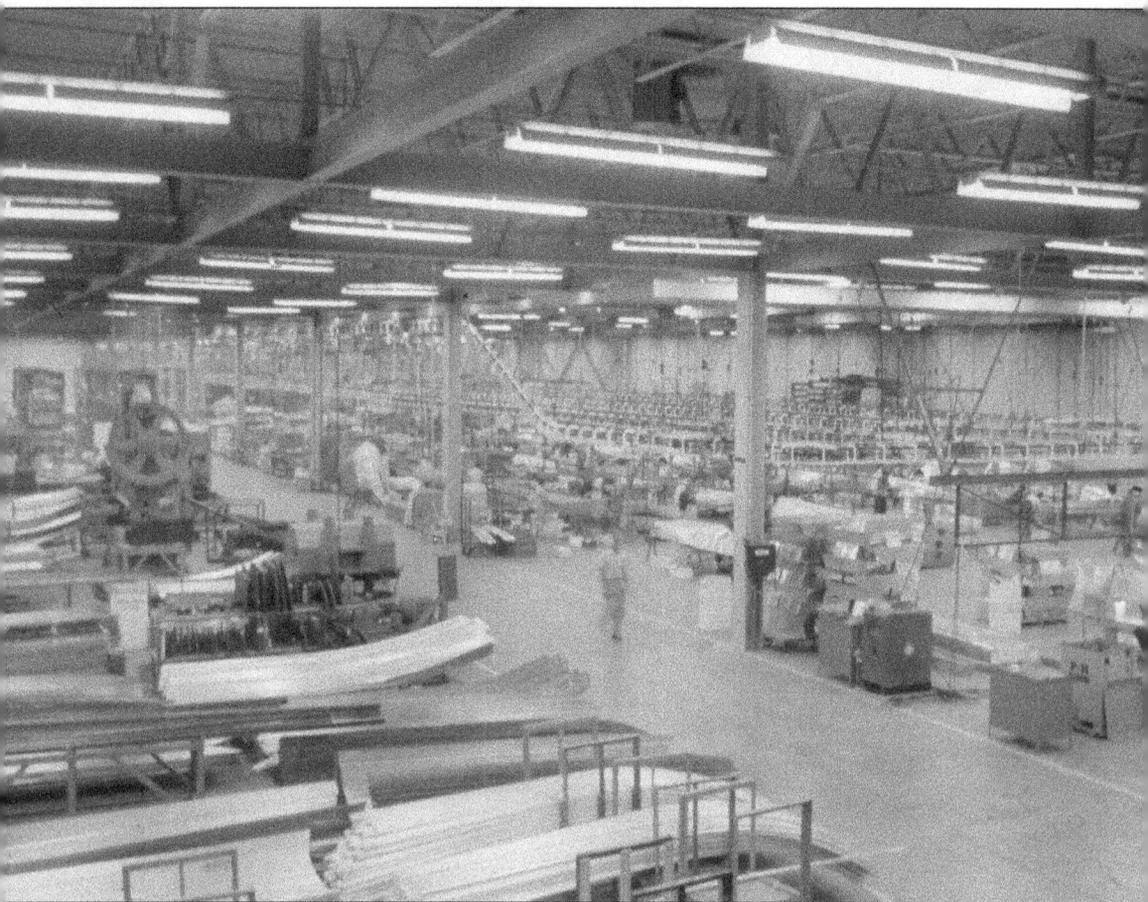

The Stanray Corporation began in 1889 as a pioneer in the production of railway equipment. After World War II, the company began to diversify to meet changing demands. It maintained its railway equipment division and corporate offices in Chicago, but it opened additional plants in Cicero, Illinois; Hammond, Indiana; Los Angeles; Ogden, Utah; and Danville. Stanray built its world-renowned traveler boat division in Danville in 1964. The huge, 370,000-square-foot facility was the largest small-boat manufacturing facility under one roof. It was also the first plant in its industry to have a fleet of its own railcars. The traveler boat division produced aluminum boats from 12 to 16 feet and fiberglass boats up to 25 feet. The $6-million plant took up 8.5 acres of the 40-acre site. The facility's production made Danville "the small-boat capital of the world." The Stanray Traveler Boat Division was in the area for only a few years, and the facility became the fabrication plant for the Hyster Company in 1968.

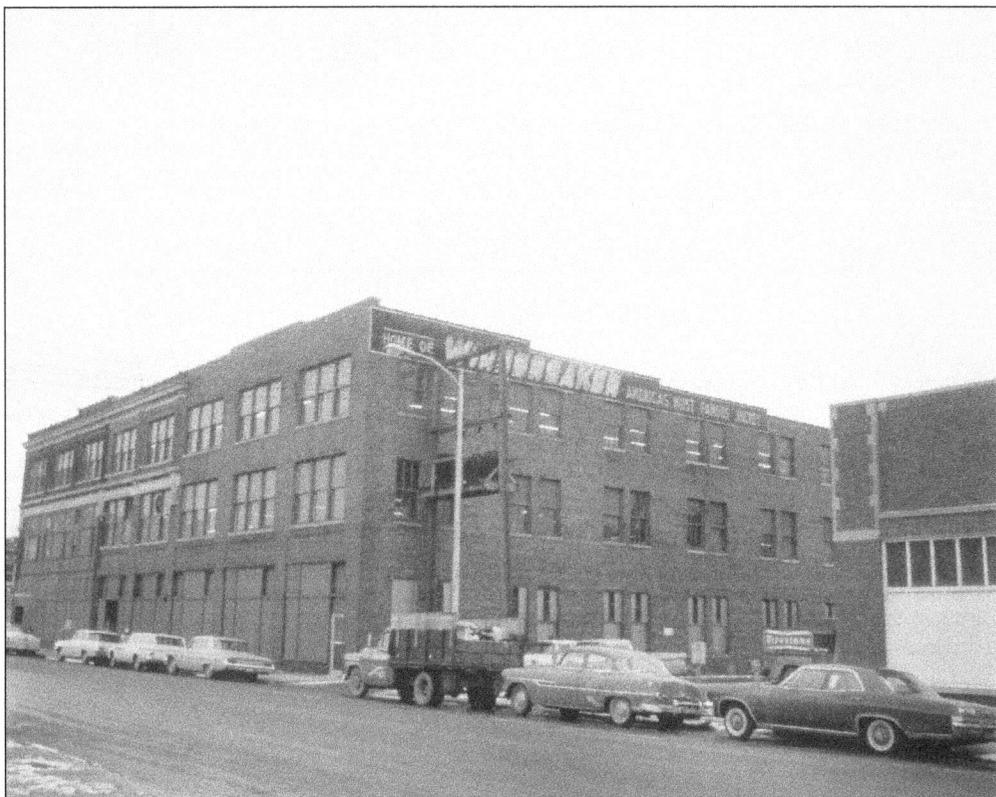

Starting in 1917, the Windbreaker Garment Factory encompassed 80,000 square feet at 118 East North Street. Windbreaker also had a 52,000-square-foot building at 1017 Bahls Street used for central distribution. By 1965, Windbreaker, which made raincoats, jackets, and other outerwear, was also the exclusive maker of Arnold Palmer golf jackets. Additionally, by 1970, it had become the licensee for the National Football League and the National Basketball Association. The business closed in 1976.

The American Agricultural Chemical trademark dates back to 1865. AGRICO, for premium-quality fertilizers, was first used in 1922. A subsidiary of Continental Oil Company (Conoco), the corporate name was changed to AGRICO Chemical Company, a division of Continental Oil Company, in 1966. Located on Ross Lane in Danville, it was the leading national producer of agricultural, turf, and garden fertilizers.

BERKELEY-DAVIS, INC. SUBSIDIARY OF THE McKAY MACHINE COMPANY
DANVILLE, ILLINOIS

Lawrence J. Berkeley, the owner of Berkeley Equipment Company of Corey, Pennsylvania, was a pioneer in the manufacturing of automatic welding equipment and mechanical stamping presses. He moved his firm to Danville in December 1942, opening a plant at 1020 Bahls Street. During World War II, the company made steering gear components for Liberty ships and mine cable cutters. Berkeley-Davis, Inc., was formed in 1955, after John P. Berkeley, Lawrence's son, joined with Charles Davis in the business enterprise. In 1956, the company obtained land on the east side of Bahls Street and built an assembly building. In 1960, the McKay Company purchased Berkeley-Davis, Inc. The company closed the facility in 1990. Automation International, Inc., a manufacturer of arc and resistance welding machinery, purchased the plant in 1992 and continues to operate it to this day.

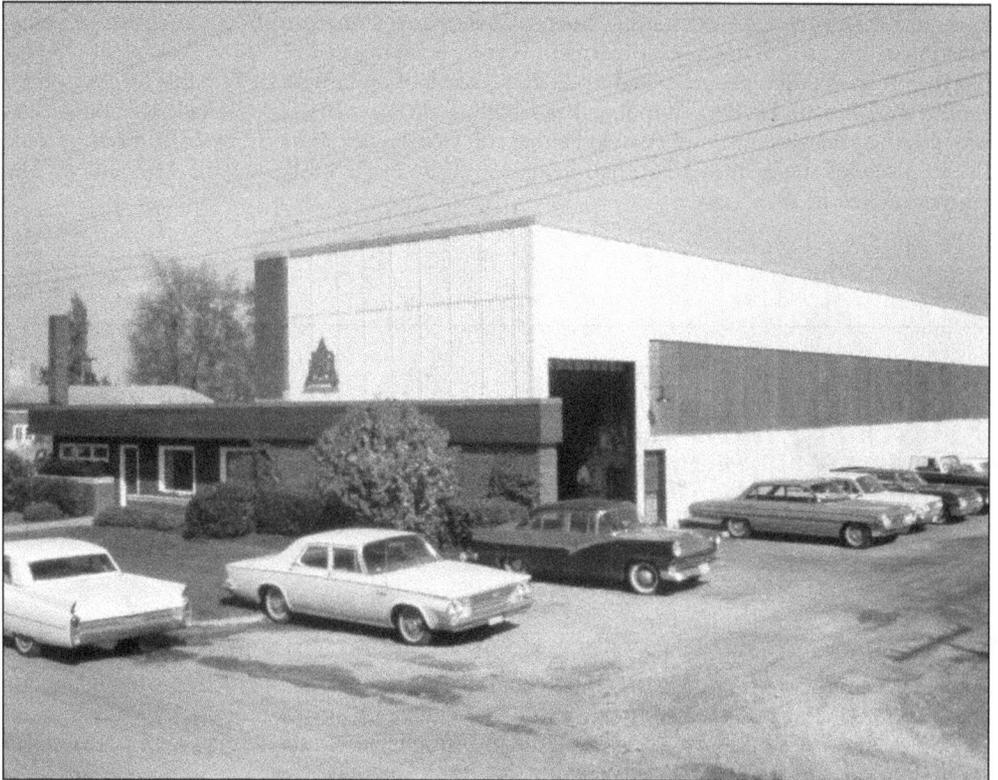

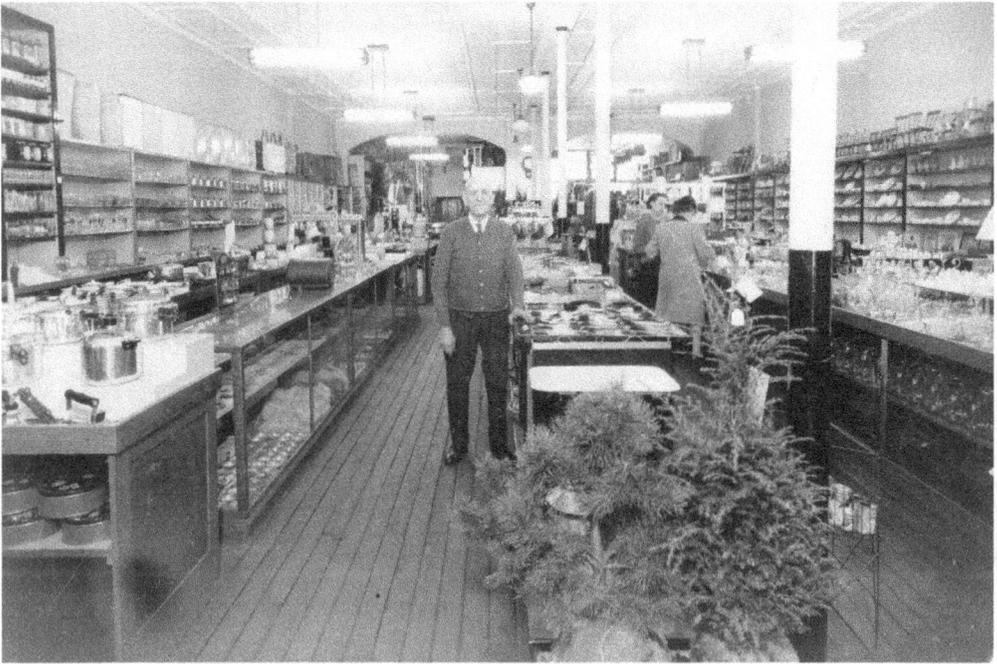

Fred Hacker was 14 years old when he went to work as a window trimmer in the grocery and dry goods store his father owned. Ten years later, in 1896, he bought the adjacent business and opened Hacker's Fair at 207–209 East Main Street. The store was Hacker's life from its opening until it closed shortly before his death in 1958. During those long decades of doing business on Main Street, the enterprise established an excellent reputation with quality merchandise and fair dealing. In 1952, Mr. Hacker was honored by the Danville Chamber of Commerce as the community person with the longest career as a businessman. The c. 1950 photograph above, taken from the front door, shows Fred standing in the center of the store. The 1945 photograph below shows his sister Mabel Stuebe next to the seed display.

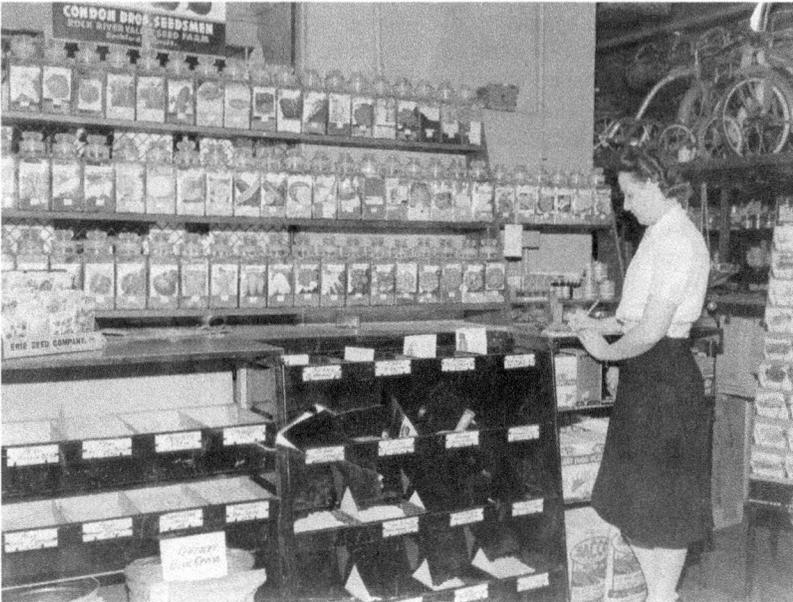

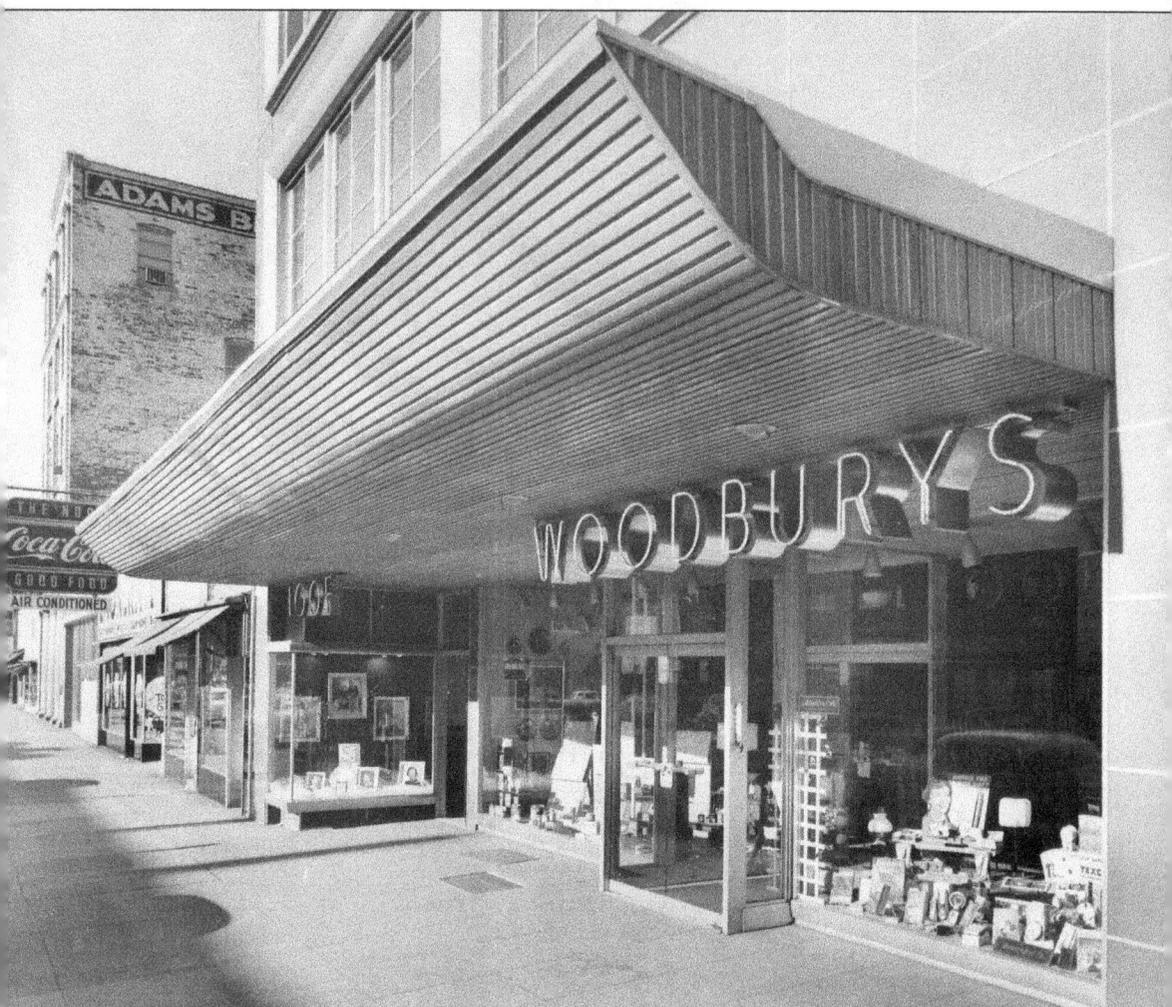

In 1846, James Sconce established a store on West Main Street that sold groceries, medicine, books, and stationery. Sconce sold half of the store's interest to W.W.R. Woodbury in 1850, and the store became known as Sconce & Woodbury. A pharmacist, Woodbury became the full owner in 1857. In 1859, Woodbury constructed a building on the southwest corner of the public square and moved his store to the first floor. He named the building Lincoln Hall for his friend Abraham Lincoln, who was practicing law in Danville at the time. Lincoln was known for regaling people with his wonderful stories in the back room of the store. In 1901, the Woodbury family decided to separate the drugstore from the bookstore portion of the business, moving the bookstore to 40 North Vermilion Street. In 1910 Woodbury Book Company moved to its longtime home at 125–127 North Vermilion Street. The bookstore was destroyed in a fire in February 1915 but was rebuilt the same year. In the mid-1990s, the business was moved to 601 North Gilbert Street. It closed in 2005.

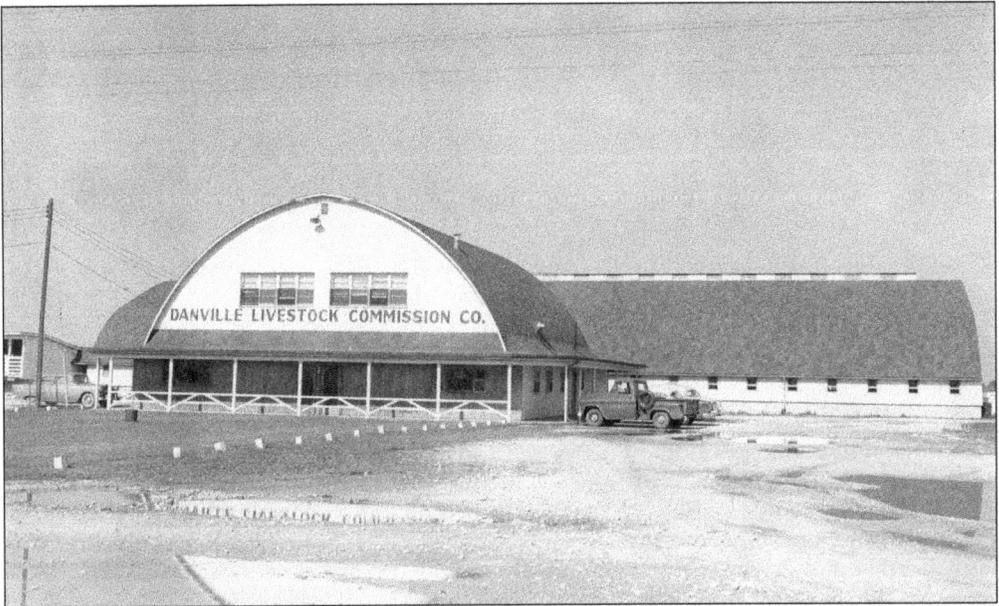

The Danville Livestock Commission Company began in 1937 at 628 East Fairchild Street, with C.M. Baum as president. The company assisted farmers with the buying and selling of their livestock. In the early 1960s, the company had this building constructed on South Henning Road. Still in business today as Danville Livestock Auction, Inc., the company continues to hold livestock auctions on the first and third Wednesdays of each month.

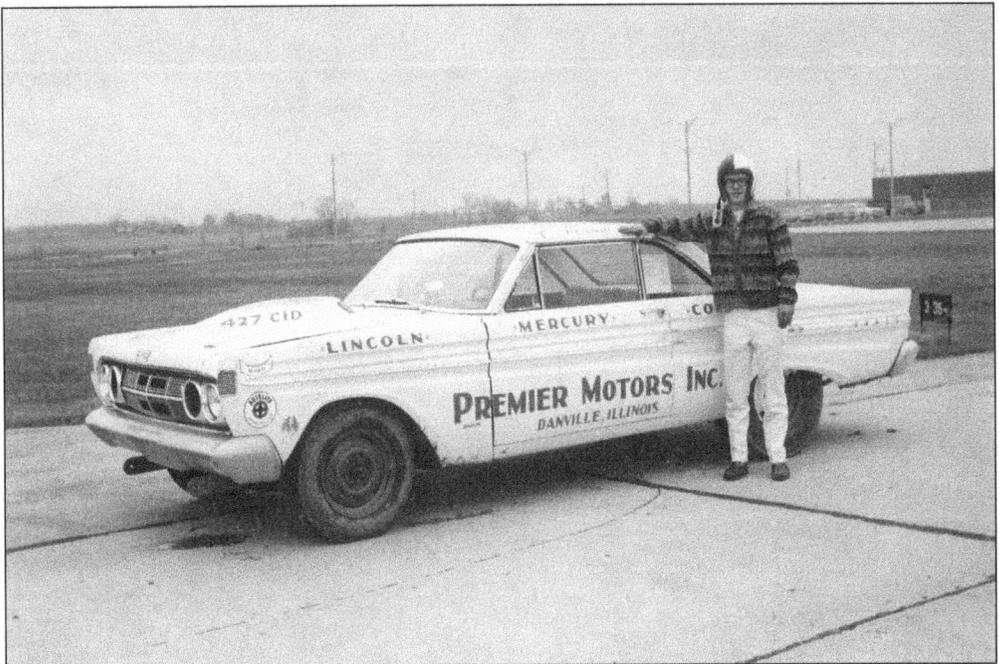

The car in this photograph is advertising Premier Motors, Inc., of Danville. Premier Motor Company, also known as J.P. Auto's, Inc., was incorporated in 1986. Located first at 501 South Gilbert Street, it later moved to 539 East Main Street, where it continues in the business of selling used cars today.

PHONE 446-2210
AREA CODE 217
TWX DANV. ILL.
7229

ESCO CORPORATION

712 PORTER STREET • DANVILLE, ILLINOIS, U.S.A.

The ESCO Corporation, also known as the Electric Steel Foundry Company, which came to Danville in 1947, was located at 1017 Griggs Street. Corporate offices were later located at 712 Porter Street. Danville was ESCO's largest sales district, and the company served the mining, construction, and logging industries, as well as refineries, pulp and paper mills, and chemical plants. The main manufacturing products were shovel dippers and dragline buckets, which were used for massive earth-moving machines, and their replacement parts. It built the largest dragline bucket at that time, which was 85 yards, enough to fill a two-car garage. The photograph below shows ESCO employees inside one of the dragline buckets produced by the company. Its capacity was 29 yards. The company closed its doors on October 1, 1982.

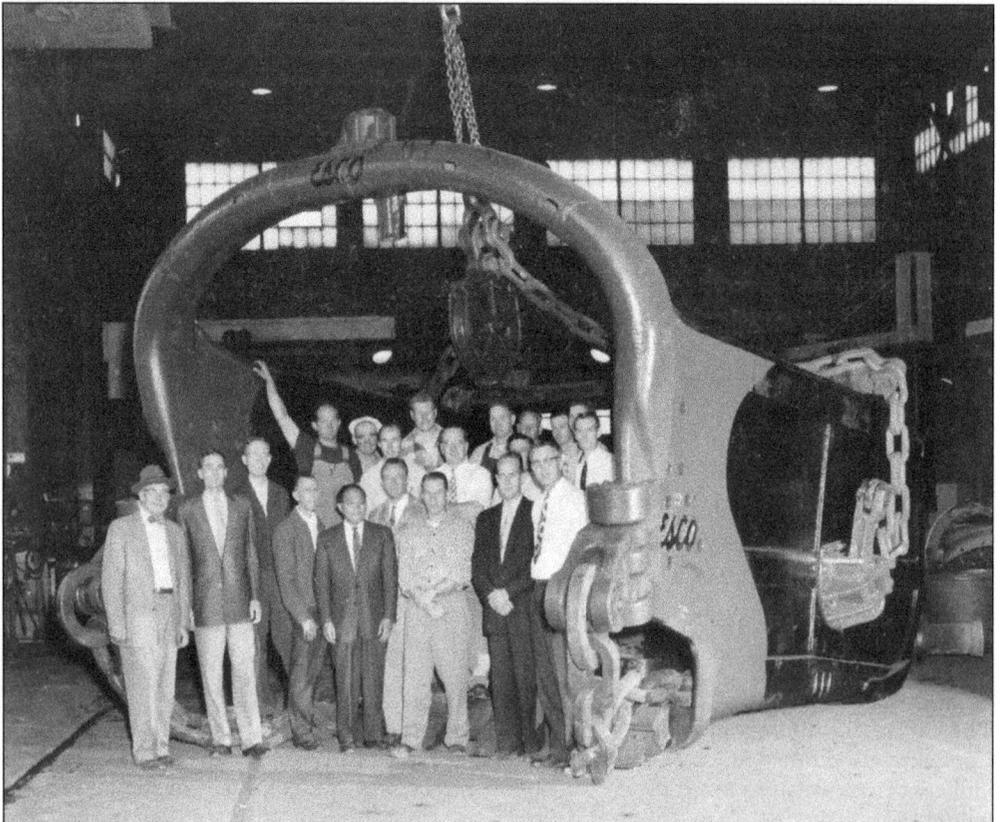

Flamingo PRODUCTS, INC.

PLANT AND GENERAL OFFICES
1003 GRIGGS STREET
POST OFFICE BOX 851

PHONE: AREA CODE 217
442-6860

DANVILLE, ILLINOIS 61834

Ray Girouard, Charles Himan, and Arthur Behlke started Flamingo Products, Inc., in 1945 at 216 Logan Avenue, primarily as a bobby pin manufacturer. Diversification occurred after purchasing the American Lady Hair Net Company of St. Louis, which manufactured the Flamingo brand of bobby pins, hair rollers, hairnets, and other hair accessories. Later, it moved to 1003 Griggs Street and, with $18,000 in financing provided by the Danville Chamber of Commerce, erected a 5,650-square-foot facility. The company went on to be recognized worldwide and eventually built a plant at 74 Eastgate Drive. Millions of women in the United States and overseas received help from this Danville company in keeping their well-groomed appearance. The image below shows Rita Delanois of Westville posing for an advertising display card. She "met herself" in many places throughout the United States.

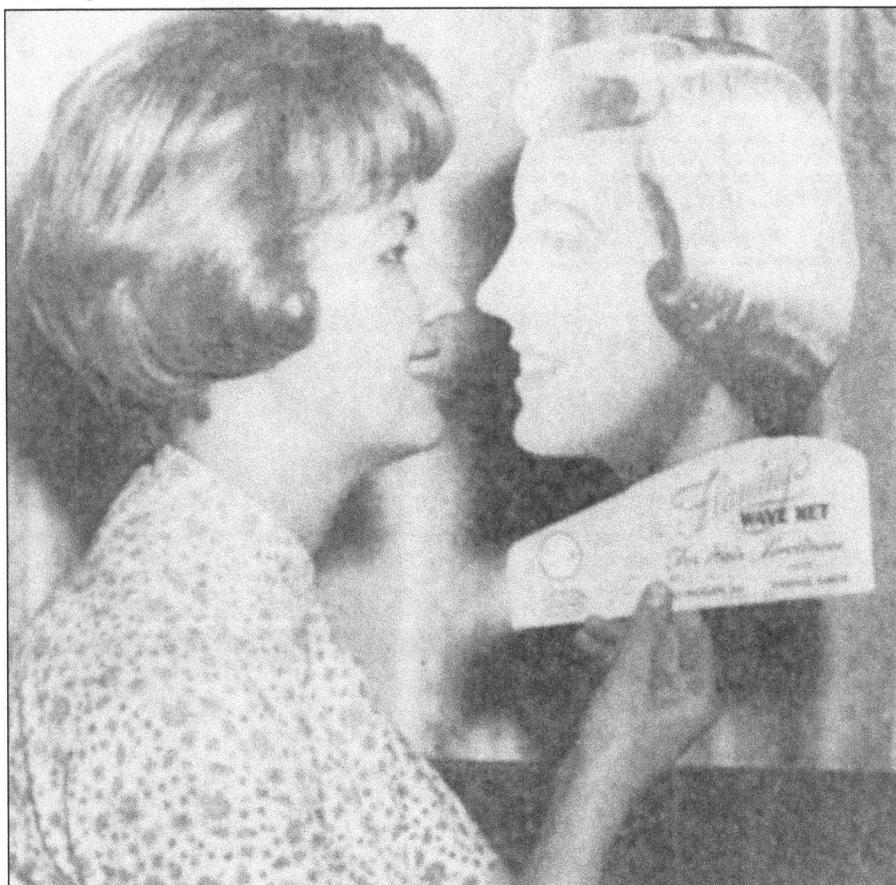

Time-O-Matic, located at 1015 Maple Street, opened in 1945 and manufactured electrical timing devices. Under the leadership of Ed Schulenburg, the production of these devices was moved to Danville from a plant in Springfield known as Sangamo Electric Company, which started in 1932. In 1971, Time-O-Matic was sold to Keith Wood. At the time of the sale, it was estimated that the firm supplied 85 percent of the sign control equipment used in the world. The Las Vegas strip utilized Time-O-Matic equipment for its famous lights. The business has dramatically expanded its office and production space over the years, including opening a branch office in Champaign. Still in business today, Time-O-Matic has kept pace with ever-changing technology. It has produced sign control equipment, industrial timers, and, currently, durable color and monochromatic Watchfire LED signs and electronic message boards. In 2013, the business was sold to the Jordan Company, a New York–based firm.

Bohn Aluminum & Brass Company, at 1625 East Voorhees Street, came to Danville in 1956, shortly after acquiring Betz Corporation, enabling the company to branch out from the domestic refrigeration area. The Danville plant was called the Betz Division until 1963. The heat transfer division, still in business today as Heatcraft, makes evaporator and condenser coils for refrigeration, heating, and air-conditioning equipment.

Started by Joseph P. Porcheddu in 1918, the Illinois Fireworks Company, at 1706 King Street in Tilton, provided fireworks for the *Century of Progress* show in Chicago, the Illinois State Fair, and the Memphis Cotton Carnival. In 1956, it became the mother company for the Danville Novelty Company, the Liberty Fireworks Display Company, and the World Fireworks Display Company, providing display fireworks to every part of the United States. The company closed in the 1990s.

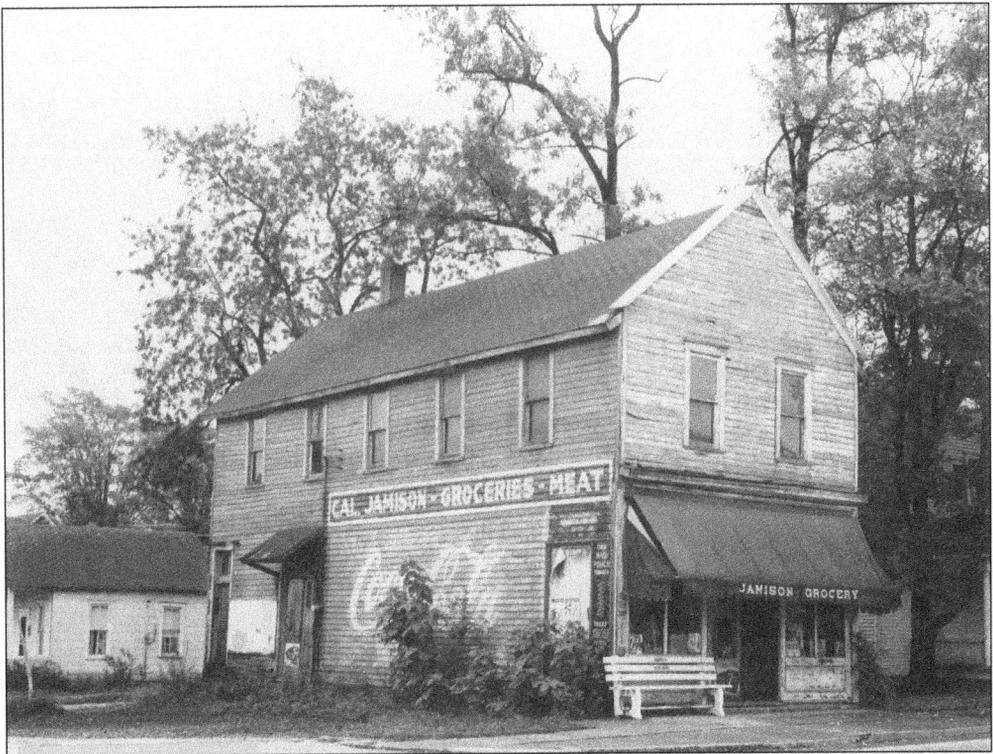

Jamison Grocery opened in 1900 at Gilbert and Third Streets in South Danville. It was the largest grocery store in the county outside of the city of Danville. Famous performer and lounge singer Helen Morgan was a frequent visitor when she lived in the area. Morgan often sang in a mission located above the store. The building was razed in 1965.

RECORDING & STATISTICAL COMPANY

Printers - Lithographers

2815 N. VERMILION STREET • DANVILLE, ILLINOIS 61834

PHONE: AREA CODE 217 446-6111 • TELETYPE: 217-443-1961

In its early years, the Recording & Statistical Company was located at 211 East Harrison Street. It later expanded and was moved to 2815 North Vermilion Street. In 1979, the local plant was sold to three Sperry Univac executives and the name was changed to the Recording & Statistical Corporation. The sale included the printing facilities and equipment in its three locations as well as the rights to the name. It was relocated to a new 85,000-square-foot facility at 74 Eastgate Drive just prior to an expansion of the Village Mall. Referred to as R&S, the plant printed business and insurance forms.

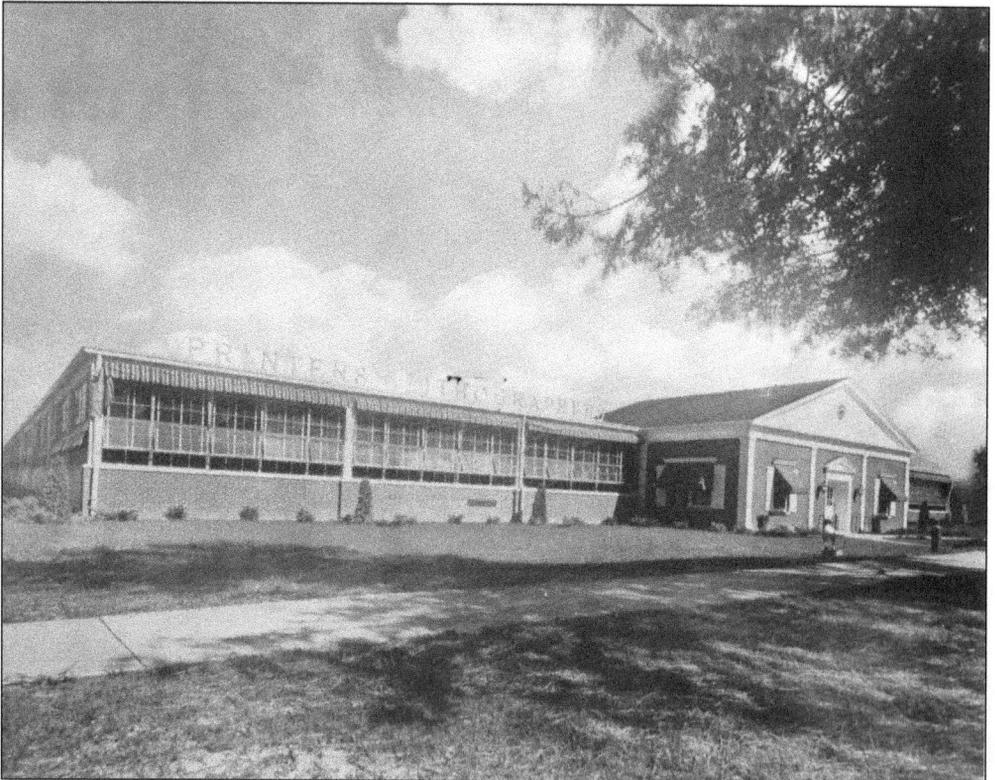

GOODLOE E. MOORE INCORPORATED

TELEPHONE
446-7900

Distributors
Manufacturers

2811 N. Vermilion Street
DANVILLE, ILLINOIS 61834

The Moore family business spanned three generations. Lindley M. Moore started a contracting business in 1871 with partner John McCoy. The partnership later dissolved, and Lindley moved his contracting business to 820 North Vermilion Street. In the 1890s, Edward S. Moore joined his father in the business and it became L.M. Moore & Son. When the founder died, the name was changed to E.S. Moore. In the late 1920s, when Goodloe E. Moore joined his father, the contracting business became E.S. Moore & Son. In 1937, Goodloe E. Moore, Inc., was established to specialize in building supplies and custom orders, later focusing on adhesives and metal hangers. In 1948, the business occupied a building with 31,000 square feet under one roof at 2811 North Vermilion Street. Some of the company's brand names include Tuff-Bond, Tuff-Weld, and Gemco. Goodloe E. Moore held several product patents and, in 1977, was given a commendation by the Danville Police Department for his production of security devices. The business was sold in 1978 to Robert B. Rew.

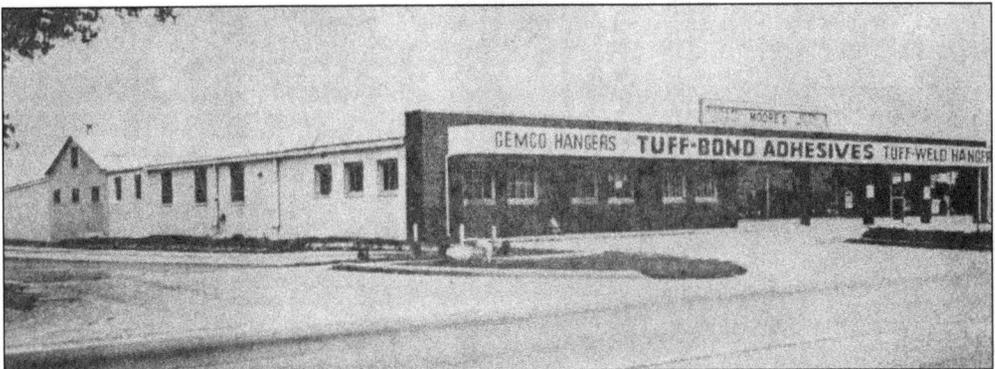

65

A branch plant of the Hyster Company opened in Danville in 1946. Utilizing buildings from the old Danville Malleable Iron Company, just east of Bowman Avenue and south of Fairchild, the plant initially began manufacturing a two-ton-capacity pneumatic-tire lift truck. A new plant was built on East Voorhees Street in 1957, which tripled the plant's volume. Also in 1957, the headquarters of Hyster Industrial Truck Division was moved to Danville, taking advantage of the ideal economic and geographical location to provide faster, more efficient service to all of their many dealers. The move placed the Danville office in complete charge of all matters concerning Hyster's 42 industrial truck dealers in the United States, Alaska, Canada, and Hawaii. The forklift assembly plant on Voorhees Street closed in 2001.

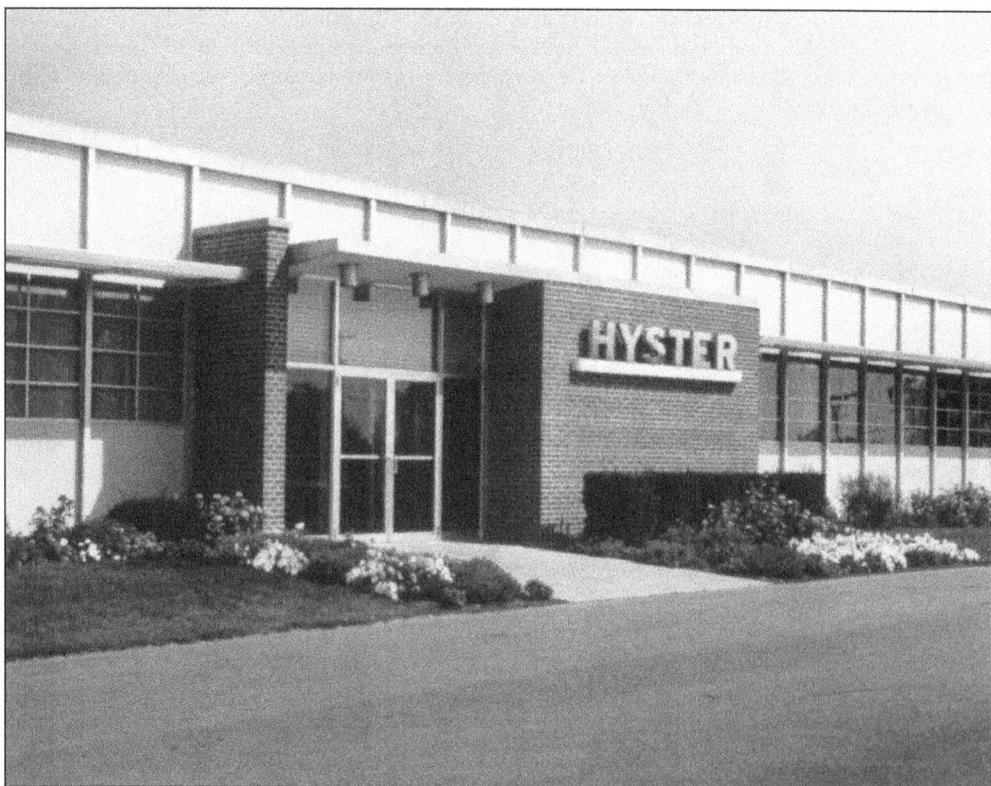

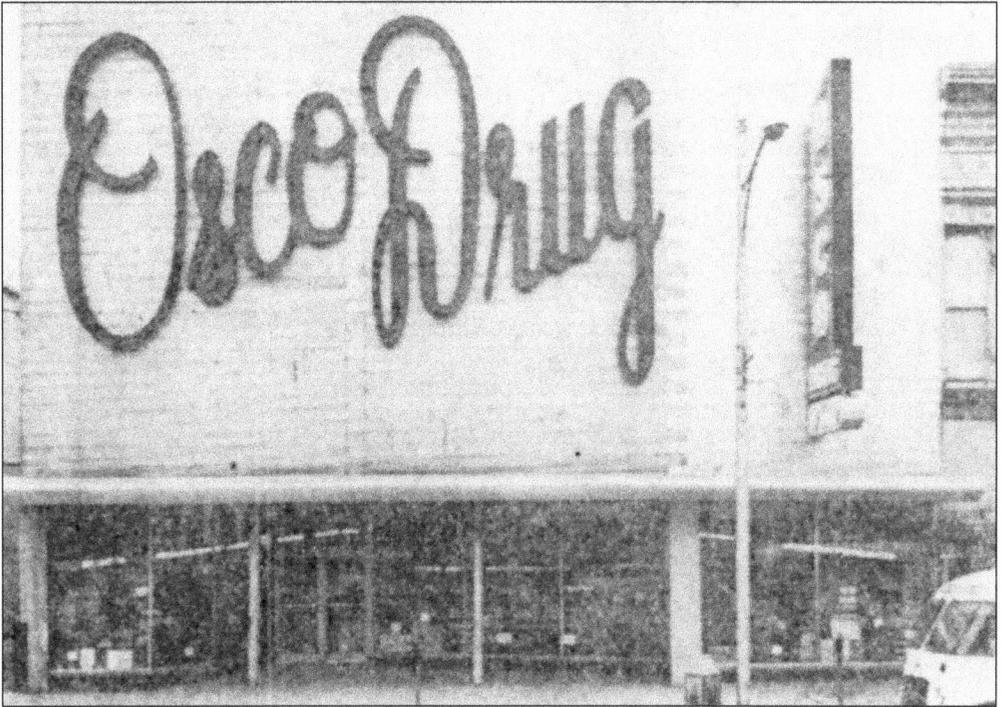

Osco Drug had its beginning in 1937 in Rochester, Minnesota, as the Self-Service Drug Company. The company later became a partnership known as Owner's Service Company, and the name Osco was coined. In 1961, Osco joined forces with the Jewel Tea Company. In 1966, the store seen above, at 21 North Vermilion Street, was the only Osco in Danville. The downtown store, which had opened about 1948, closed in 1978. Osco Drug reappeared in town as part of a Jewel/Osco at 909 North Gilbert Street in 1984. Osco constructed a new facility on West Fairchild Street in 2001, but it was only open until 2006. (Both courtesy of the *Commercial-News*.)

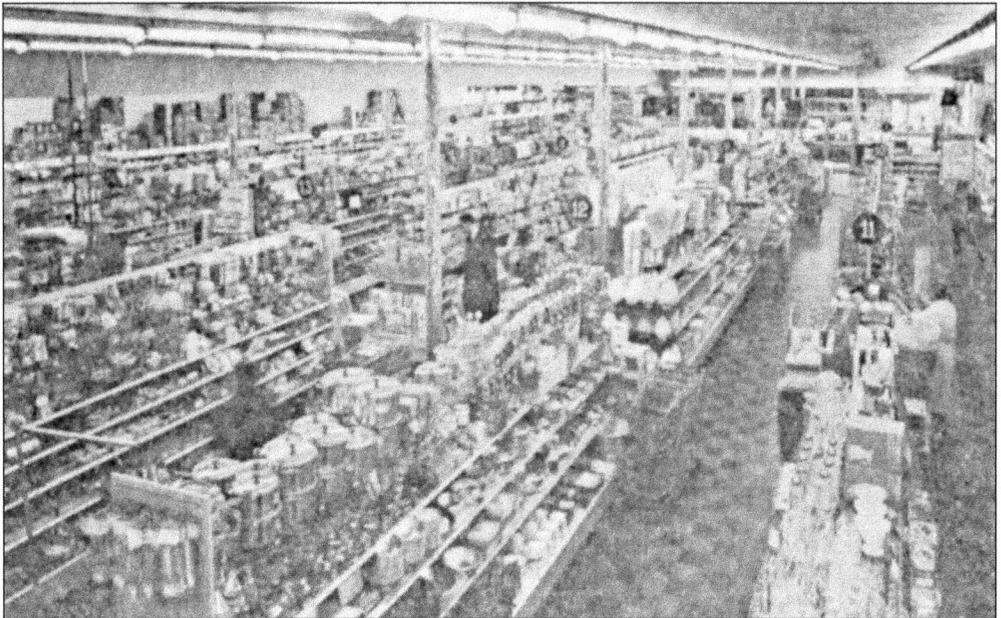

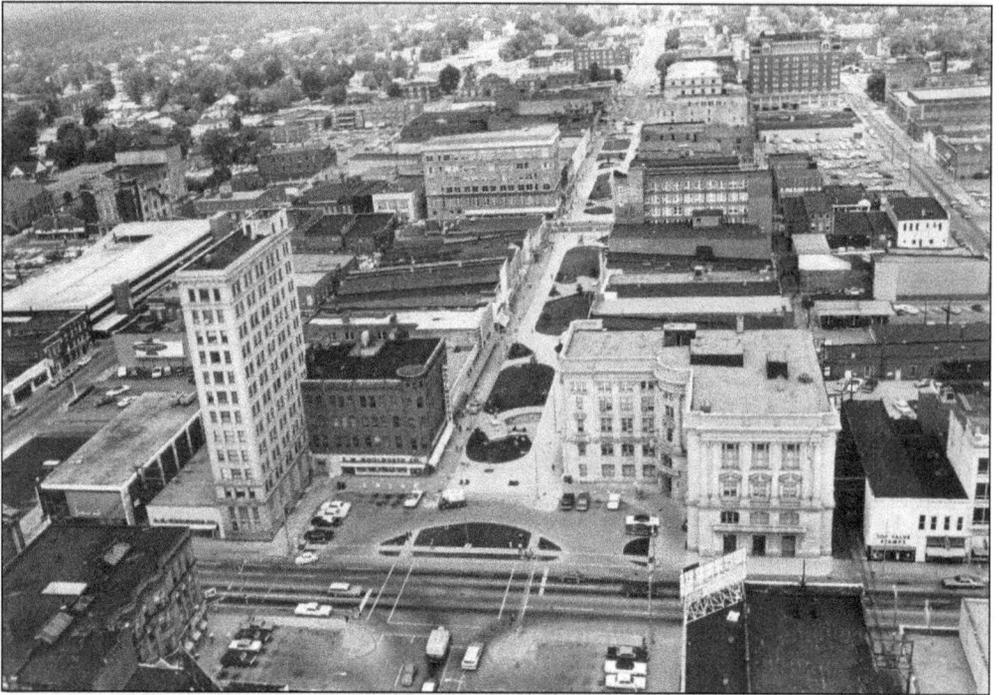

In 1967, the first park mall in Illinois was created in Danville's downtown as the first phase of urban renewal. The open-air mall extended from the north side of Redden Square to North Street and from North Street to Harrison Street. Mall developers believed the complex would increase business activity and draw more shoppers from a wider area. The photograph above is an aerial view of the mall showing the south entrance from Main Street clearly, with the flagpole centered at Main and Vermilion Streets. The image below shows the north portion of the mall from North to Harrison Streets. The mall was removed in 1987, returning North Vermilion Street back into a viable thoroughfare and eliminating the flagpole from the center of the road.

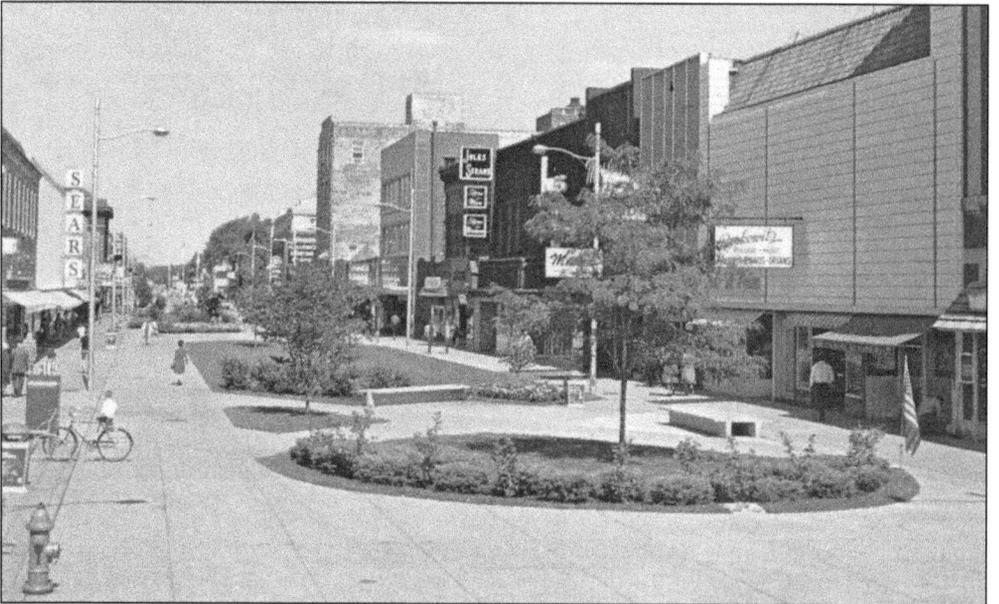

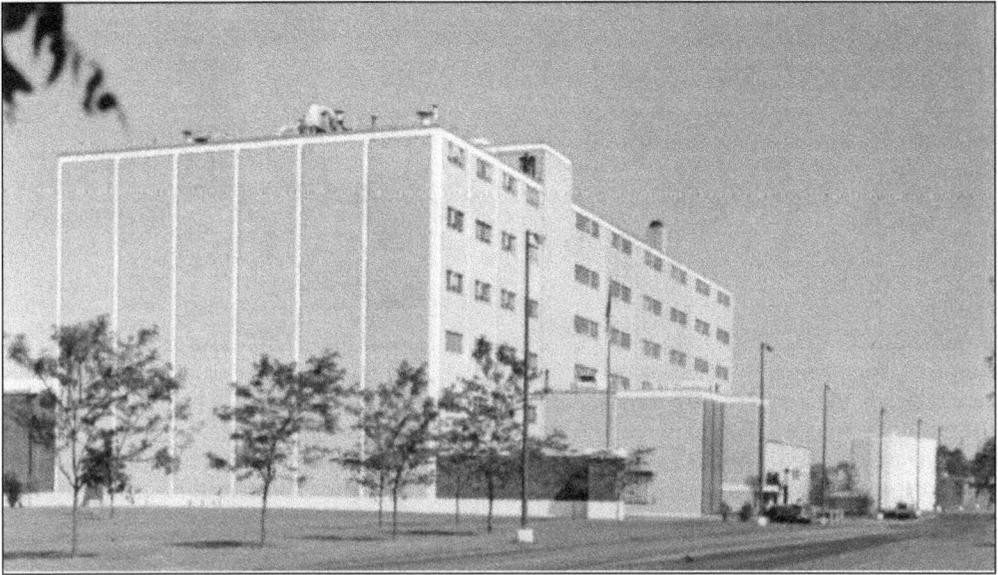

The Chicago-headquartered Quaker Oats Company cited Danville's aggressive business climate and civic organizations, excellent transportation facilities, and the accomplishments of local government when it announced its decision to build a new plant here in 1968. Located on a 47-acre tract at 1703 East Voorhees Street, between Bohn Aluminum and Hyster, construction of the plant was completed in 1971. It is the only Quaker Oats plant in Illinois, which makes food products. Expansions to the facility were done in 1977 for prepared cookie mixes, in 1982 for chewy granola bars, and in 2000 to increase production of ready-to-eat cereals and chewy granola bars. In December 2000, PepsiCo acquired Quaker Oats Company in order to gain control of Gatorade, the dominant brand in the sports drink market. The plant is still operating today.

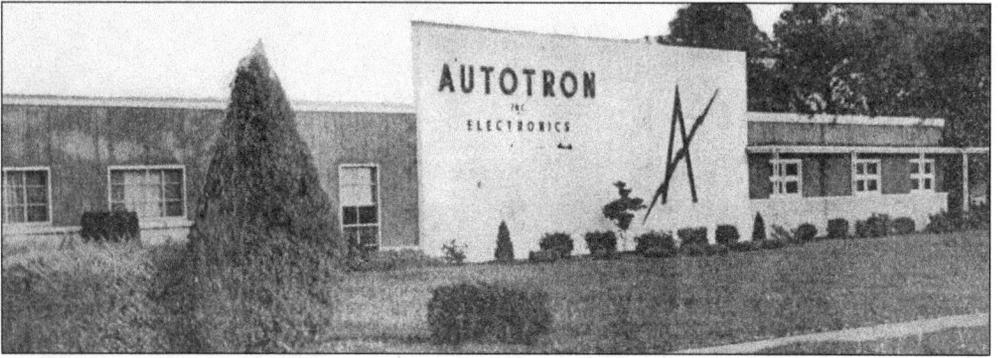

Autotron, Inc., began in downtown Danville in 1945 as a manufacturer of electronic controls for worldwide industry. In 1955, it moved to 3269 North Vermilion Street, where it increased its size to 14,400 square feet. Industrially, Autotron's controls were used in passenger elevators, by conveyer and material handling companies, and in the automotive, food, and brewing industries. The company closed its doors in the late 1990s. (Courtesy of the *Commercial-News*.)

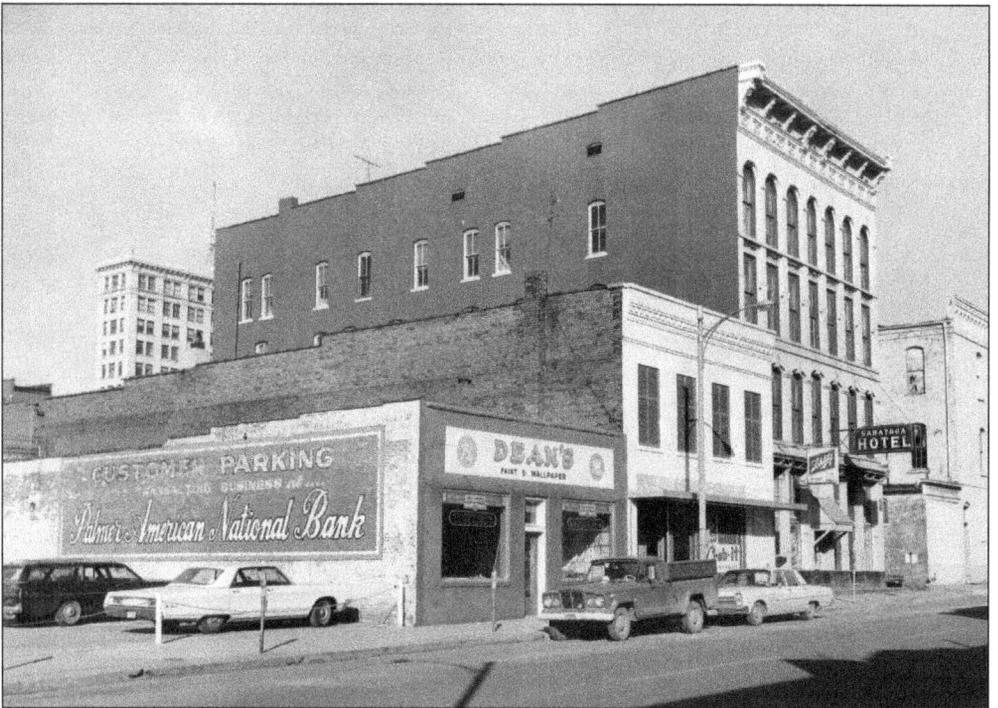

This 1971 photograph shows businesses on the west side of the unit block of South Hazel Street, including the Saratoga Hotel, the Saratoga Tavern, Grab-It-Here, and Dean's Paint & Wallpaper. The Grab-It-Here food chain, established in 1903 by Columbus S. Paxton, included 70 stores located within a 75-mile radius of Danville. In 1968, Paxton's son Ernest sold the Grab-It-Here stores to Dolly Madison Industries, which restructured and continued the chain.

The Illinois Power Company building, on South Vermilion Street, housed the passenger waiting room for the Illinois Traction System. The Danville Gas & Electric Street Railway Company owned and operated the streetcars and trains of the Illinois Traction System. In 1923, the Illinois Power & Light Company purchased the utility and continued to operate the streetcars and trains. In addition, the company sold ice from door to door and provided steam heat and water service. By 1936, the traction system service was phased out, but Illinois Power continued to provide electricity and natural gas to thousands of customers over a 15,000-square-mile area. From the mid-1940s to the mid-1950s, Illinois Power constructed several power plants throughout the state, including one northwest of Danville. Before these new plants were built, the utility purchased 95 percent of the power it provided its customers; afterwards, it produced 95 percent of the power it provided. In 1971, the company's offices were moved to 1155 East Voorhees Street. In 2000, Illinois Power consolidated its Champaign and Danville offices, closing the Danville office.

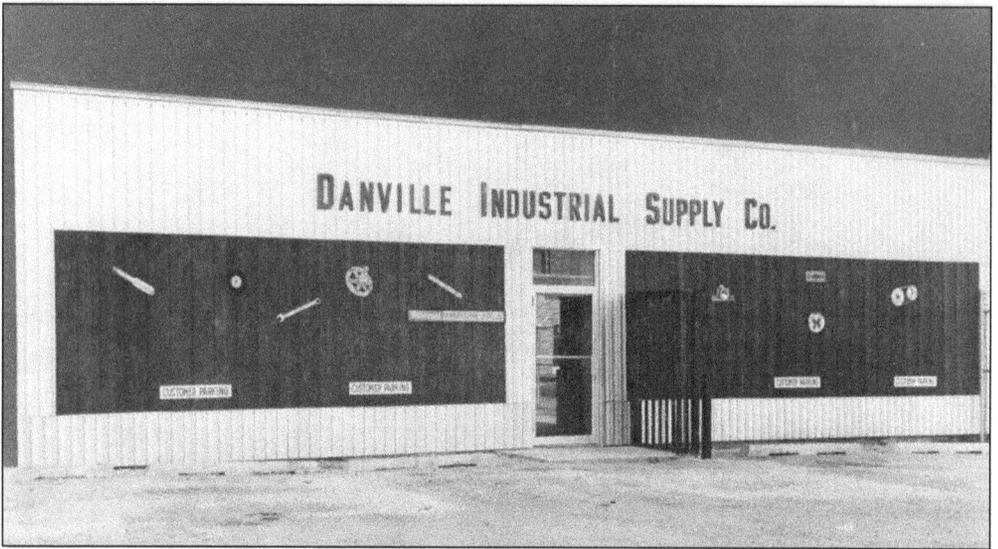

Danville Industrial Supply Company began in the late 1940s at 35 North Washington Avenue. The company was first operated by president Robert E. Seybold, and, later, by Thomas W. Conron. The industrial supplier relocated to 1260 Michigan Avenue in the 1990s and is still in business today.

Built in 1973, Jocko's Restaurant was owned by Lowell R. "Jocko" Diveley. It is now operated by Steve and Lee Diveley of the Diveley Development Corporation. The restaurant's location, on West Williams Street, is the former site of the freight house for the Cleveland, Cincinnati, Chicago & St. Louis Railroad (also known as the Big Four), which was the inspiration for the railroad-themed interior.

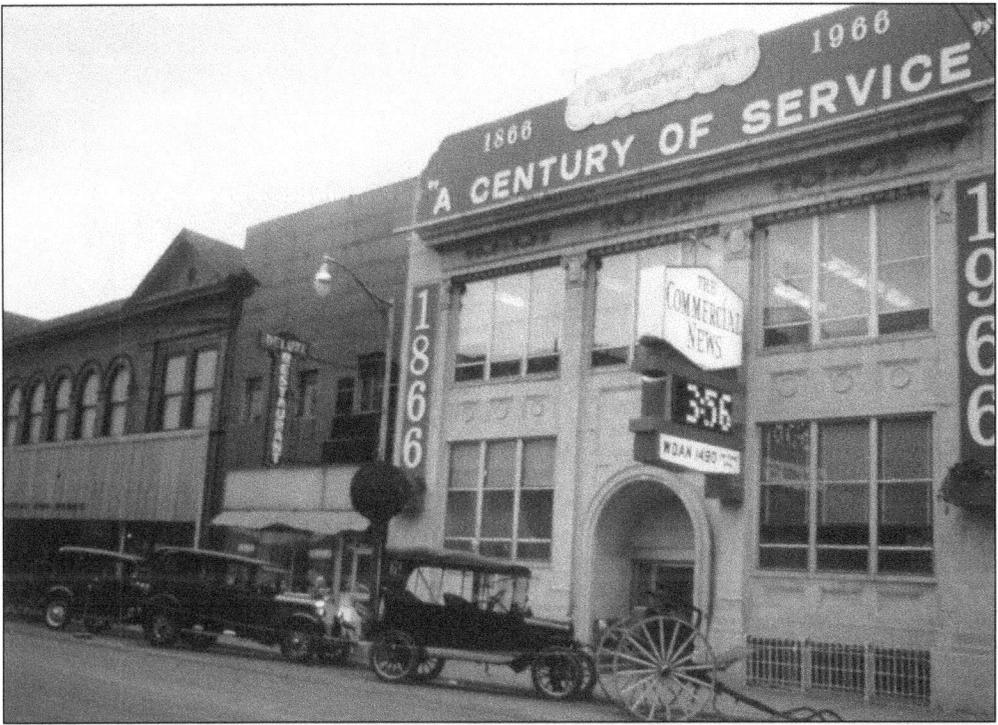

The *Commercial-News* was established in 1866 on the second floor of a bank building on West Main Street. Initially called the *Danville Commercial* and printed weekly, it began publishing daily in 1878 after a merger with the *Danville Times*. The *Commercial-News* has survived several mergers but only three location changes in its 147-year existence. The *Commercial-News* is still being published today, with its offices located at 17 West North Street. The 1987 view of the *Commercial-News* newsroom below shows staff at their Visual Digital Terminals (VDTs). The system, installed about 1979, enabled staff writers to submit stories faster to city and universal copy desks for checking, copy editing, and headline writing, and to faster dispatch to the composing room for photocomposition processing and the ultimate transmission to offset presses. The man to the right holding the telephone is reporter and columnist Kevin Cullen.

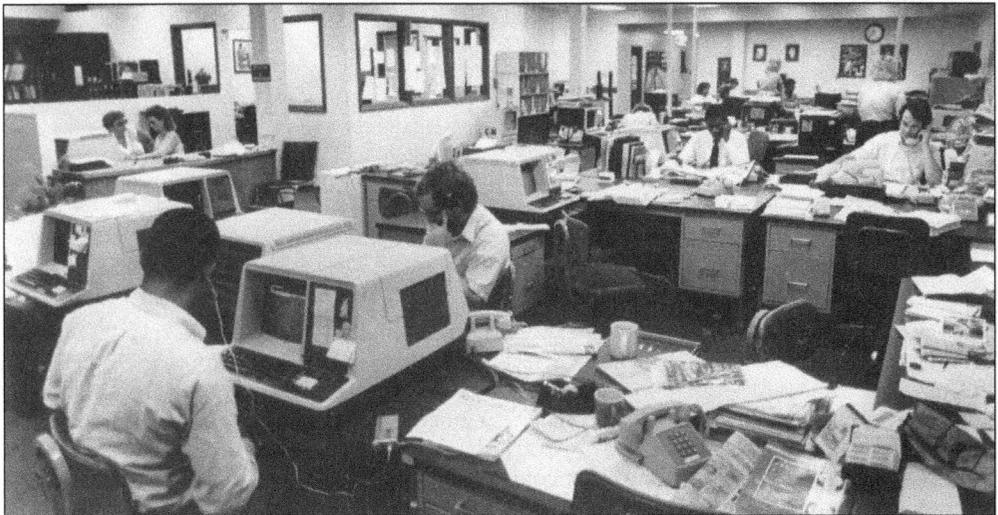

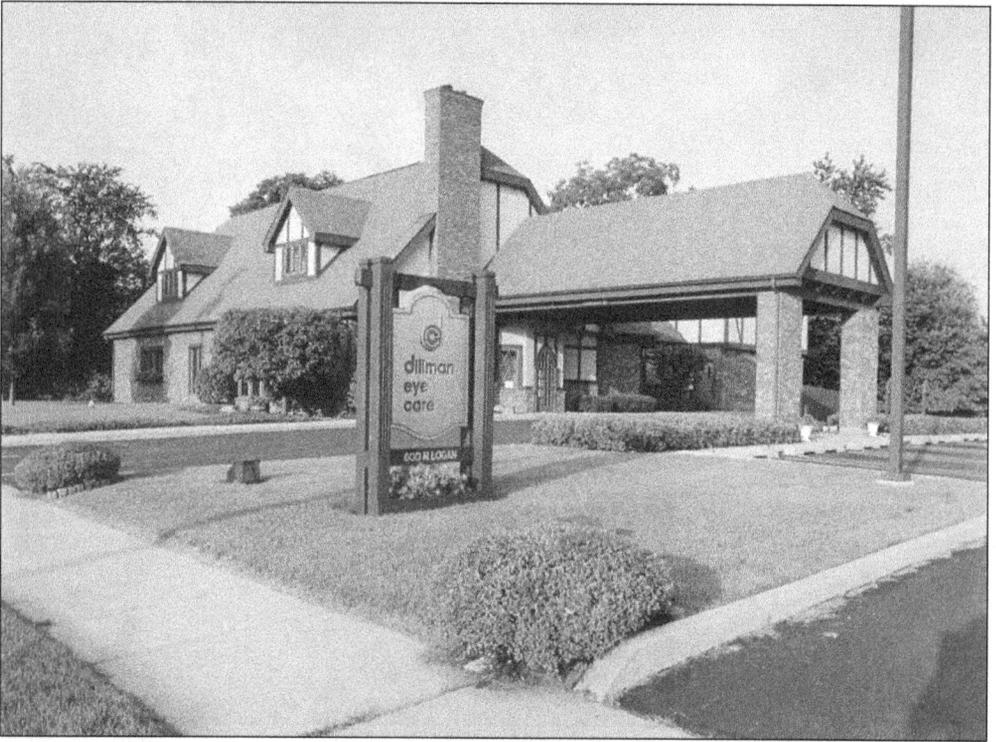

Dr. David Dillman was among the first ophthalmologists in the nation to offer CK (conductive keratoplasty) Blended Vision as a technique, using radio waves to correct presbyopia. The Dillman Eye Care Building, at 600 North Logan Avenue, was built in 1981 at a cost of $475,000 and features examination rooms, offices, and a fitting room. Dr. Dillman continues to practice at this location and is considered a leader in his field.

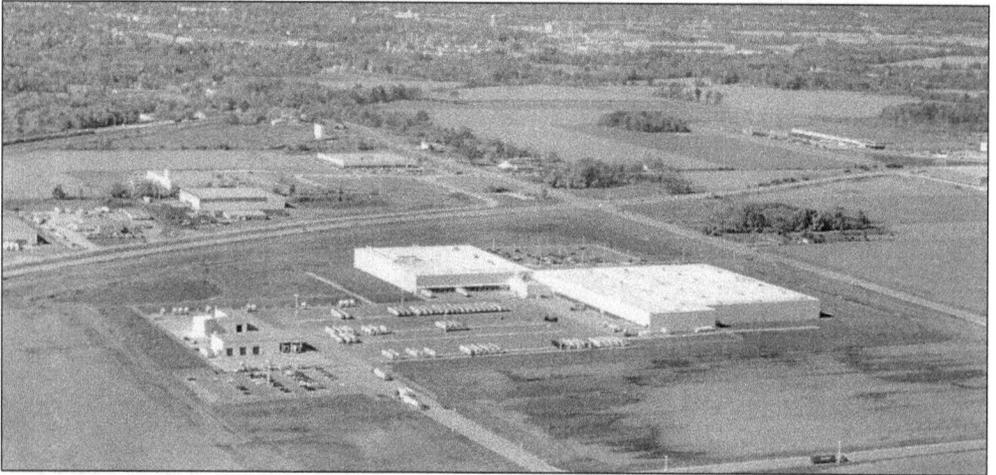

McLane Midwest, Inc., at 3400 East Main Street, a subsidiary of Wal-Mart Stores, Inc., opened in 1993. In 2000, an 80,000-square-foot addition was added to its warehouse, providing additional storage space and 18 truck docks. The company, a grocery and food service distributor, provides services to Walmarts and Sam's Clubs. In 2003, the company became a subsidiary of Berkshire Hathaway, which also owns, among other companies, Dairy Queen, Fruit of the Loom, GEICO Insurance, Pampered Chef, and Benjamin Moore Paints.

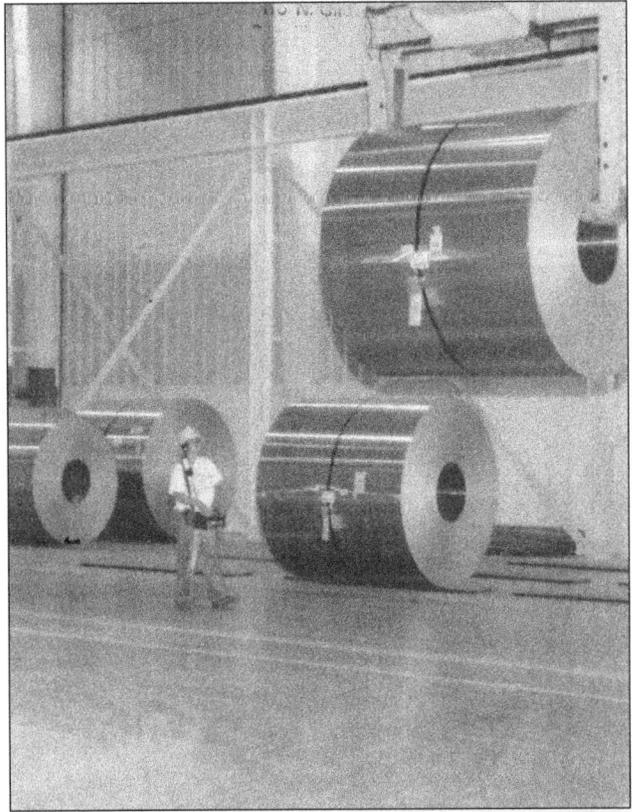

The Aluminum Company of America (Alcoa) opened its Danville facility in 1997 in the Southgate Industrial Park. Aluminum processing at the plant has evolved over time to meet the demands of an ever-changing market. It initially heat-treated the aluminum and then rolled it back into coils. Eventually, the company began cutting the coils into chevron-shaped panels used for automotive hoods and trunks, which were then shipped to stamping facilities. The high industry standards met by Alcoa won the Danville plant a preferred place on a vendor list used by the nation's top automakers, including Chrysler, Nissan, Ford, Honda, and Subaru, as well as several commercial businesses. (Both courtesy of the *Commercial-News*.)

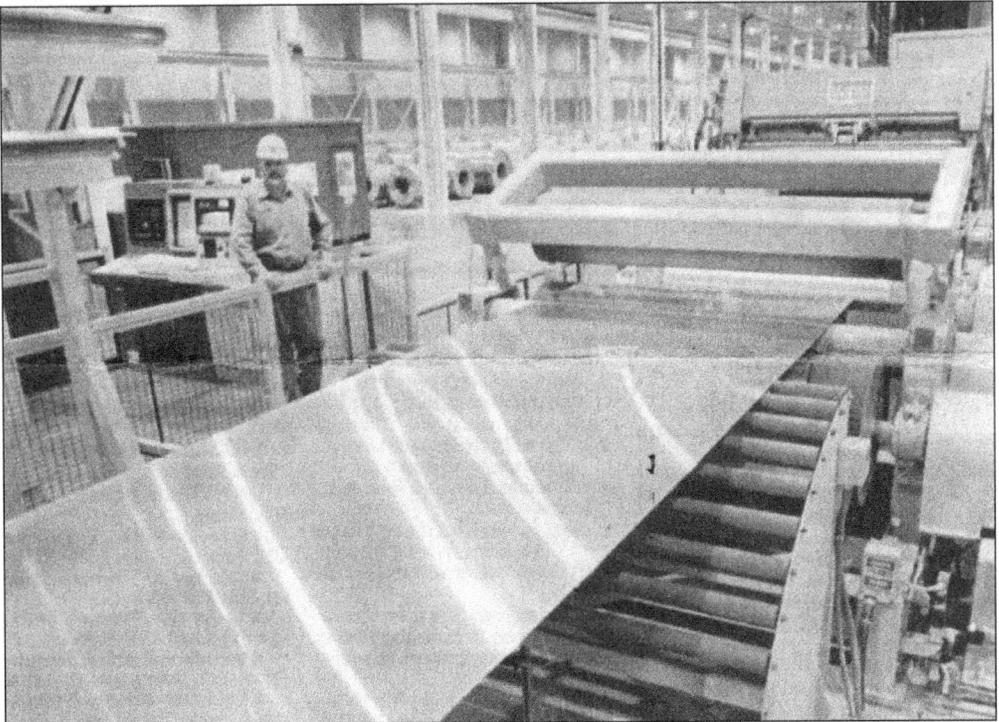

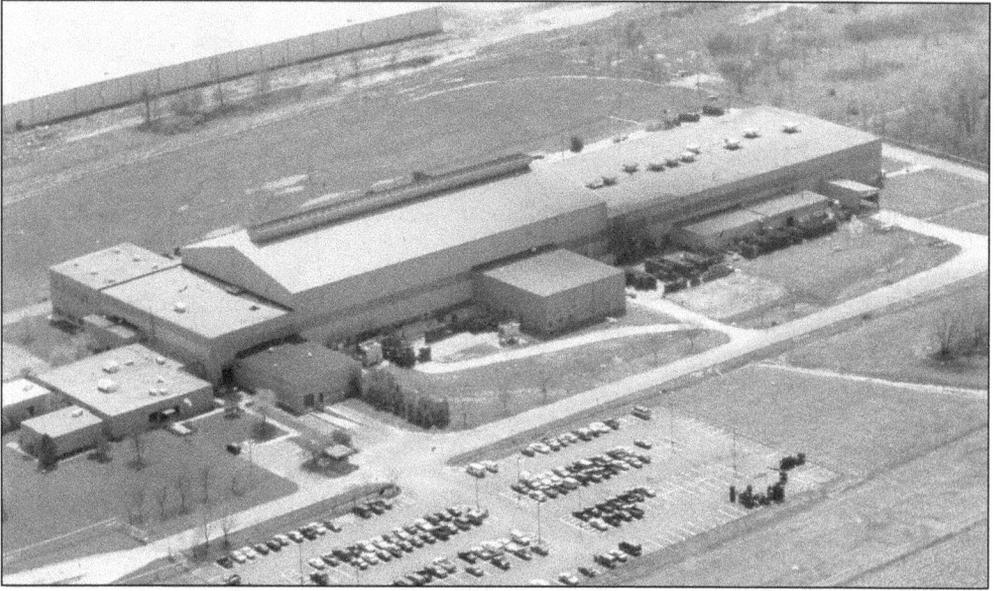

The Krupp Gerlach Company of Liechtenstein opened its Presta division in Danville, at 75 Walz Creek Drive, in 1994 to broaden its scope of products. This plant manufactures camshafts, steering columns, and universal joints for the automotive industry. Ford and Chrysler are Presta's two largest customers. The plant is highly automated and robotic, with all machines computer driven. The company transports parts to the United States, Canada, Mexico, Venezuela, Argentina, and Brazil.

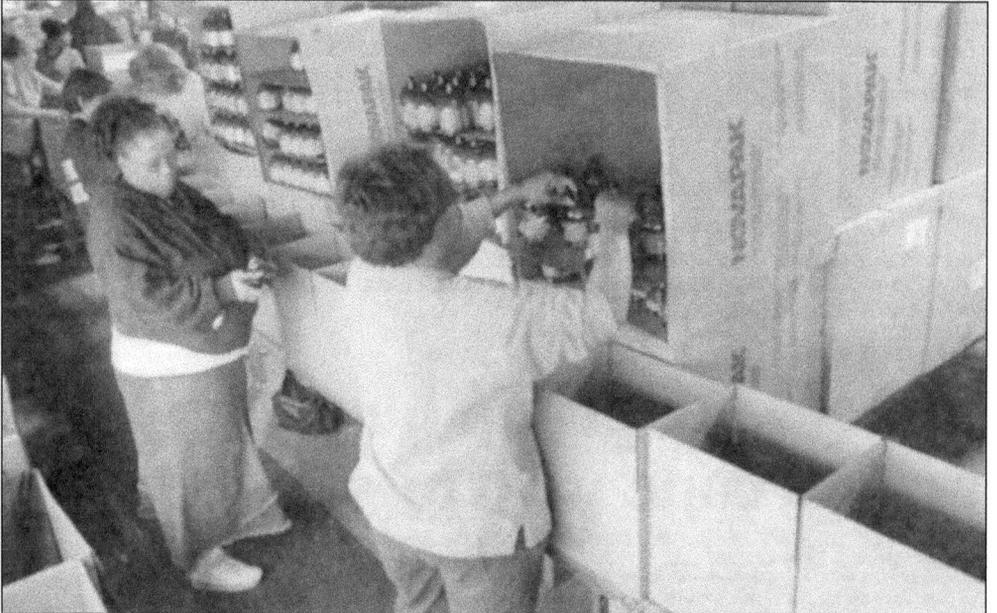

EnvirOx, at 1918 East Fairchild Street, first started in Danville around 1997, when the company introduced an environmentally friendly cleaning product called H2Orange2 to the commercial cleaning industry. Later, the company launched the OurHouse division, which sells a line of home cleaning products. EnvirOx products cannot be bought in stores but are available through the company's website or from home ambassadors. Here, workers at EnvirOx prepare household cleaning kits for shipment. (Courtesy of the *News Gazette*.)

The Danville Metal Stamping Company, Inc., has been a member of the community since 1946. The company has been involved through the years with the development and production of fabricated metal components for the gas turbine, missile, rocket, and commercial industries. The business grew from a three-person stamping shop to a company employing more than 400 workers. About 95 percent of the equipment used at the factory is computer controlled. The company has grown to include two Oakwood Avenue facilities, a plant on Martin Street, and also Thermo Techniques, a brazing and heat-treating plant on Oakwood Avenue. While 30 percent of their business is military, some of their other customers have included General Electric, Rolls Royce, Pratt & Whitney, and Honeywell. Parts from the company help small business jets and Boeing and Airbus planes to fly. (Both courtesy of the *Commercial-News*.)

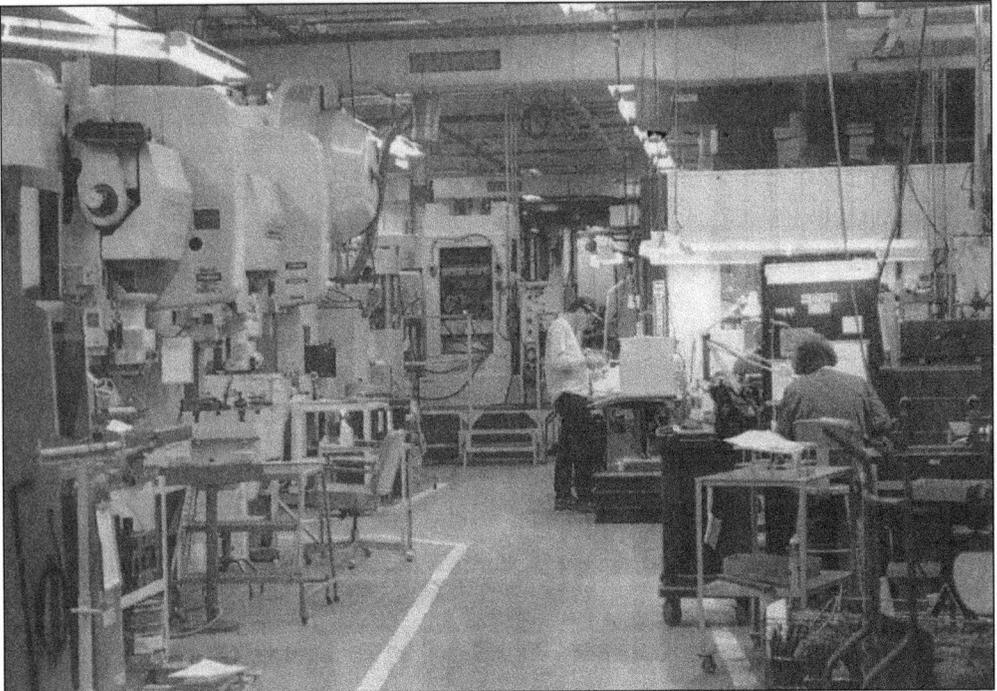

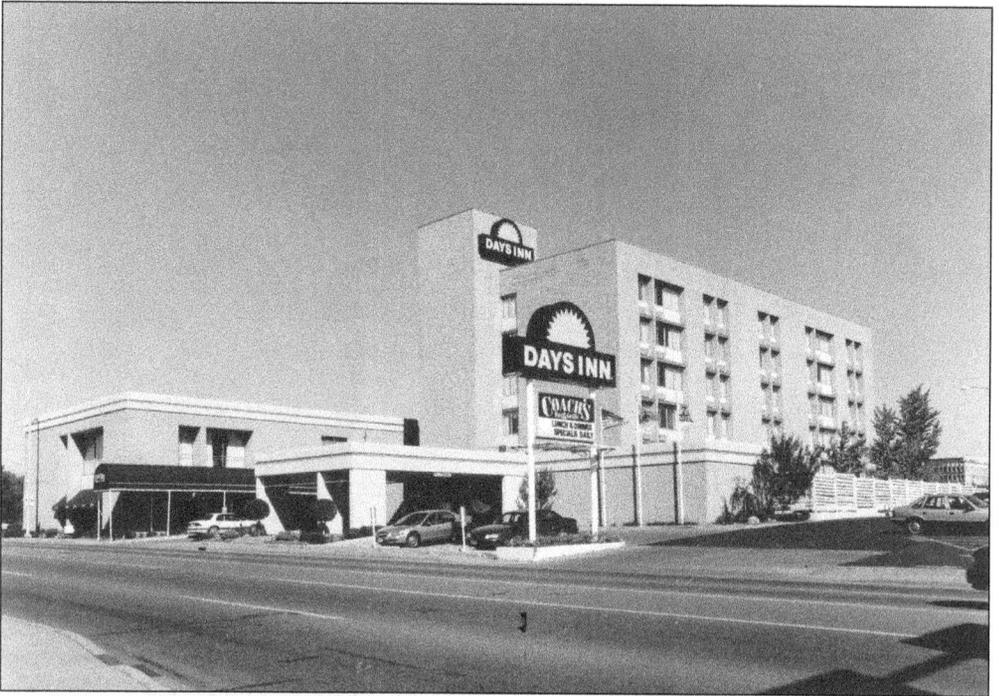

The Sheraton Motor Inn was built at 77 North Gilbert Street in 1974 at a cost of two million dollars. It was the first new hotel or motel built in Danville since 1963. Robert Hible & Associates were the architects for the building, and Schendel Builders of Danville were the contractors. The hotel later became the Lincoln Inn, then a Days Inn, and it is currently operating as Days Hotel.

Freightcar America, Inc., established in 1995 at 2313 Cannon Street, produced about 80 percent of the aluminum coal cars in North America. Located at the site of the old Chicago & Eastern Illinois Railroad shops, the company designed and patented the aluminum railcar it produced. Preceding Freightcar in this same location was Danville Industries, Inc., which began in 1970. In 2006, the company christened the 100,000th car manufactured at this site. In May 2013, the company ceased production at the plant. (Courtesy of the *News Gazette*.)

Two

What a Way to Go

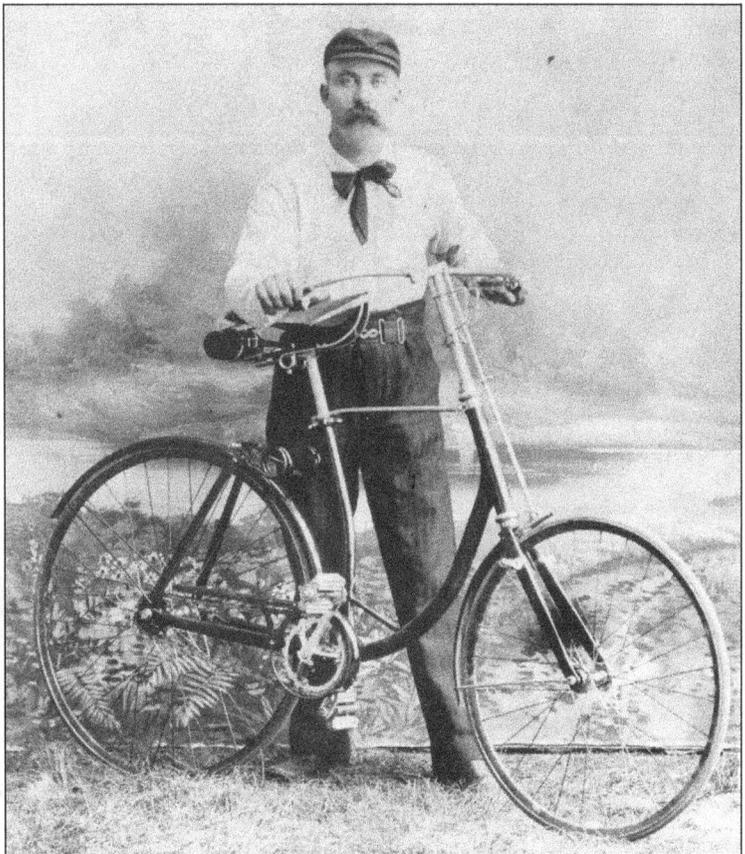

Robert Holmes is seen here with one of the first "Safety" bicycles with solid tires. Holmes Bros. was noted for selling anything on wheels. By 1898, the business was offering automobiles for sale, both steam- and gasoline-propelled. Evidently, it had no takers until about 1901, when E.J. Ryan bought a single-seat steam carriage. This was believed to be the first car owned in Danville.

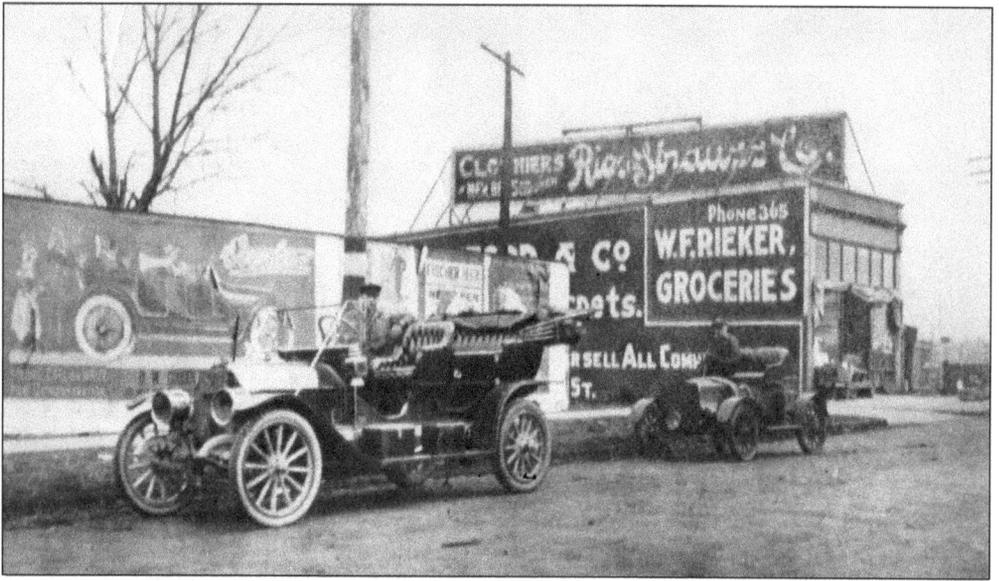

Joseph V. Fairchild (left) sits in a 1909 Buick. Mike Geraty is in a Gale, made in Galesburg, Illinois. The Gale is going to the junkyard, and the two vehicles are sitting on Gilbert Street at the north end of Memorial Bridge. The billboards behind the cars were used to advertise not only businesses but also special events in the area.

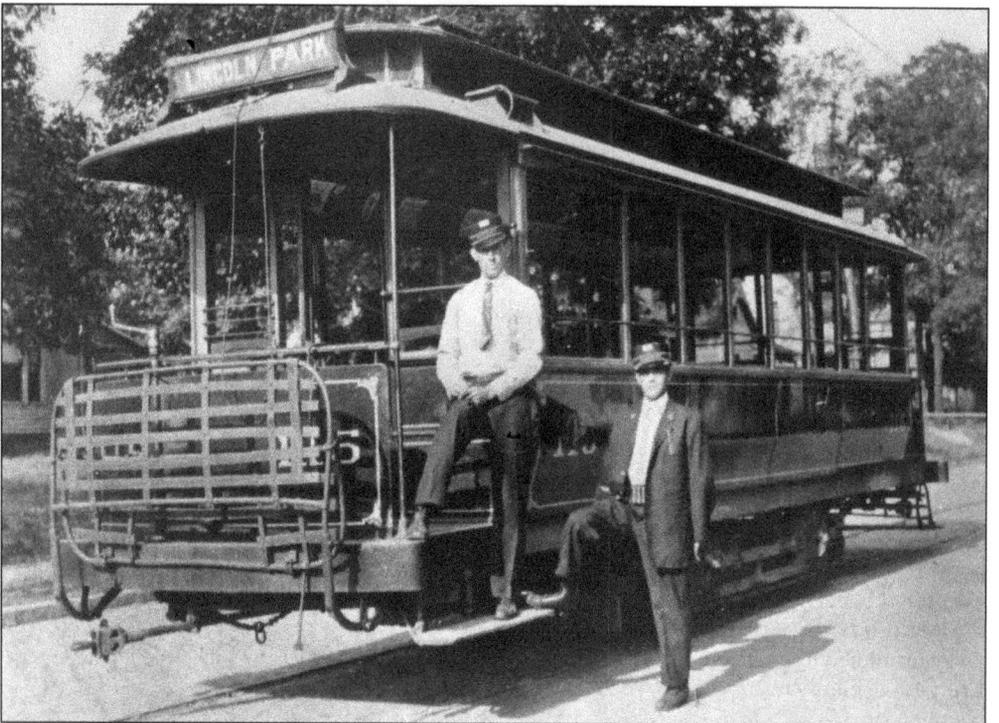

Car No. 115 was part of the Lincoln Park line. The interurban began in Danville in 1883 under the auspices of the Citizens Street Railway Company. These early open-air cars often had curtains that the passengers would help the conductor roll down in inclement weather. In winter, straw was often added on the floors to provide warmth for the passengers' feet.

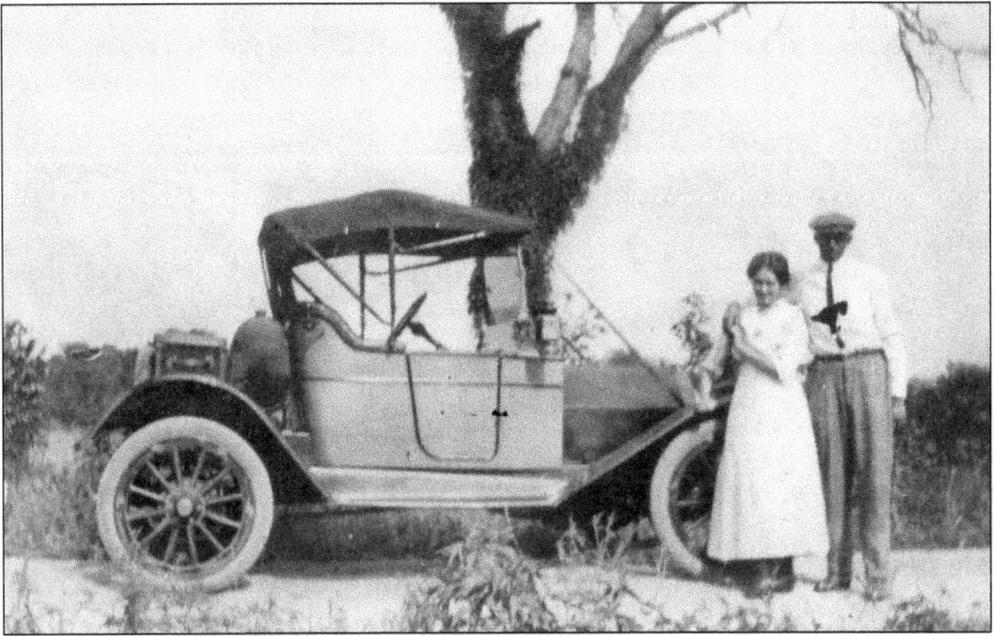

Albert and Mable Mauck purchased this Krit in 1912. The cost of the car was $900, as can be seen on the copy of the check below. It was drawn on the First National Bank, with payment being made to Robert Holmes & Bros., whose business was at 32 North Hazel Street. The purchase was made on a counter check, something that is not seen in banks today. The check was printed by George E. Cockerton & Son, printers, bookbinders, and rubber stamp publishers, whose business was at 20 East Harrison Street.

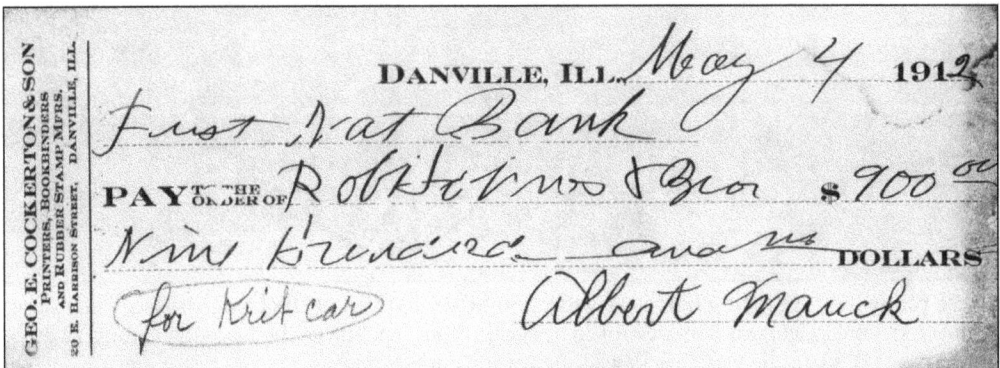

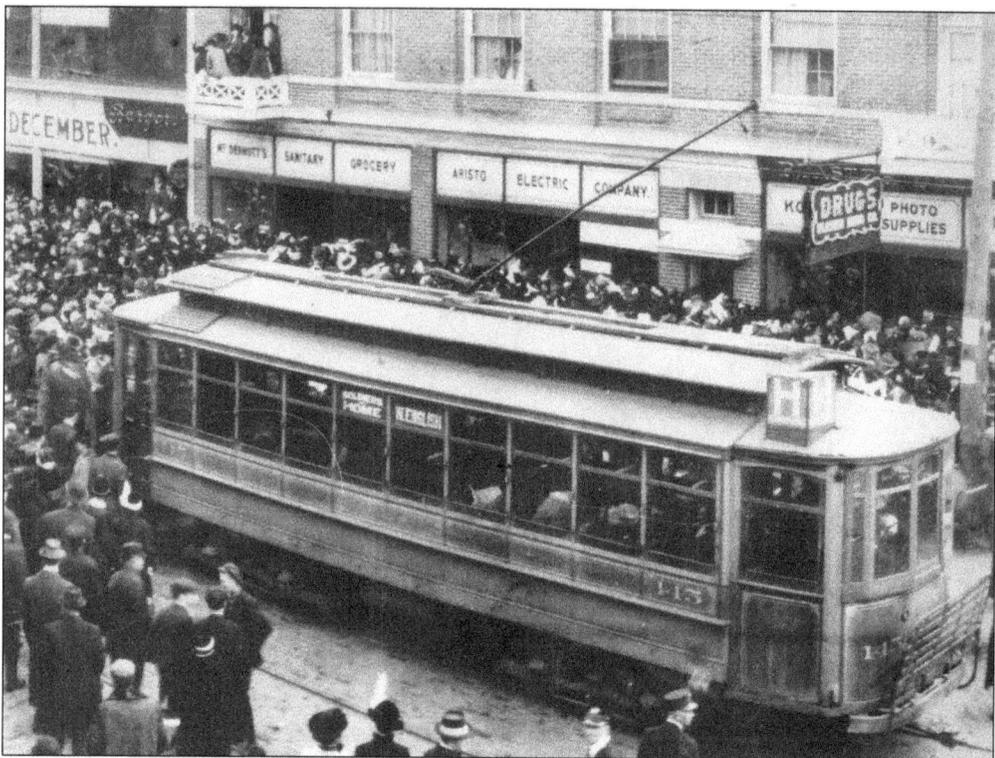

Dollar Days at Barger's Department Store were a big draw for downtown Danville. This streetcar on East Main Street had trouble moving through the crowds that had gathered for the Barger & White sale on November 29, 1914.

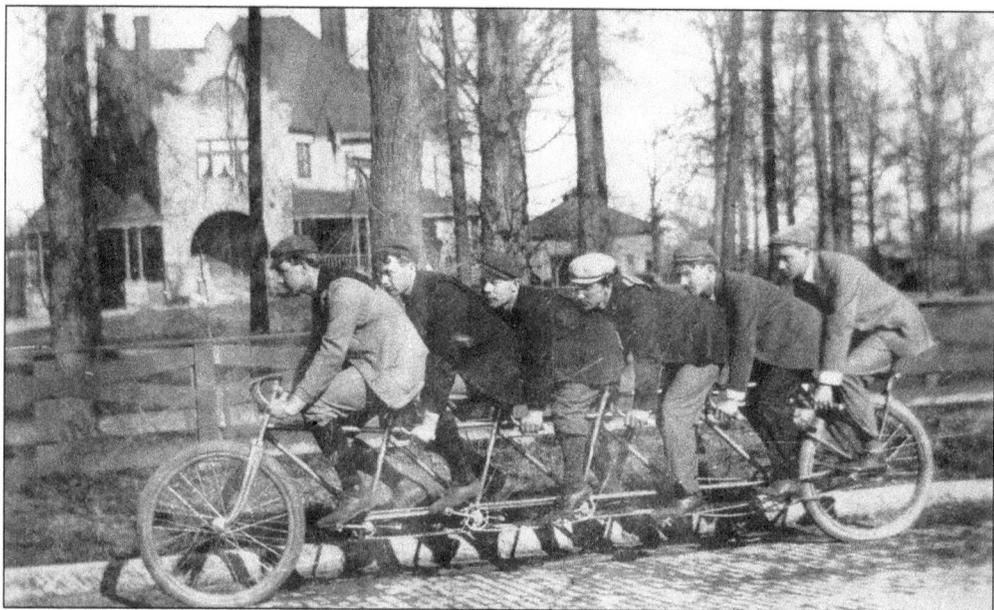

These young men are racing north on Vermilion Street in front of the Dodge house. The house, built by Anson Dodge, was later destroyed by fire. It is now the site of the Danville Family YMCA. Early streets in Danville were brick, with limestone curbs.

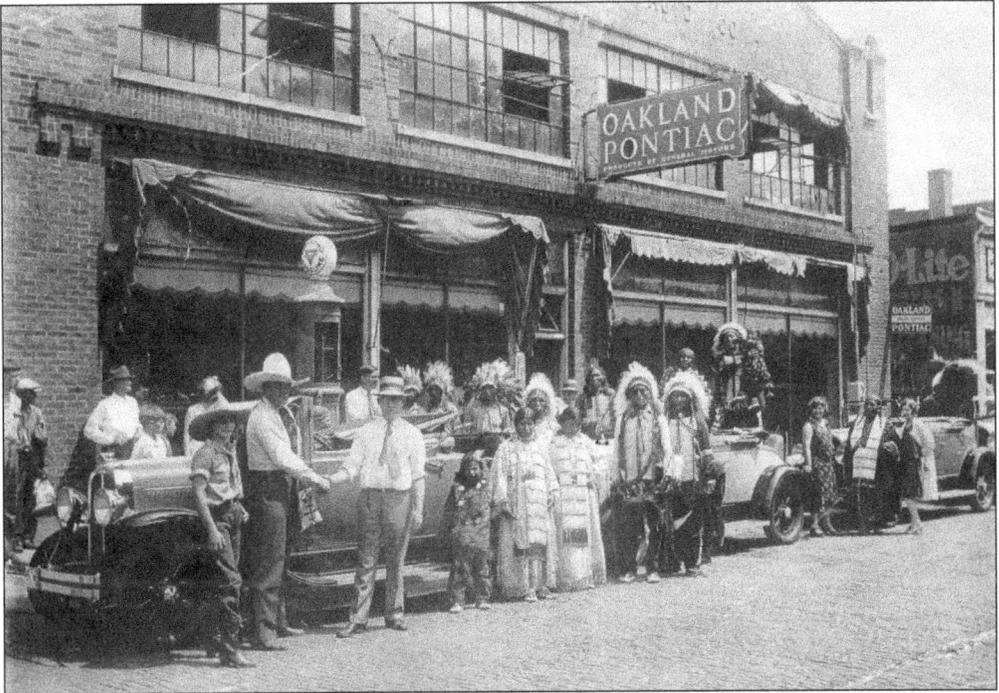

The unveiling of new cars was often a major event in the city. This photograph was taken at Barkman's, at 141–143 North Walnut Street. The gentleman shaking the cowboy's hand is an unidentified member of the Barkman family. Barkman's was the local distributor for Oakland and Pontiac products. The gasoline pump sports the Marland Oil Company logo.

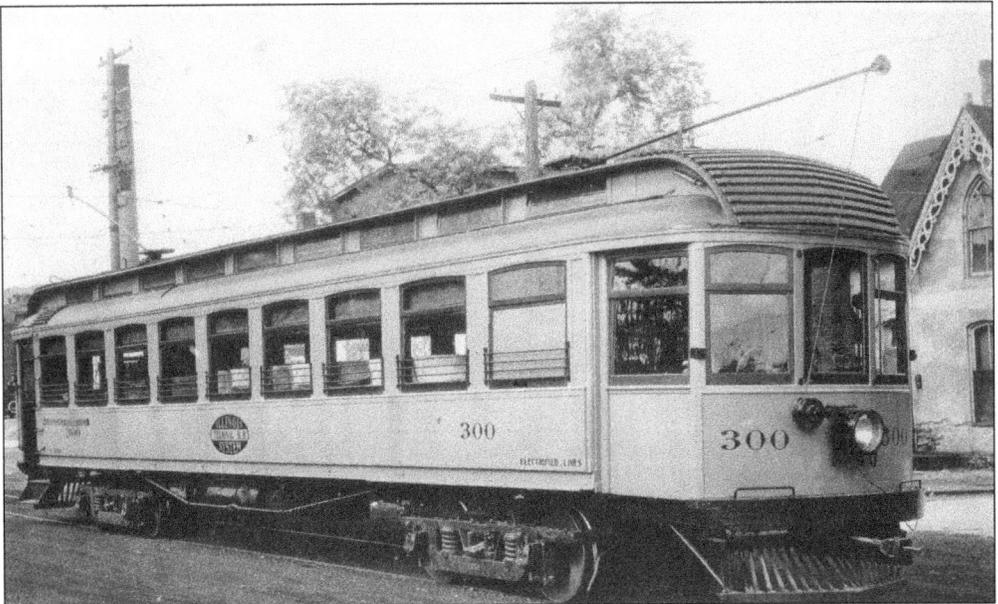

This double-ended, two-man suburban car was seen on South Vermilion Street in the early 1920s. The car was delivered to Danville in 1907 and was used for the Danville-to-Ridge Farm run. By this time, the company was known as the Illinois Traction System, and it connected many of the smaller towns throughout central Illinois.

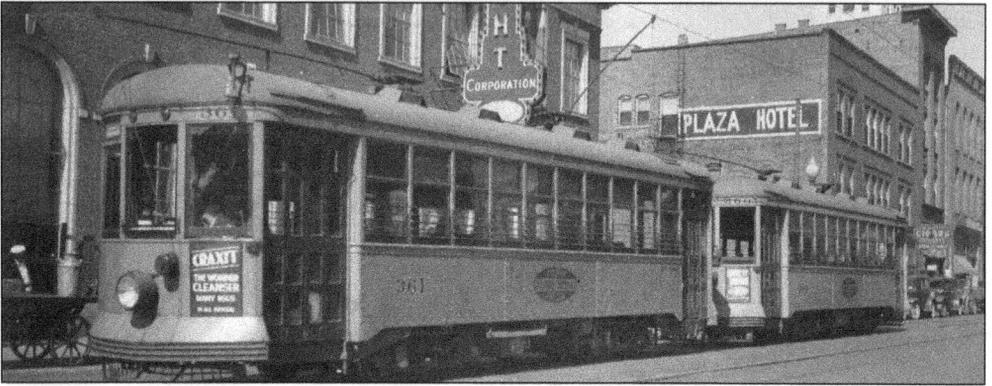

In 1923, the Illinois Power Company took over the interurban system in Danville. Its main office was on South Vermilion Street. This 1933 photograph shows the dual cars parked in front of the office. By 1936, the power company was phasing out the streetcar service. Final lines were removed from the South Vermilion Street area in 1952.

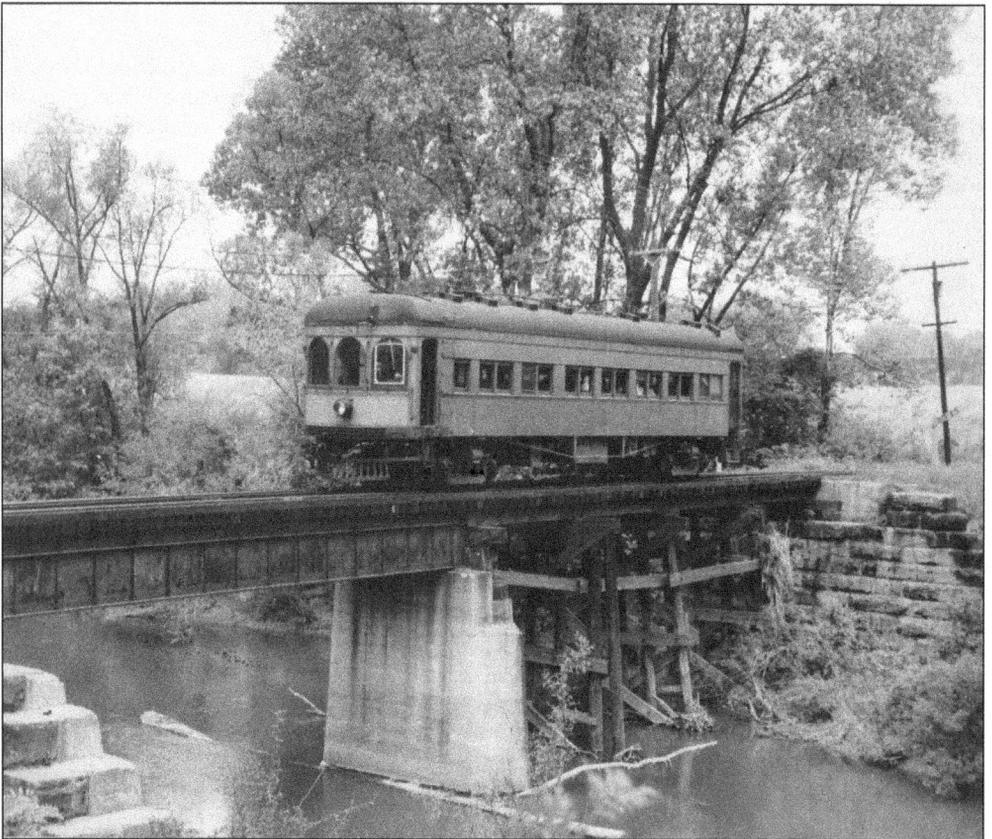

This car is heading west over the bridge at Ellsworth Park. It was made in 1913 by the St. Louis Car Company and was retired in October 1953. In 1942, it was painted orange and red when the company changed its colors and logo.

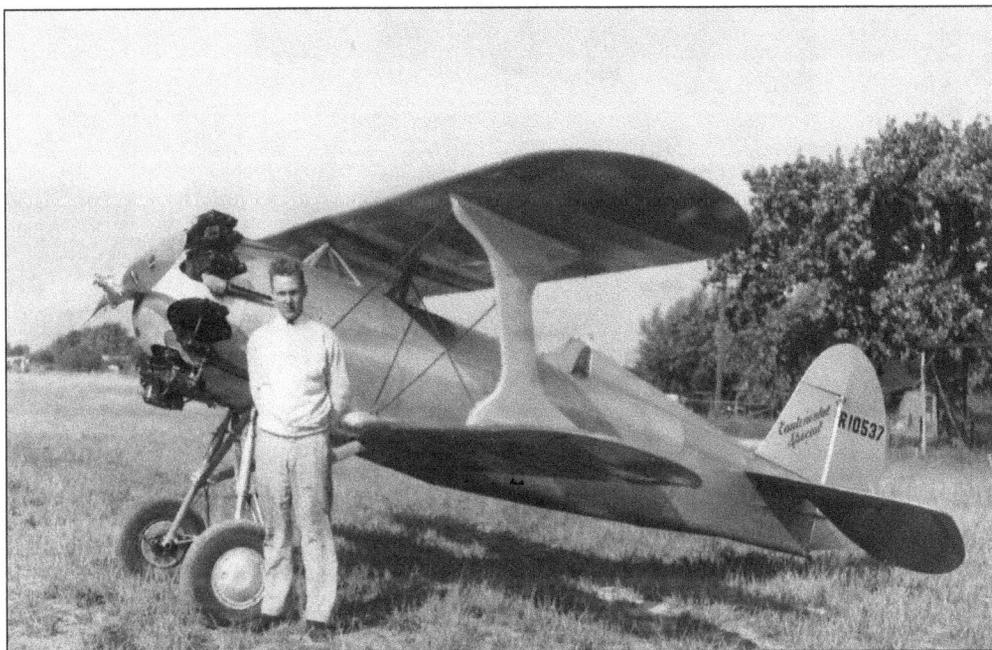

Jimmie Barton and his Continental Special were a sight often seen in the skies above Danville. This photograph was taken at the old Fourteenth Street Airport in 1936. This airport served as the municipal airport until 1955.

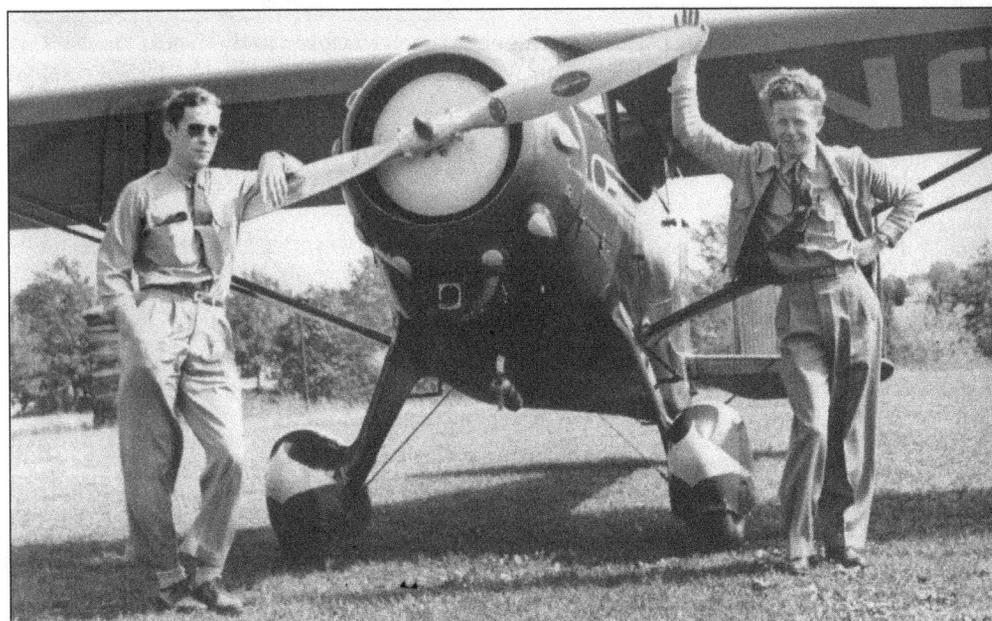

Ken Johnson (right) stands with his plane at the local air show in 1939. The first flight occurred in Danville in September 1911. Until 1934, the first airport was the chamber of commerce field, east of Danville on Route 10. The municipal airport was on Fourteenth Street, and it was followed in 1950 by the present-day Vermilion County Airport. In 1977, it was renamed the Clarence Carter Field. All passenger service was discontinued in Danville in 1997.

West Main Street was a bustling place when this photograph was taken in the 1940s. These young gentlemen are cruising in front of Thompson Washing Machines, at 22 West Main Street. Note the streetcar tracks in the middle of the street.

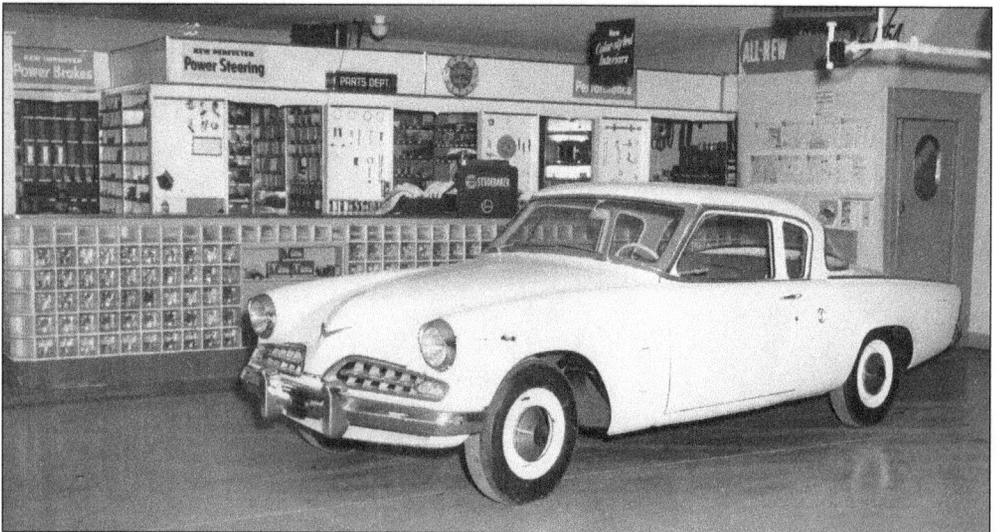

Automotive dealers and repair shops touted the newest in cars, parts, and accessories. This photograph shows the interior of Landsdown Motors, at 109 East North Street. Note that the signs advertise new and improved power brakes, power steering, and color-styled interiors. The car is a mid-1950s Studebaker.

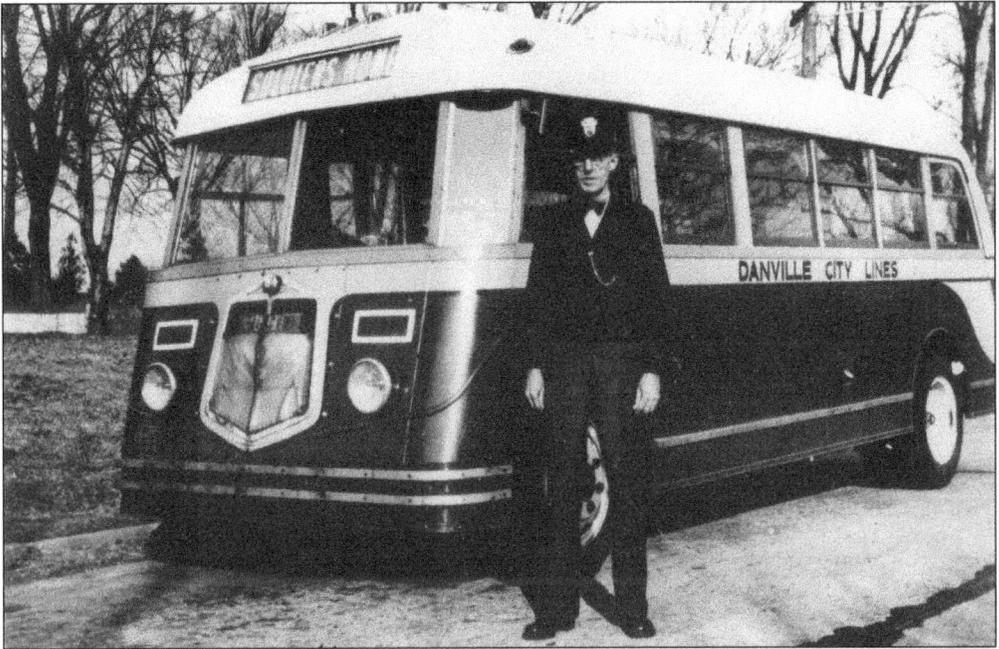

In the mid-1920s, Illinois Power started the first bus lines in Danville as they were phasing out the interurban service. Danville City Lines was begun in about 1936 as a part of the Bee Line Transit Corporation. It was 5¢ for a ticket, with a transfer costing a penny more. Bee Line Transit was in operation until 1970. In 1977, Danville Mass Transit was firmly established in the city. The photograph above is a Danville City Lines bus on the Soldier's Home route. A bus is seen below at the garage on South Hazel Street.

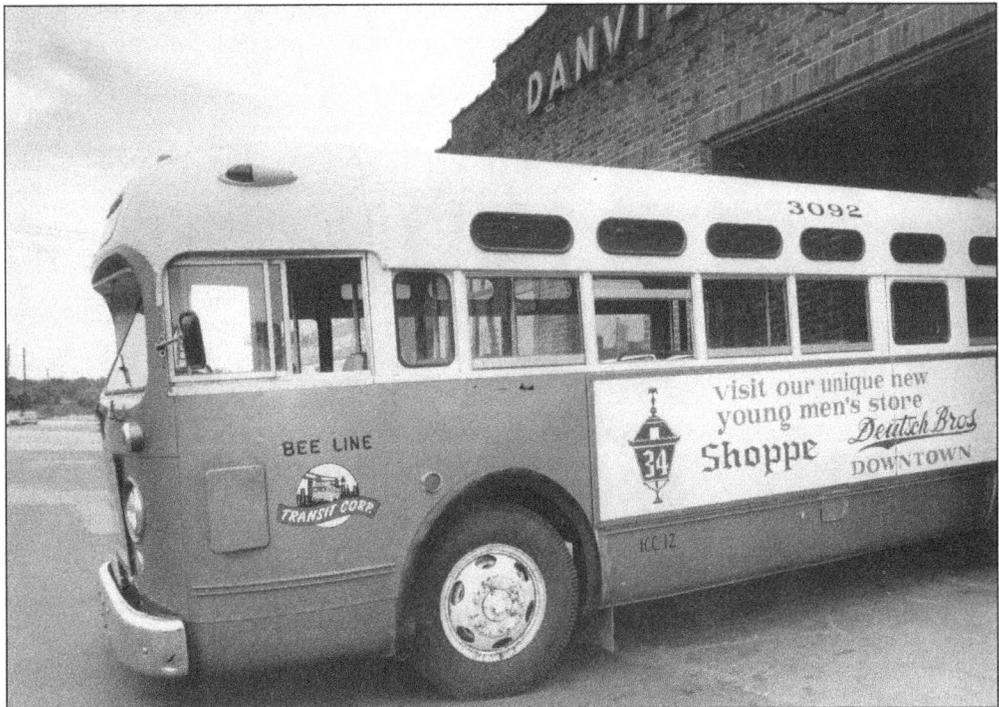

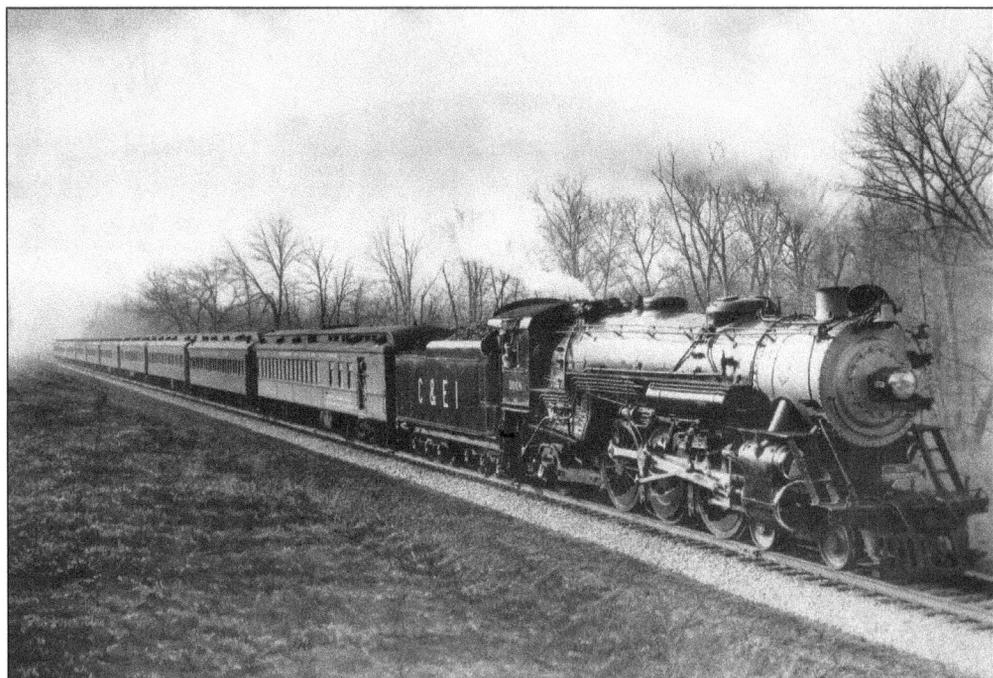

In 1869, Danville Junction was established when five railroad lines traveled through the city. The junction was not more than one acre of land, but it was a busy place until it was closed in 1919. Railroad passenger service continued in Danville until the 1970s. Two of the more well-known trains were the *Dixieland* and the *Dixie Flagler*. The photograph above shows the *Dixieland*—Chicago & Eastern Illinois (C&EI) train No. 92—north of Vincennes, Indiana, in 1938. The photograph below shows the C&EI *Dixie Flagler*, which ran from Chicago to Miami. The route was opened in 1950 and ran until 1957. It was an all-coach streamliner that utilized six different railroads on its journey of 1,455 miles.

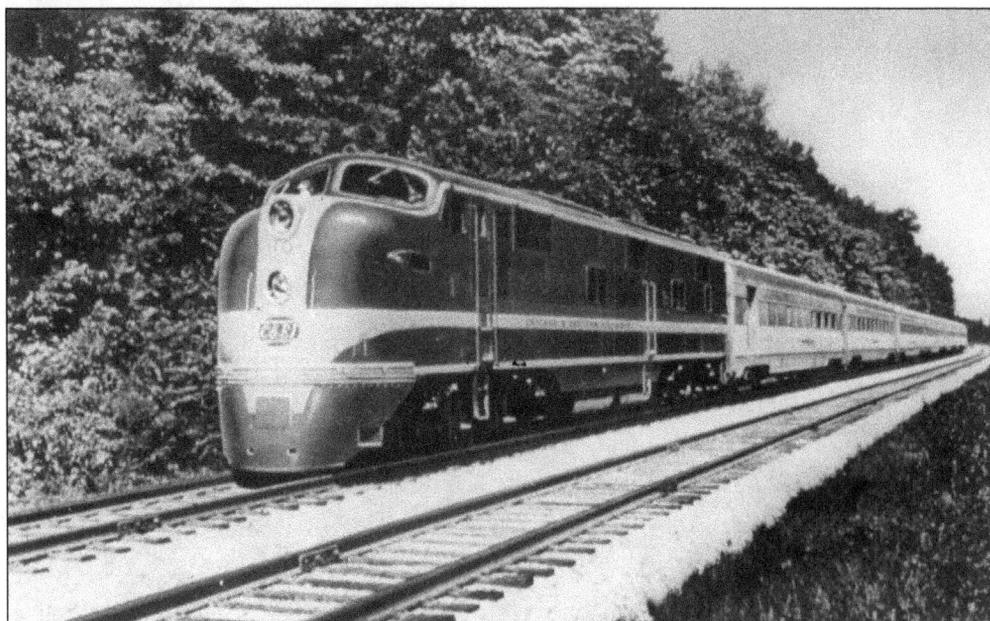

Three

ALL WORK AND NO PLAY

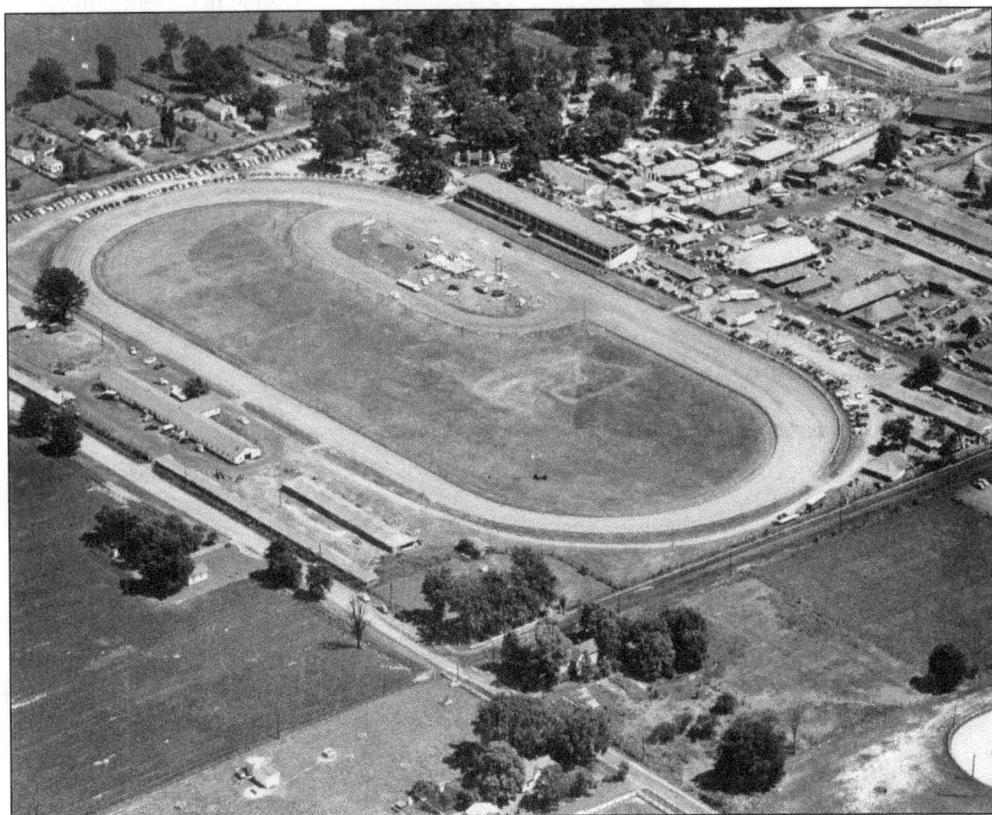

This is an aerial view of the Illinois and Indiana Fairgrounds, on East Fairchild Street. The first fair opened here in 1919, and the fair continued at the East Fairchild Street location through the mid-1950s. Harness racing was a major attraction at the early fairs, and the grandstands held 12,000 people. In the upper right corner, the midway attractions can be seen.

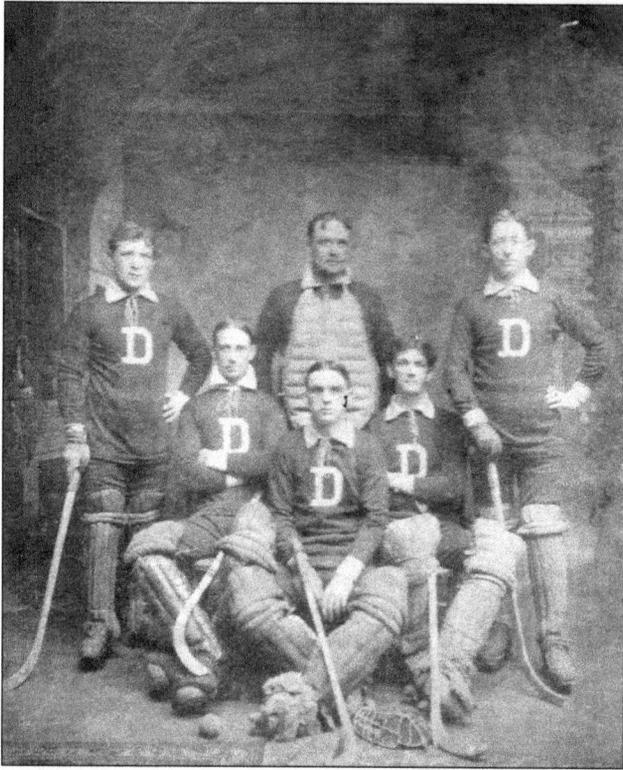

For a number of years in the early 1900s, Danville sported a roller hockey and polo club. The team was part of the Central League Polo Club. Of special note in this image are the extensive shin guards worn by the players for protection.

Jude Myers started "barehanded ball" in Danville in 1868, beginning a procession of teams that carried the Danville banner in amateur, semiprofessional, and professional baseball. In this 1911 photograph of the Danville Cardinals, Hod Eller is second from the left. Eller, a pitcher, eventually played with the Cincinnati Reds from 1917 to 1921, completing his career with a 60-40 record and a lifetime 2.62 earned run average.

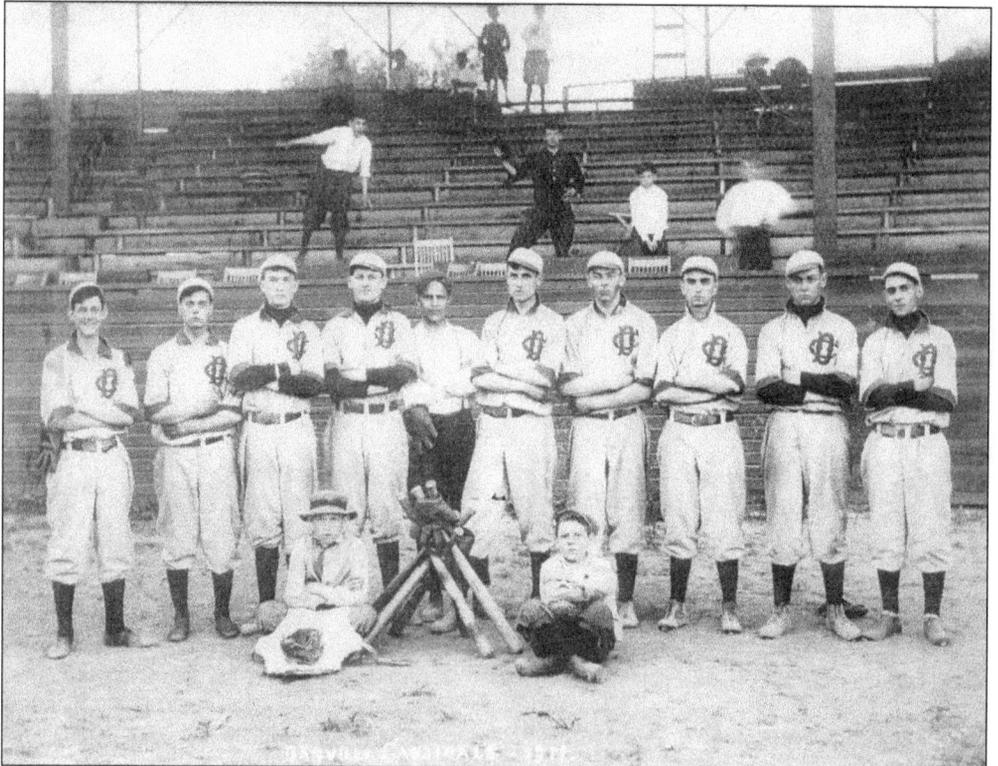

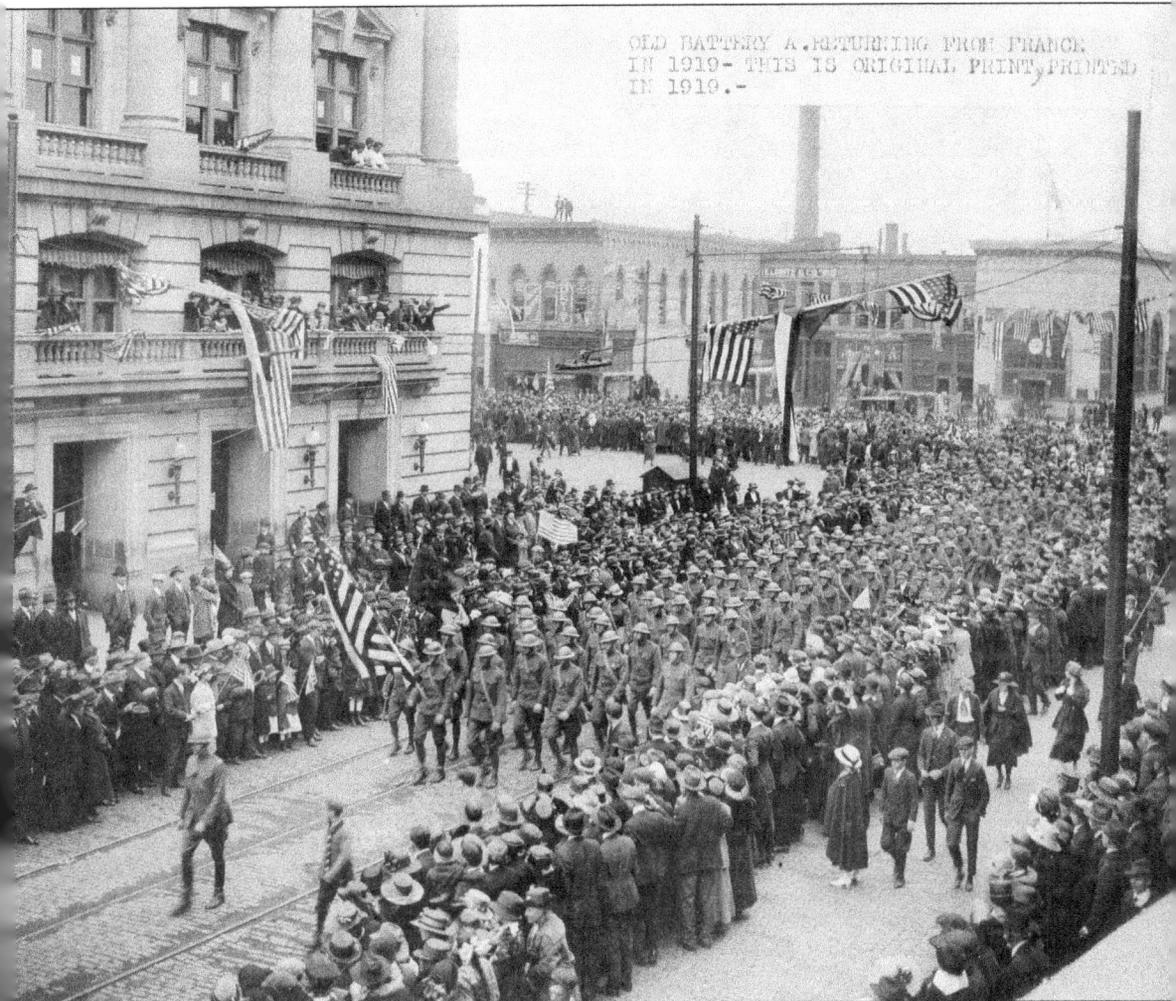

OLD BATTERY A RETURNING FROM FRANCE IN 1919- THIS IS ORIGINAL PRINT, PRINTED IN 1919.-

As Battery A, 149th Field Artillery, returned from France in 1919, Danville area residents gathered at the public square to welcome them home. According to local newspaper accounts, more than 1,000 viewers crowded the square for the parade. On September 24, 1919, the square was dedicated as Redden Square, after Col. Curtis G. Redden, commander of the battalion. The building to the left is the Vermilion County Courthouse. In the background is the old Palmer National Bank and other buildings that were later demolished during urban renewal in the mid-1970s. The soldiers are marching from the east along Main Street, which was the location of the Wabash depot.

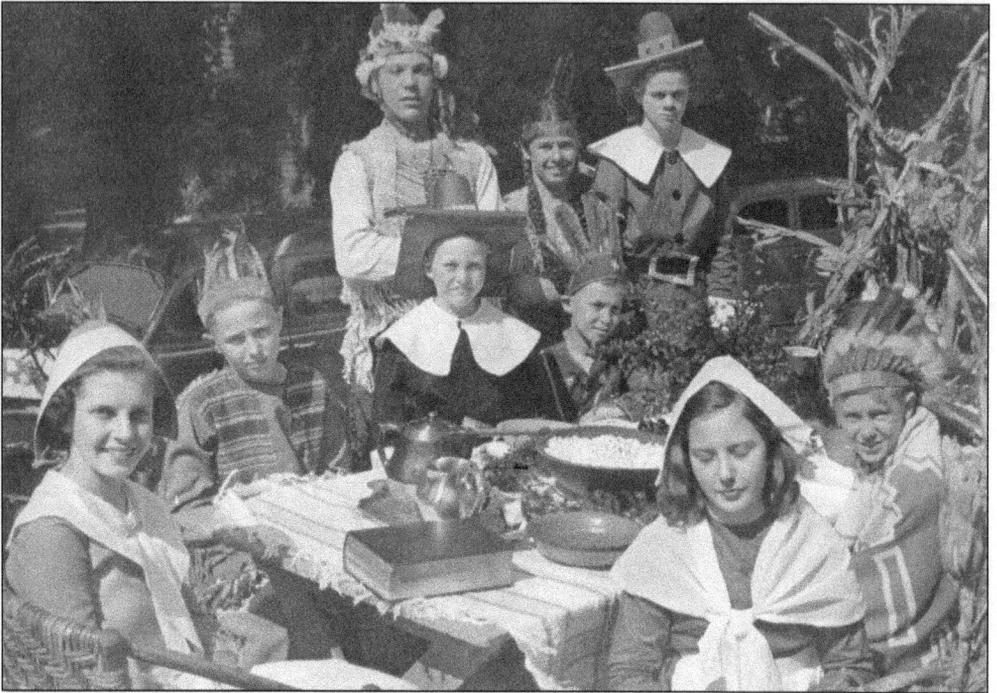

The Vermilion County centennial, in 1926, included many activities. Children played a major role in the many productions that accompanied the event celebrating the early pioneers in Vermilion County. After a parade with historical floats, such as the one above, cast members performed on a large production stage that was erected at the county fairgrounds. Of note in the photograph below are the horse barns in the upper right corner. Also visible is the railing for the racetrack. The production stage is located on the lower portion of the track in front of the 12,000-seat grandstand.

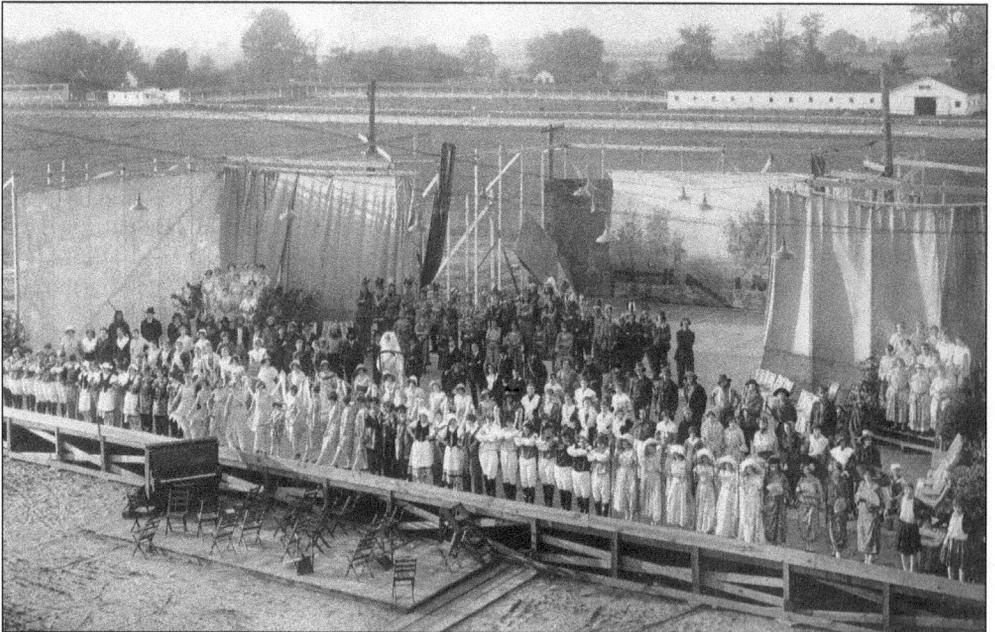

The 1939 Golden Gloves championship fight was won by Art Brady (right) in the fifth round by a very close decision. Russ Hance was the other contender, and John Dill was the referee. Golden Gloves matches were held at the Illinois State Armory, on North Hazel Street, from 1930 to 1951. Proceeds from the matches benefited American Legion Post 210, Bradley Mayberry Post 736, and the Sunshine Health Camp.

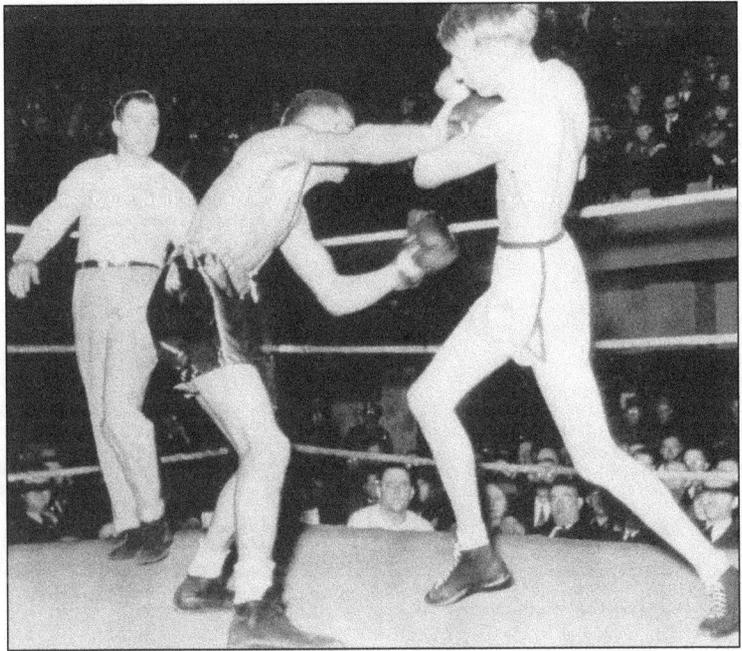

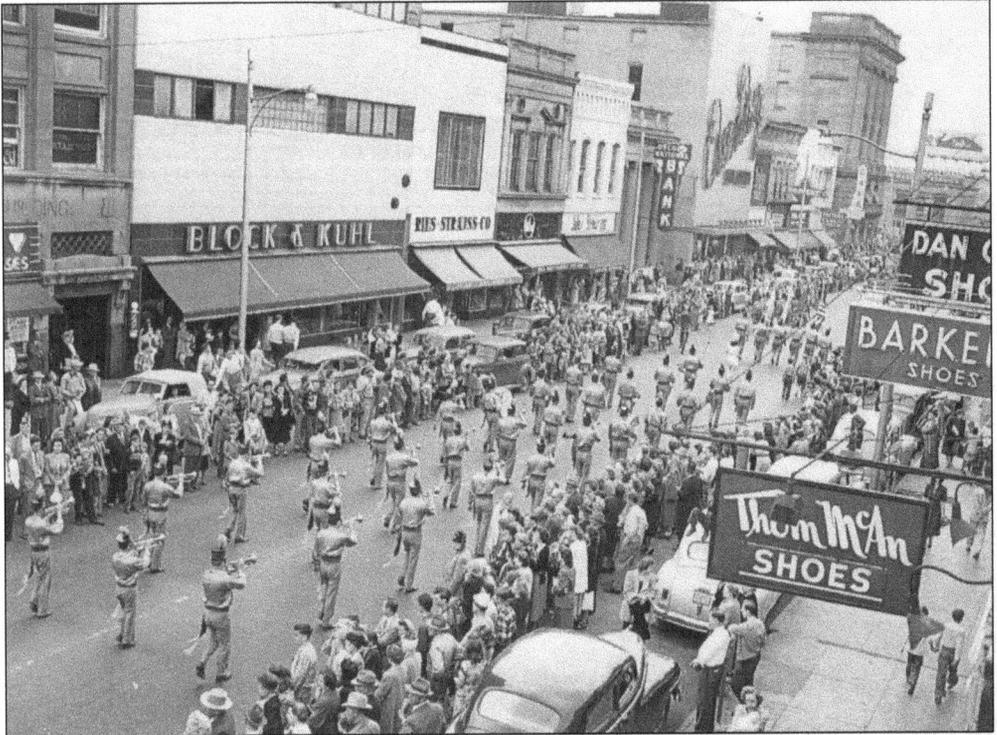

As can be seen in this photograph, everyone loves a parade, and they were held frequently in Danville. Whether for Memorial Day, the Fourth of July, or Labor Day, Vermilion Street was the site of many parades through the years. Of special note in this photograph are all the businesses, which no longer exist today, that catered to area customers, including three shoe stores that were situated side by side.

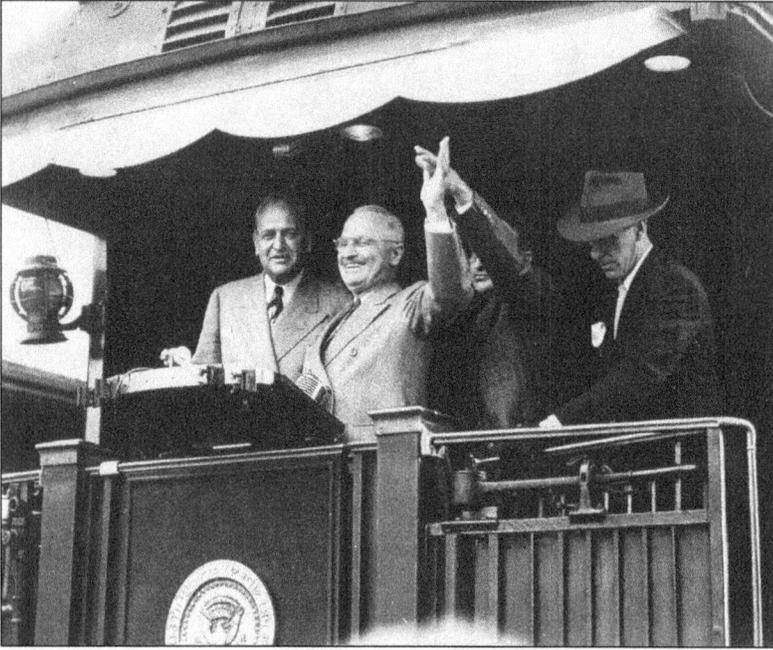

During his 1948 bid for reelection, Pres. Harry S. Truman visited Danville as part of his whistle-stop campaign. The local citizenry climbed on roofs and the tops of boxcars to get a better look at the candidate when his train stopped at the Wabash station on Main Street.

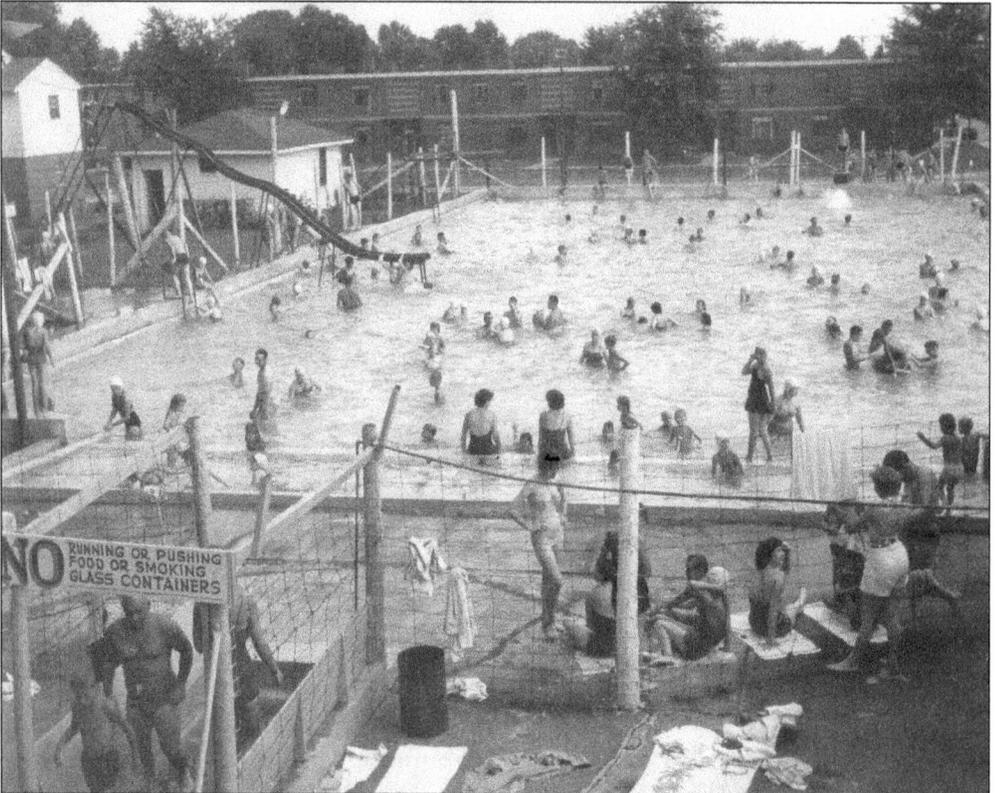

It is hard to believe that the I&I swimming pool, built about 1922 at the Illinois and Indiana Fairgrounds, was the only pool in the city. It was an oasis for thousands of hot, screaming, happy children. After being run by Wilbert and Anita Luke for 24 years, the pool closed in 1977.

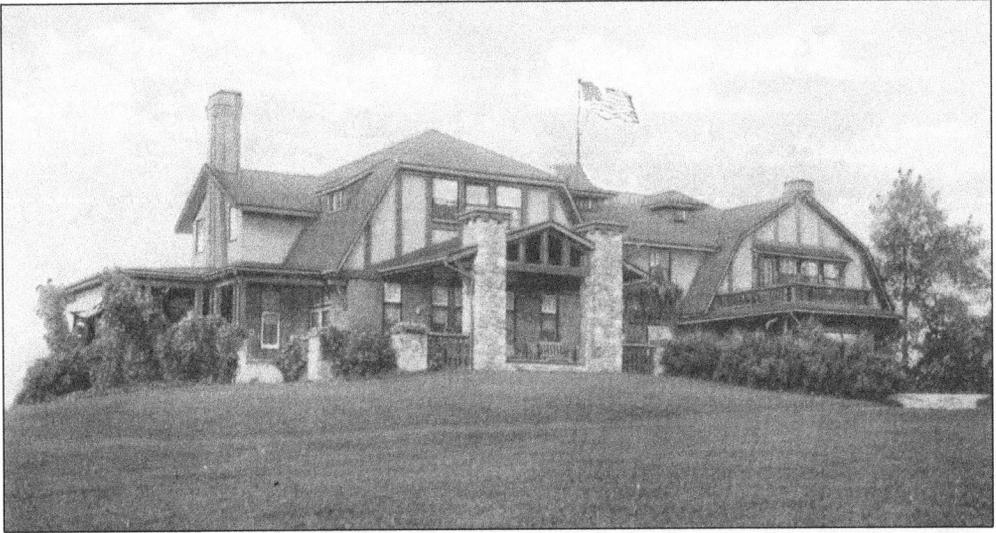

This English Tudor–style building, designed by Charles Lewis, was built in 1911 for the Danville Country Club. In 1928, *Commercial-News* editor John H. Harrison purchased the 64-acre club grounds and gave them to the city, and the former country club was named Harrison Park in honor of his mother, Minta. It originally opened as a nine-hole golf course, and the Works Progress Administration expanded it to 18 holes in the 1930s.

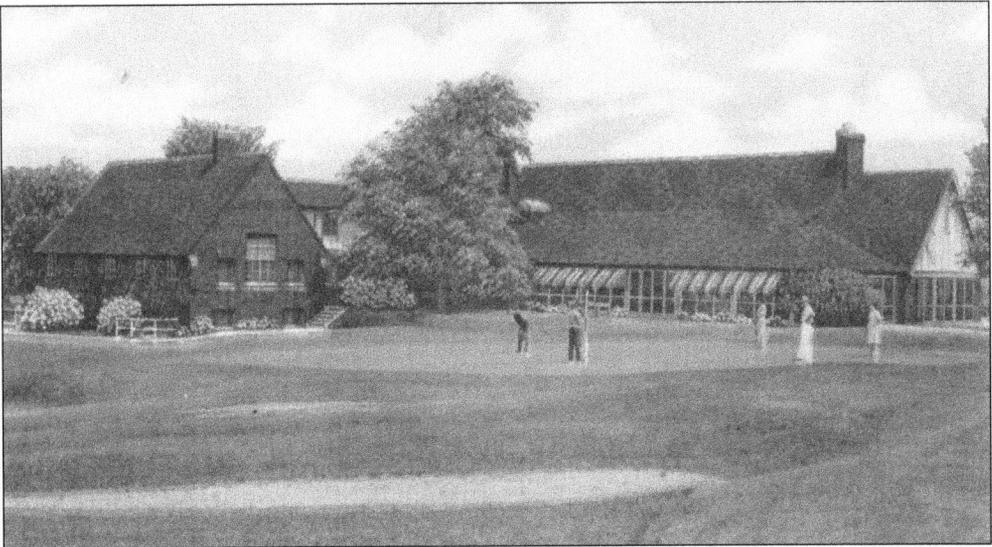

The Danville Country Club's roots in the community go back to 1904, when the Danville Golf Club was founded. Golf was in its infancy at that time, but it became a major summer sport in the area by the 1930s. The club moved to its present location, seen here, in about 1929. The club was a great place to see friends, socialize, play golf and tennis, and swim.

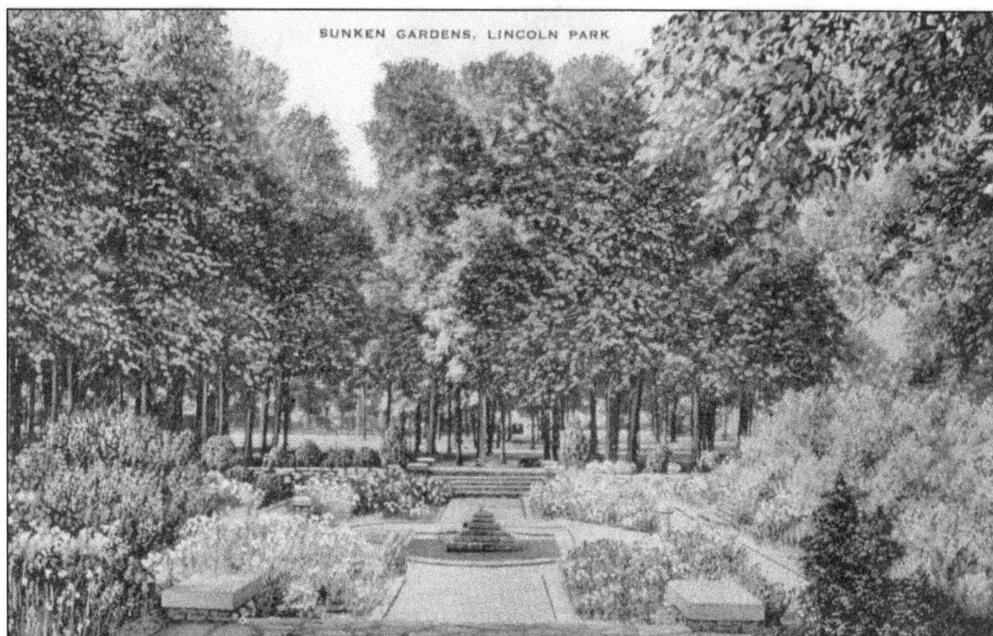

SUNKEN GARDENS, LINCOLN PARK

Lincoln Park was established in 1891 with a gift of 21 acres by William Bundy. Little development was done until the pavilion was built in 1915. The Sunken Gardens were situated near the northwest corner of the park. Work was done in the early years by members of the Danville, Roselawn, and Men's Garden Clubs. The garden was discontinued in the early 1980s when the site was filled and leveled.

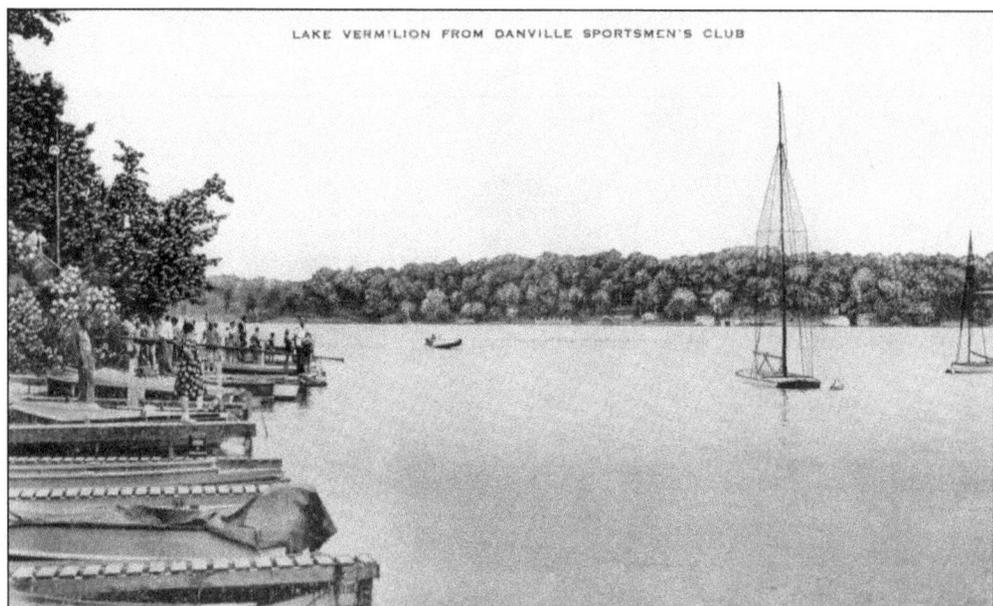

LAKE VERMILION FROM DANVILLE SPORTSMEN'S CLUB

The Danville Sportsmen's Club was incorporated in April 1953 to promote conservation of soil, water, and wildlife and encourage sportsmanship in the citizenry. Situated on Lake Vermilion, the club offered its members a wide range of activities, including a clubhouse, a playground, boat docks, and a beach. Special programs were also presented periodically on wildlife and waterfowl in the area.

Camping has been popular since the early 1900s. Whole families could enjoy sightseeing from the luxury of their own automobile. In Danville, many campgrounds and tourist parks were established to accommodate these travelers. Hartshorn's Big Canyon Camp Grounds was just such a business, offering more than just the rudimentary amenities.

The Danville Keggers softball team was formed in August 1970. Playing in local leagues and traveling throughout Illinois and west-central Indiana, the team won over 50 awards. Seen in this photograph from around 1973 are, from left to right, (first row) Dale Ross, David Stimac, Kirk Griffen, Kent Griffen, Jim Miller, Bruce Taylor, and Ron Warner; (second row) Danny Denny, Jim Slayton, Fred Pancoast, Roger Seibert, Butch Listner, Jack Estes, and Bob Chalkus.

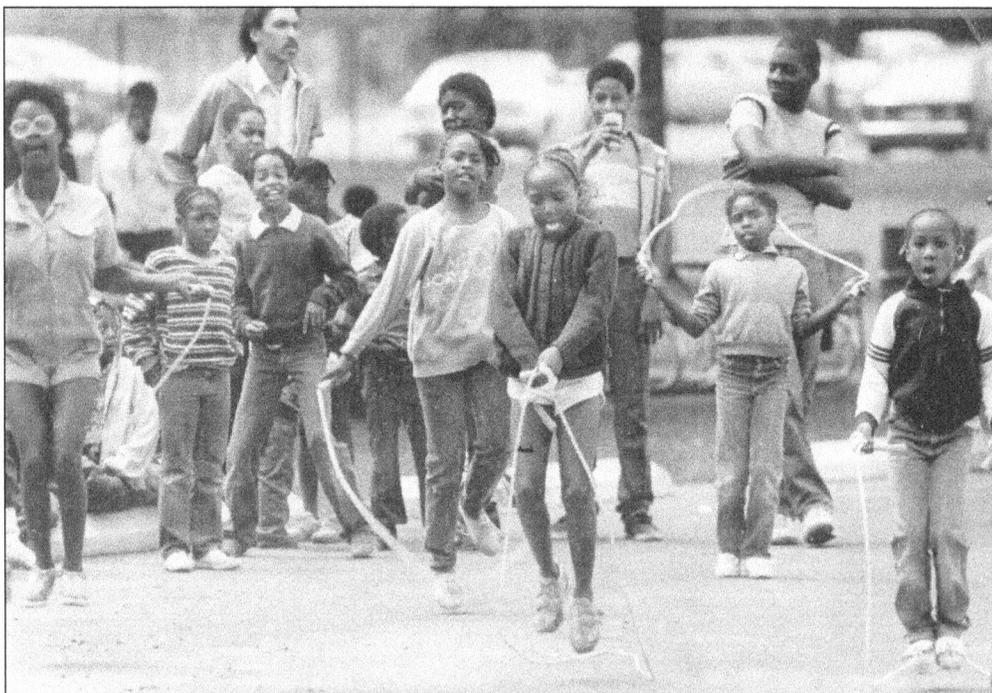

Children of all ages enjoyed the Danville Housing Authority Recreation Department's cookout at Garfield Park in August 1985. Jump rope tournaments, with the chance to show off skills and jumping tricks, were some of the fun activities of the day.

Ice hockey first made its appearance at the David S. Palmer Arena in 1981 with the Danville Dashers. In 1994, the Wings came to Danville, and they continued until 2004. This photograph is of the 1996 Danville Wings hockey team on the ice at the arena.

Four

MEET AND GREET

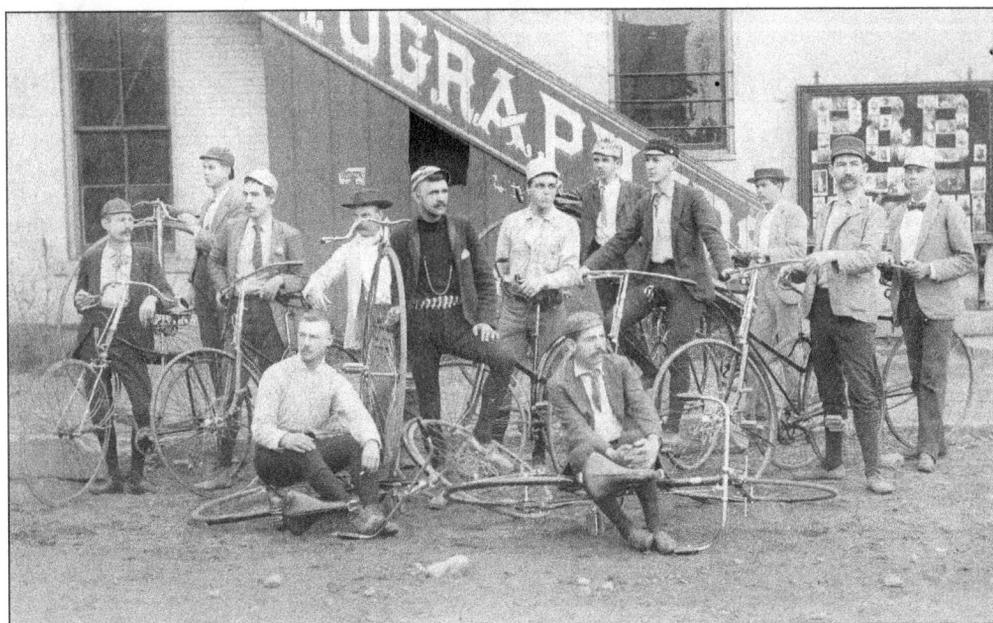

High-wheel bicycles were the fad between 1872 and 1892. In Danville, the Woodbury Book Company sold Waverly Bicycles. Frank Natho was in charge of the bicycle department and taught many people how to ride. This photograph of the Danville Cycling Club, founded in 1889, was taken on September 15 of that year at the southwest corner of the square in Danville.

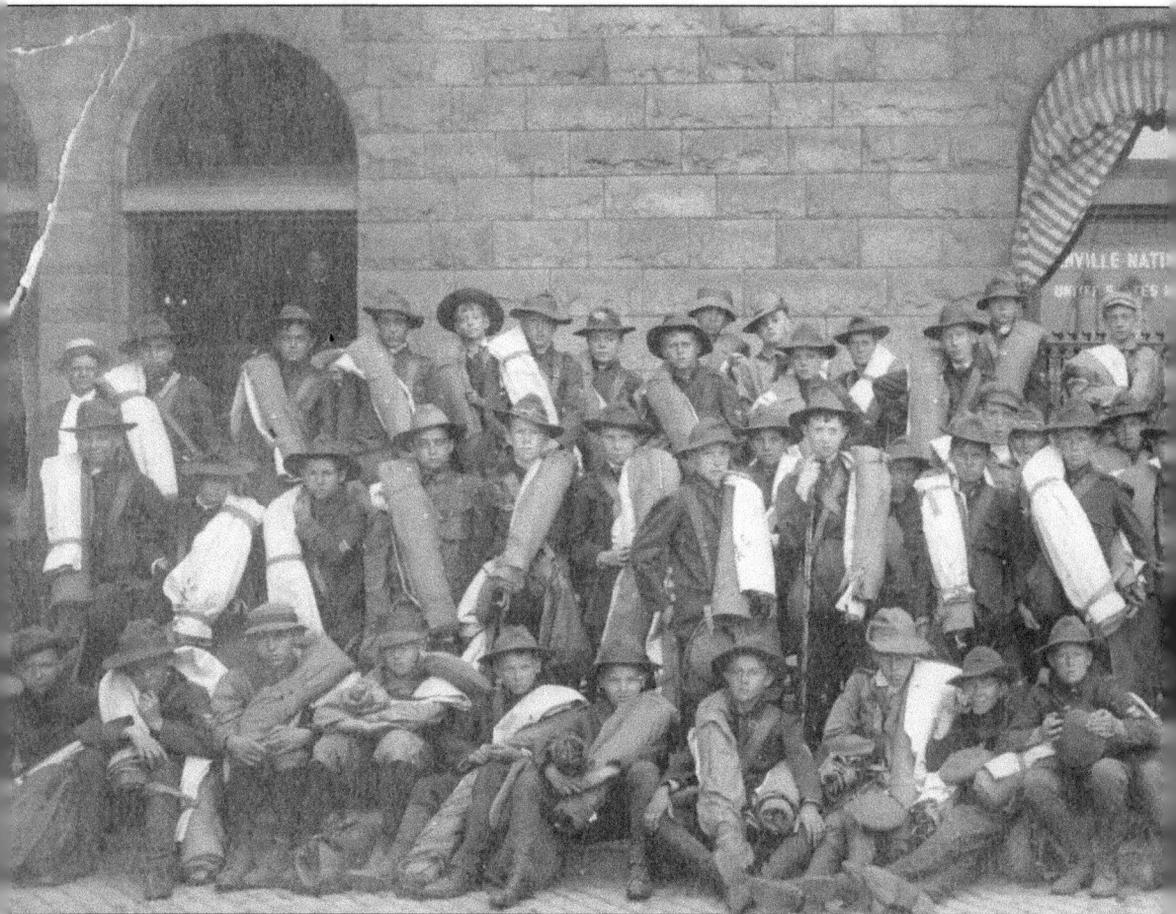

This photograph shows Danville Boy Scout Troop No. 1 on their way to camp in June 1911, posing in front of the Danville National Bank, on the southwest corner of the public square. Many of the early Boy Scout activities in the Danville area were church-sponsored, with the troops meeting in their facilities. Later, troops expanded into the schools, and many young men were then able

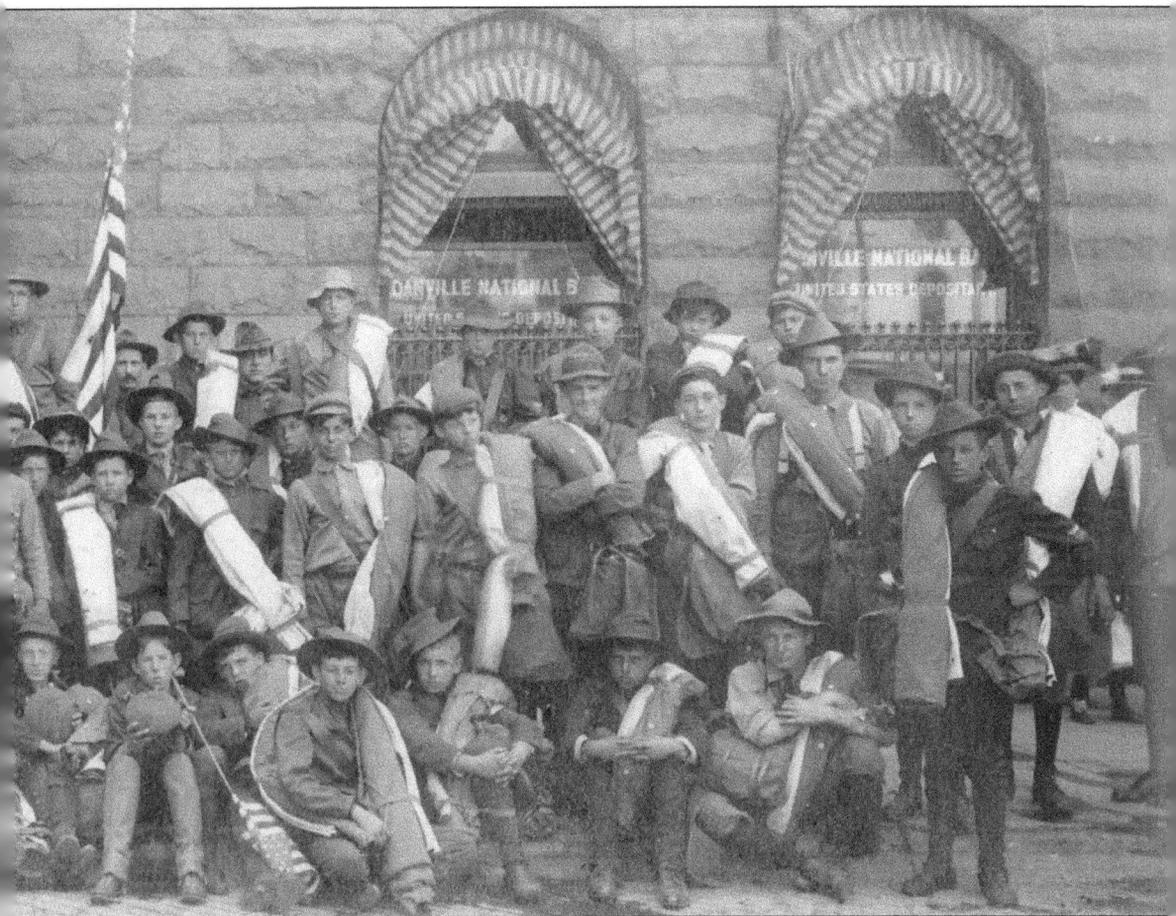

to participate in Scouting activities. Boy Scouts of America was founded in 1910 by William D. Boyce of Chicago, three years after Robert Stephenson Baden-Powell, a hero of the Boer War, wrote the first handbook, *Aids to Scouting*, and held the very first camp in England in 1907.

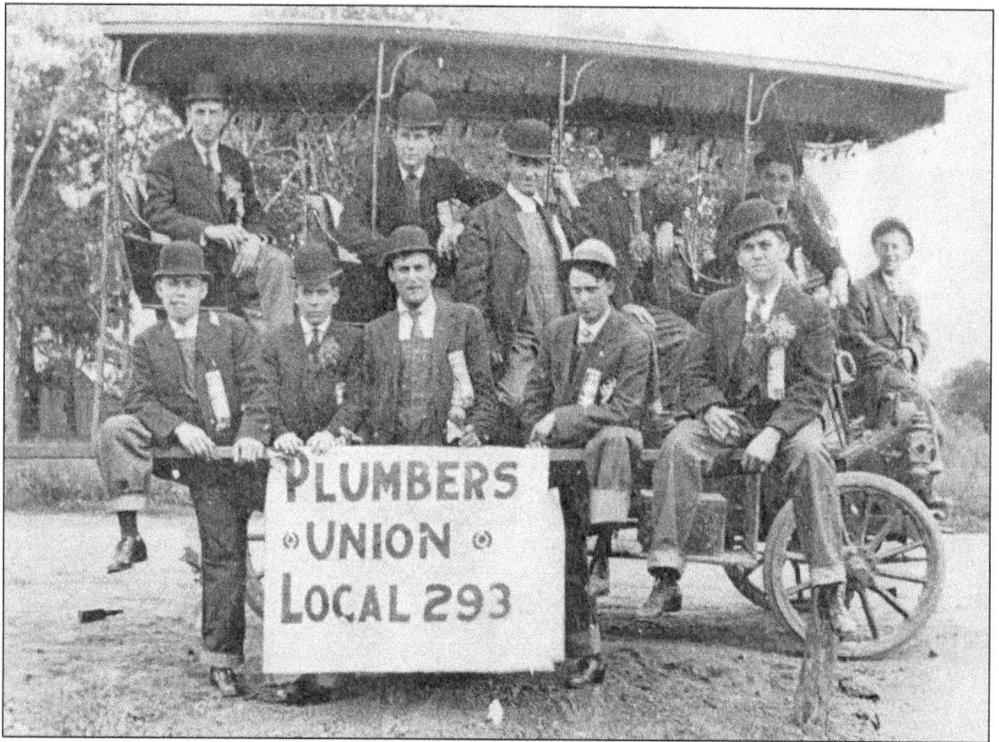

Labor unions in the United States have fought for the eight-hour workday, paid overtime, workers' compensation for injuries on the job, unemployment insurance, a guaranteed minimum wage, health insurance, paid sick leave, paid vacation, and paid holidays. Plumbers Union Local 293 began in Danville in 1907. In 1994, it merged with Terre Haute, Indiana, Local 157, and the Danville office became a satellite office for Terre Haute. The photograph above shows the group in its early years preparing for one of the Labor Day parades. The photograph below shows the first welding class in 1937.

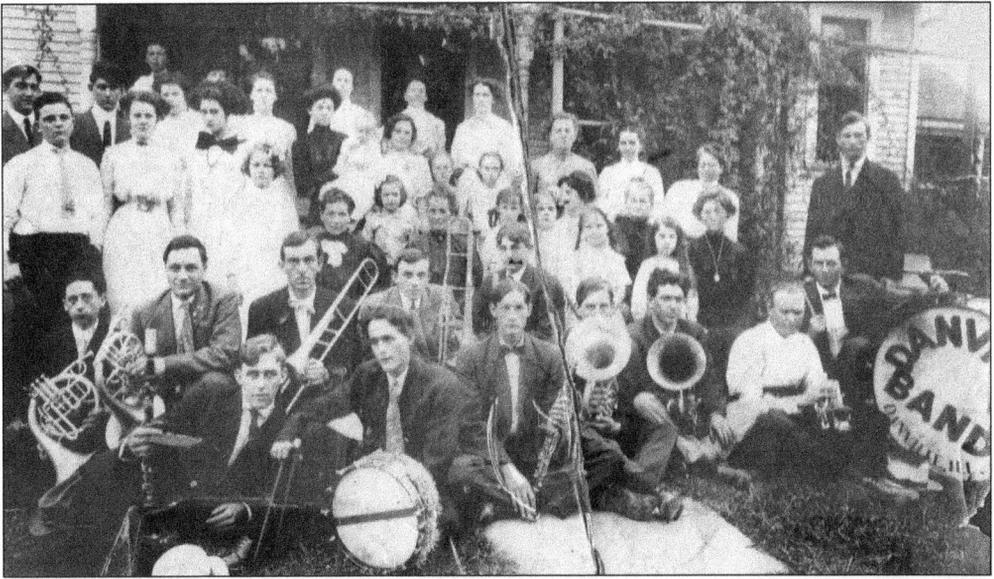

The Danville Band was a forerunner of the Danville Municipal Band that began in Danville in 1940. Performances were informal and practices were held at a band member's home. Behind the musicians are their families, who offered support to the band. Performers usually sat in chairs with the audience clustered around, many of them sitting on the ground.

Danville's Masonic bodies have played a significant role in the history of the city since the inception of the Olive Branch Lodge in 1846. They claim two major titles: the oldest continuous fraternal organization and the largest membership. This photograph shows members of the Masonic quartet. They are, from left to right, (first row) D.W. Telling, tenor; W.H. Pundt, baritone; and O.V. Shaffer, organist; (second row) G. Haven Stephens, tenor; and G.W. Telling, bass.

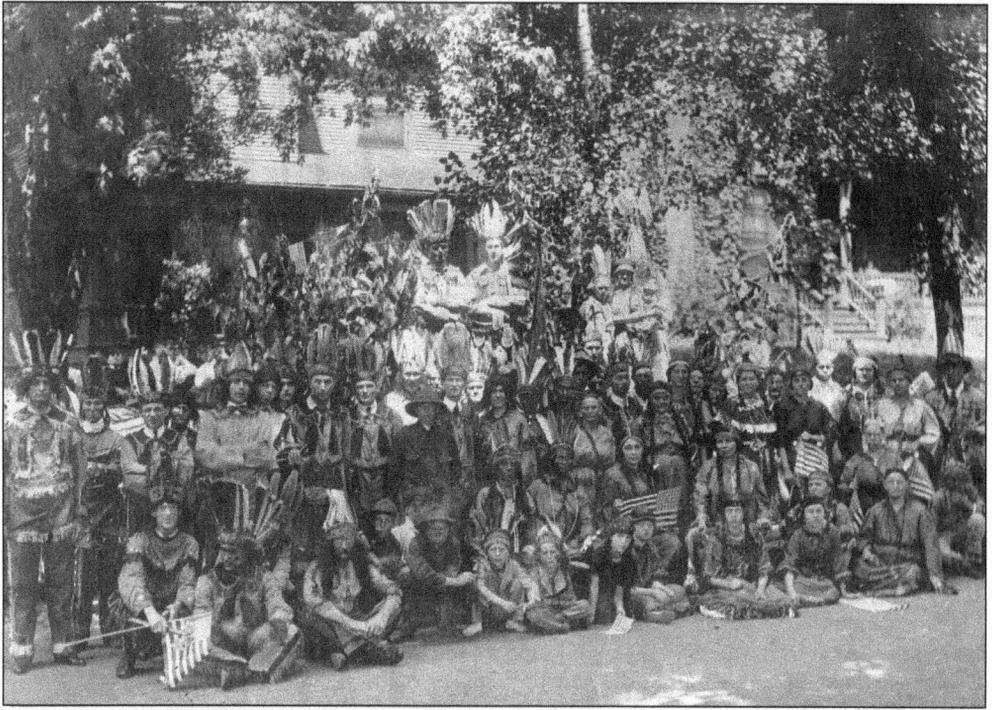

The Improved Order of the Red Men originally began as the St. Tammany Societies in 1771. It was reorganized in 1816 as a benevolent society instituted for social purposes and the mutual support of members. This photograph shows participants at a Red Men Lodge powwow in 1913.

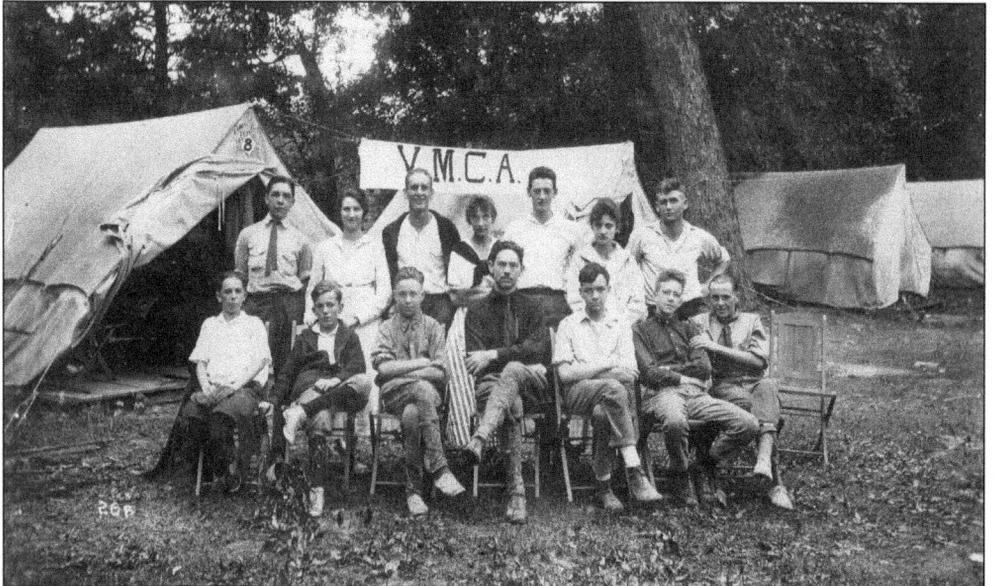

Locally, the Young Men's Christian Association (YMCA) was organized in 1883 to promote evangelical religion among the young men of the city and to improve their mental, social, and physical condition. This photograph shows a local group at camp in 1916. Camping was an integral part of the YMCA program, which allowed the young men to experience nature and learn self-sufficiency while developing camaraderie and friendships.

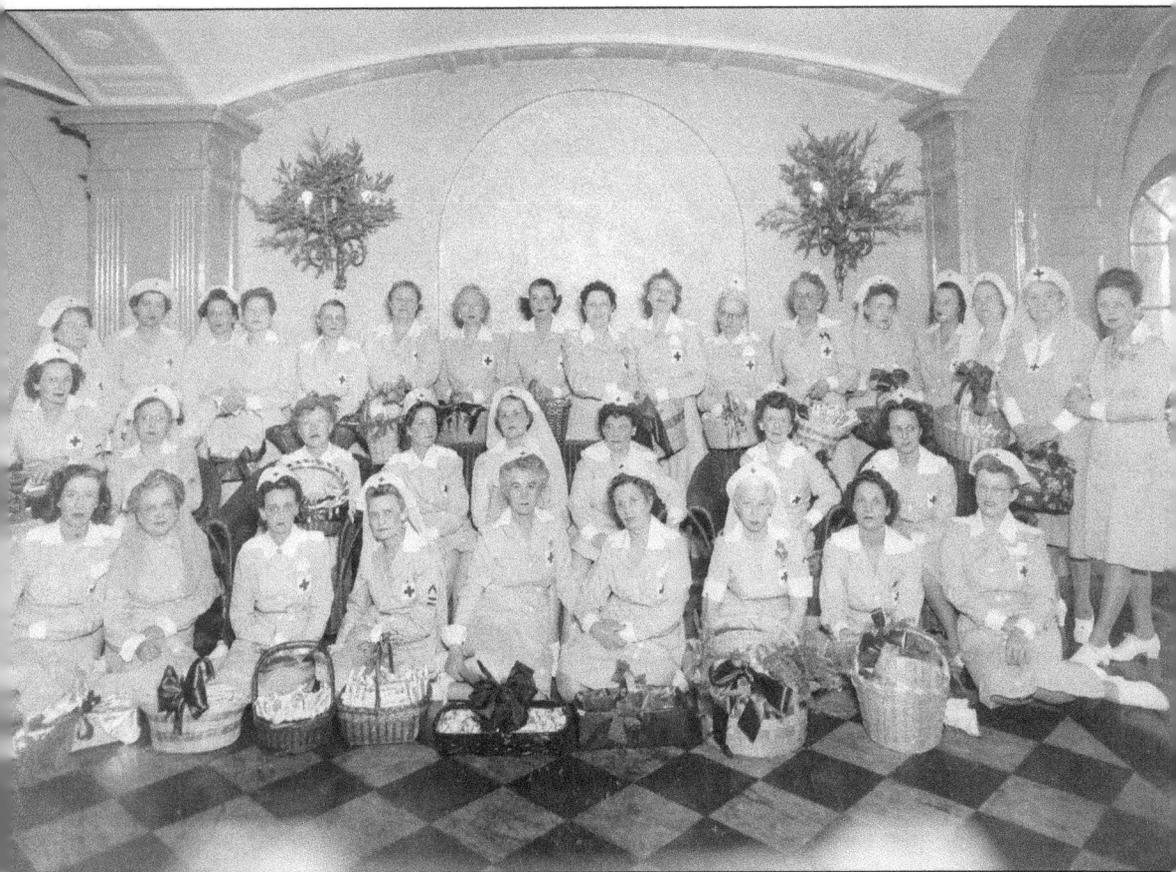

The Danville Chapter of the American Red Cross was begun in April 1905 by Dr. Stephen Glidden and received its wartime charter on April 19, 1917. In 1919, the Danville chapter became one of the few Illinois chapters to continue with a peacetime program. The local chapter occupied a home at 320 North Franklin Street from 1942 until 1982, when it razed the home and constructed a new building in the same location. In June 2008, the local Red Cross merged with the Central Illinois chapter, located in Champaign. This 1940s photograph shows members of the local chapter, from left to right, (first row) Janet Phillips, Hazel Rink, Mae Willett, Inez Kienzle, Harriet Ankele, Hattie Burke, Grace Bowman, Gertha Firebaugh, and Mari Weathers; (second row) Mary Mauerman, Neta Jones, Elizabeth Cannon, Madge Wagner, Nelle Wehling, Lotus Harper, Caroline English, and Espana Dietrick; (third row) Dorothy Clark, Catherine Butterworth, Kate Fishback, Mildred Brandenburger, Gladys Chandler, Mabel Mauck, Clara Crozier, Alma Meis, Beth Carsman, Edna Reynolds, Helen Skinner, Bea English, Hat Driskell, Jane Allen, Gladys Cline, Agnes White, and Opal Leverenz.

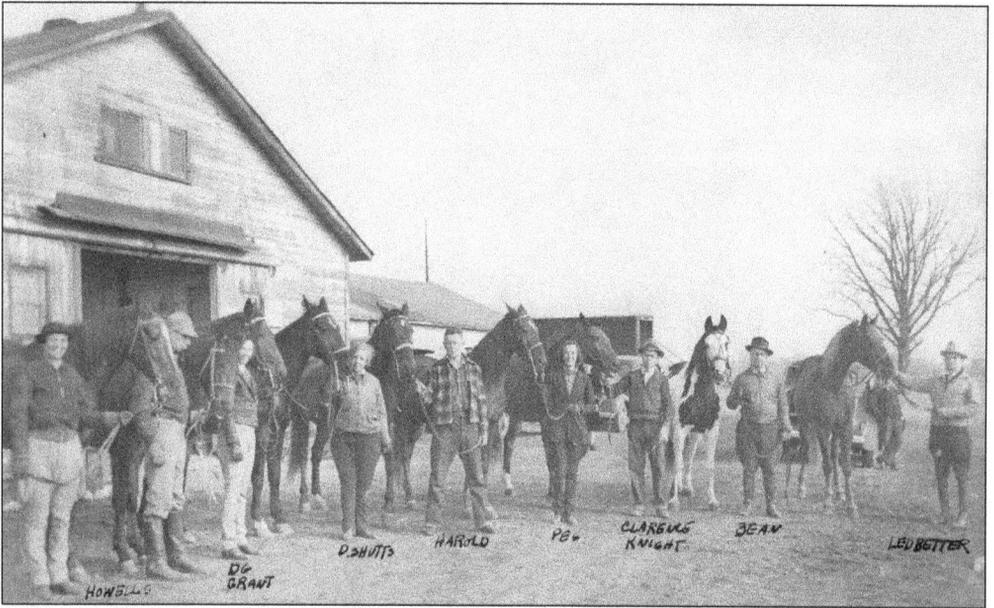

There have been many social groups in Danville through the years. This photograph shows members of the Danville Riding Club in Fair Park. They are, from left to right, Mr. and Mrs. Bert Howell, Dorothy Grant, Dorothy Shutts, Harold Adams, Peg Adams, Clarence Knight, ? Bean, and E.L. Ledbetter.

The American Association of University Women was started in New York in 1881 to give educated female members an arena to voice their vote. Historically, it has been an advocacy group for equality for women and girls and has promoted social improvement and lifelong learning for women. The Danville branch started in 1925. Seen here are cast members from the 1938 Christmas play, directed by Danville High School Latin teacher Harriet Rewerts.

106

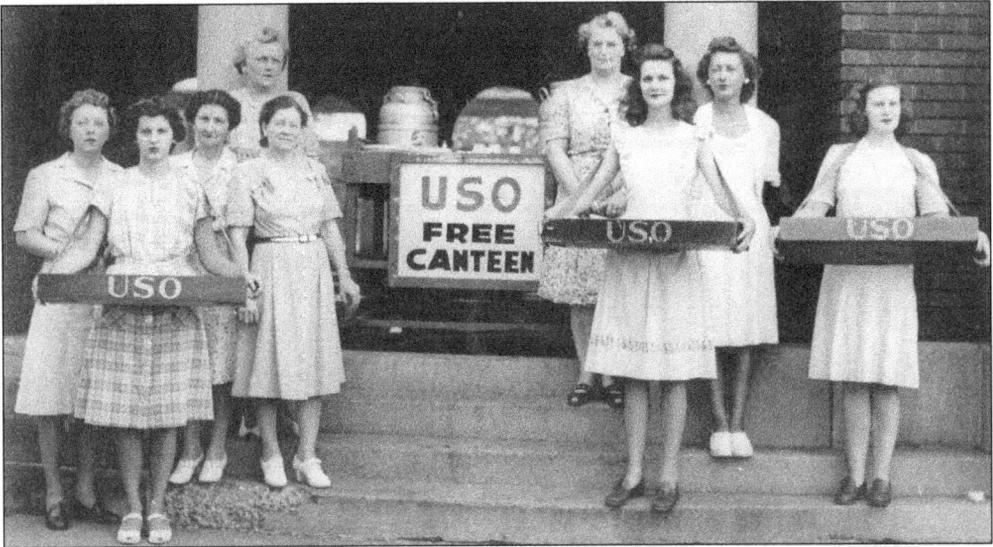

The USO Home in Danville, at 402 West North Street, was open for about two and a half years, closing on January 26, 1946. The USO Home and Canteen earned a nationwide reputation for friendliness. It did not charge servicemen for food served. This photograph of USO volunteers includes, from left to right, Audrey Allison, Phyllis Thalman, Ruth Bell, Clara Bolenbaugh, Hattie Johnson, Hazel Speakman, Lu Porter, Louise Roseman, and Barbara Steeley.

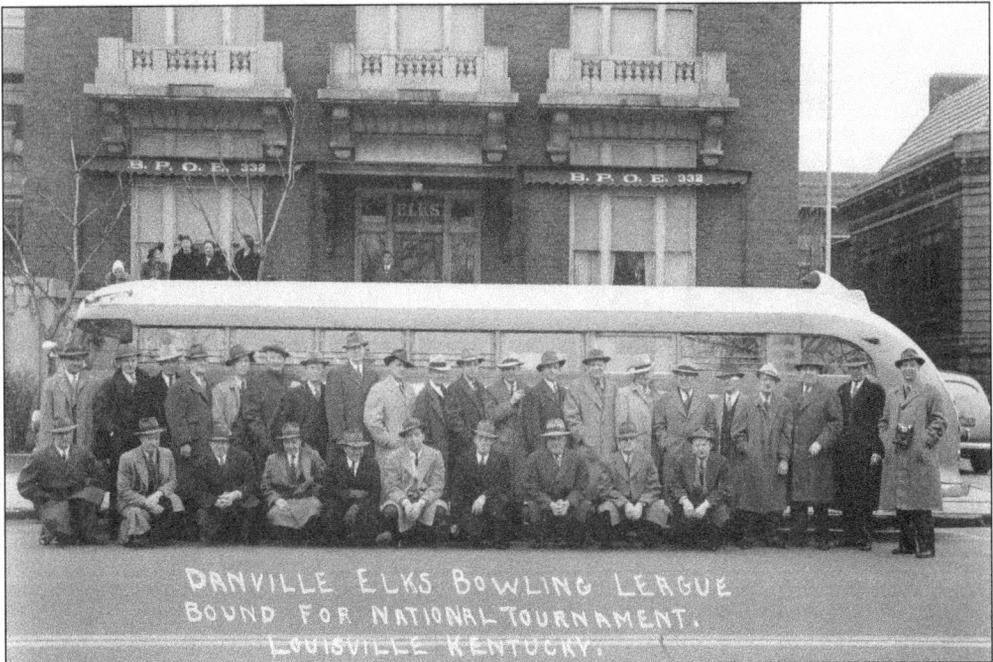

The Danville Benevolent and Protective Order of the Elks Lodge 332 was organized on December 10, 1895, and officially opened its lodge, at 309 North Vermilion Street, in January 1896. This organization is distinguished for its charitable works, including presenting hundreds of area students with college scholarships and sponsoring activities for children, veterans, and the disabled. The Danville Elks Bowling League is seen here bound for the national tournament on March 29, 1942.

The Danville Boat Club was formed in 1928 in order to purchase the Walnut Hill Boat Club, with each new member becoming a part owner. The club hosted social and water events including boating, water sports, dancing, bridge parties, and steak fries. This photograph shows ladies at a 1940s Danville Boat Club tea party. They are, from left to right, Mildred Leverenz, Florence Overstreet, Helen Howell Newman, Armada White, and Edna Cooney.

Red Mask Players, Inc., is among the oldest community theater groups in the Midwest. Founded on December 1, 1936, productions were given in various locations until a permanent home was acquired in 1962, at 601 North Vermilion Street. The 1948 production of *Guest in the House* included, from left to right, (first row) Ruth Tuggle, Mary Saladino, and Martha Ann McEvoy; (second row) Louise Ercenbrack, Alden Bracewell, and Pat Ewing.

Five

SERVE AND DEFEND

The Danville police force is seen here in front of the old city hall building on North Vermilion Street in the early 1900s. This photograph reflects the many changes in police attire from the early 1900s, when most officers and patrolmen sported mustaches and the uniforms closely resembled Army garb of the Civil War era.

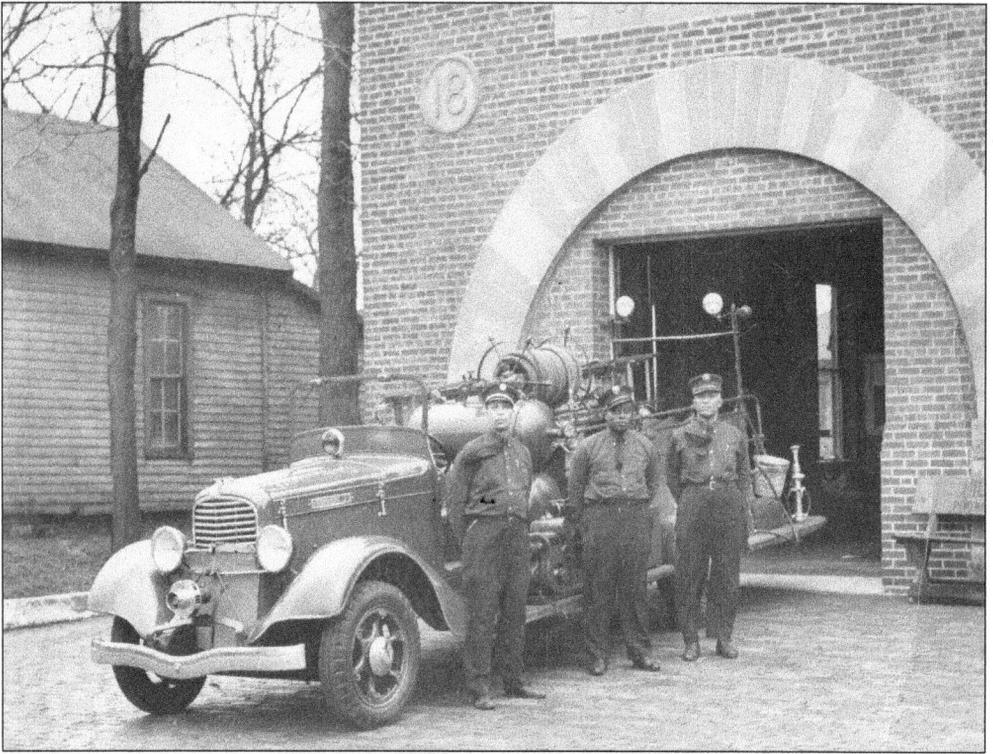

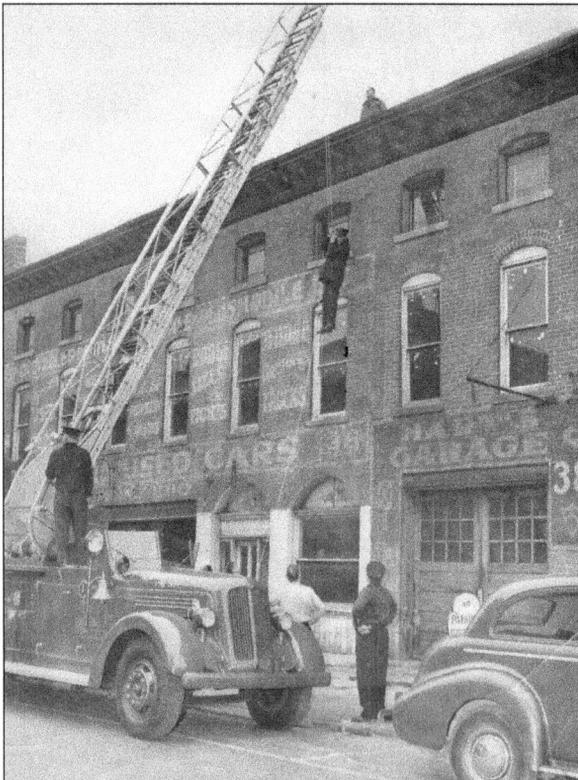

From left to right, Henry Thompson, Granville Gaddie, and Charles Lee stand in front of engine house No. 2, at 705 North Walnut Street. The two-story brick structure was constructed in 1898 to house the first group of African American firefighters in Illinois. It closed in 1963 when the city's fire department was integrated. The building still exists today and houses the Danville office of Habitat for Humanity.

Practicing procedures and maneuvers is part of training as a Danville fireman. This photograph, taken just north of station No. 1, at 28 North Walnut Street, shows firemen practicing rescue maneuvers above Hart's Garage. Walter Flaherty is on the ropes and Floyd Taber and Herman Lanter are at the turntable on the truck.

Fire Chief Howard D. Rindt (center) holds the poster advertising fire prevention week. During this special week, schools, businesses, and households in the area were made aware of the newest practices for fire prevention. All residents were encouraged to participate, and firemen often went door to door to meet area residents, as well as visiting schools and conducting fire drills.

The city hall building at 402–406 North Hazel was built in 1953. Three levels provided for three separate functions: city offices, the central fire department, and the police department. The police department moved out in the 1970s, when the Public Safety Building was constructed. In 1995, city offices moved to a renovated building, 17 West Main Street, and the fire department moved to suburban stations. The building was razed in June 2009.

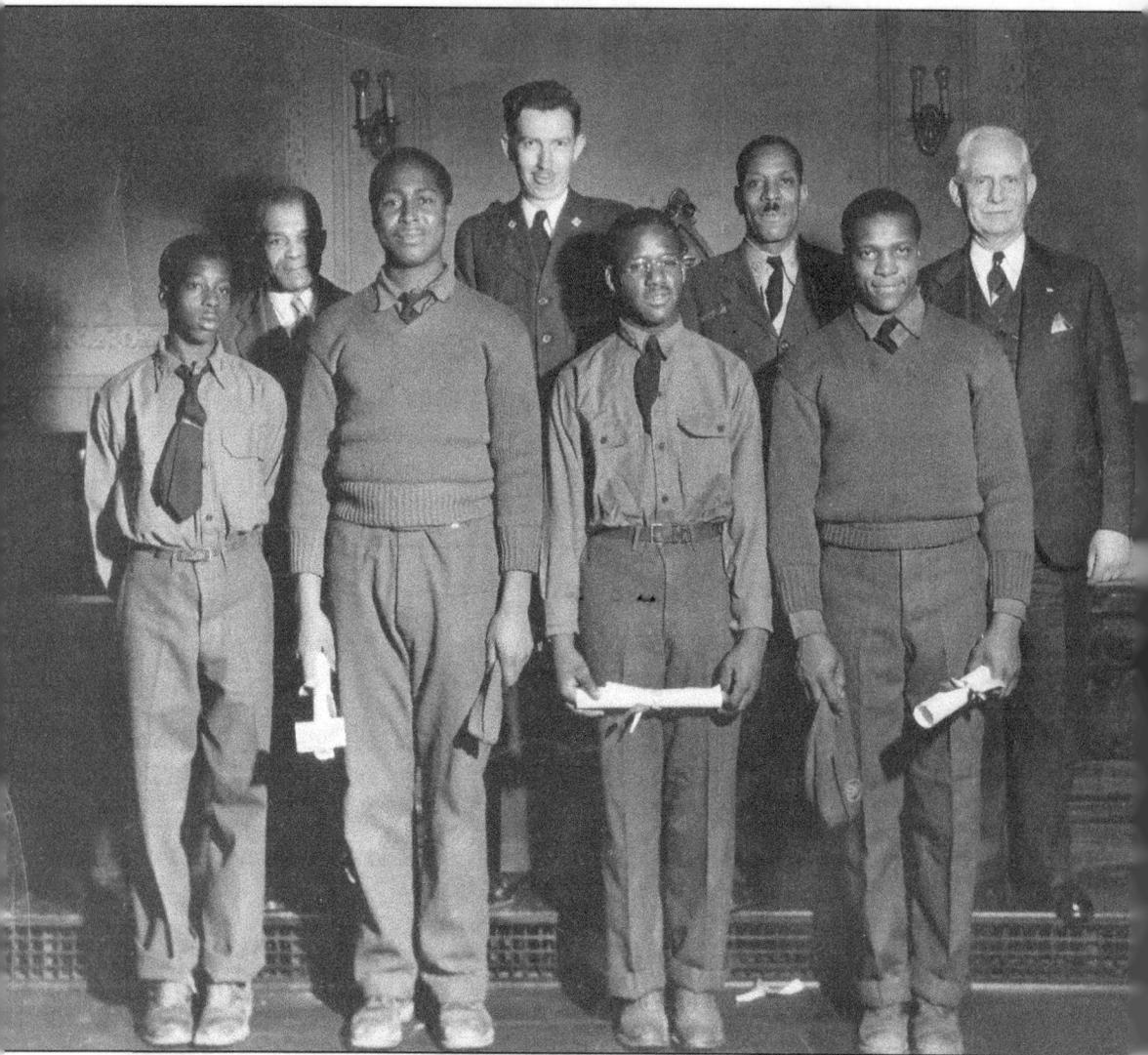

Land west of Danville, proposed for use as a state park, was approved as the site of a Civilian Conservation Corps (CCC) camp in May 1939. Five carloads of portable barracks arrived at the park in June. More than 1,200 acres were purchased by the state from the United Electric Coal Company. Members of the State Park Committee, headed by Clint C. Tilton, and directors of the Danville Chamber of Commerce, gave their written assurance to state park officials that $15,000 would be raised to purchase an additional 400 acres in order to complete the park. This photograph, taken on December 17, 1940, shows young members of the CCC graduating from their training class. Larkin Tuggle (second row, far right) was the school superintendent. Today, area residents enjoy the fruit of their labors at Kickapoo State Park.

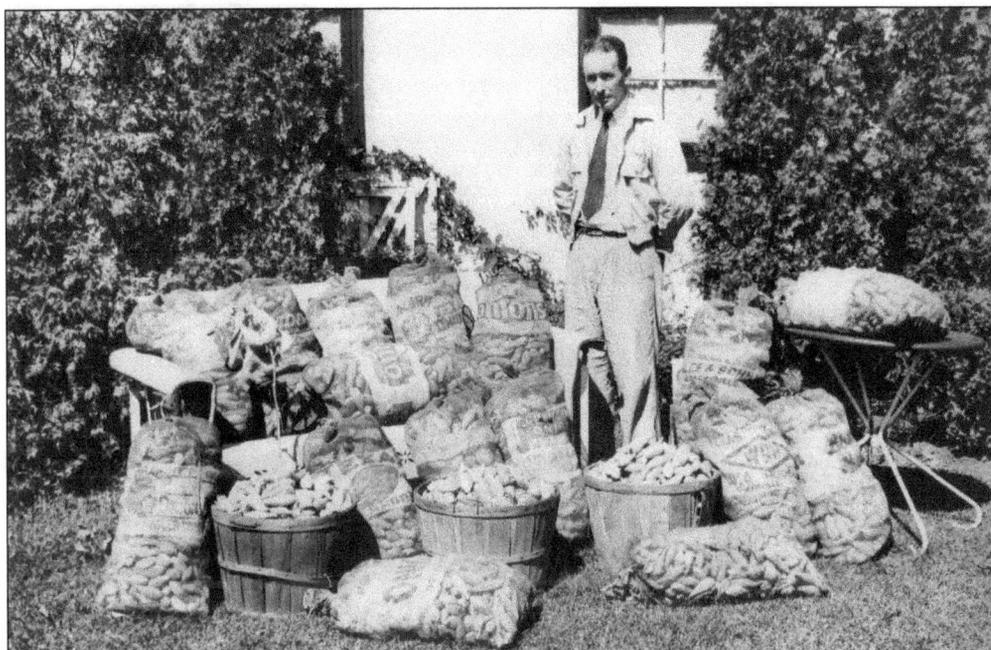

Milkweed pods were used to make parachutes during World War II. Danville citizens helped with this war effort by picking and collecting milkweed pods. Farmers, who usually worked to eradicate this pesky weed, planted fields of milkweed for parachutes. K.H. Shields of Danville, one of the individual pod pickers, is seen above with his collected bounty. Service organizations were called upon to help with the war effort at collection centers throughout the city. The photograph below shows Boy Scout helpers at the milkweed pod collection center unloading bags of pods from pickers.

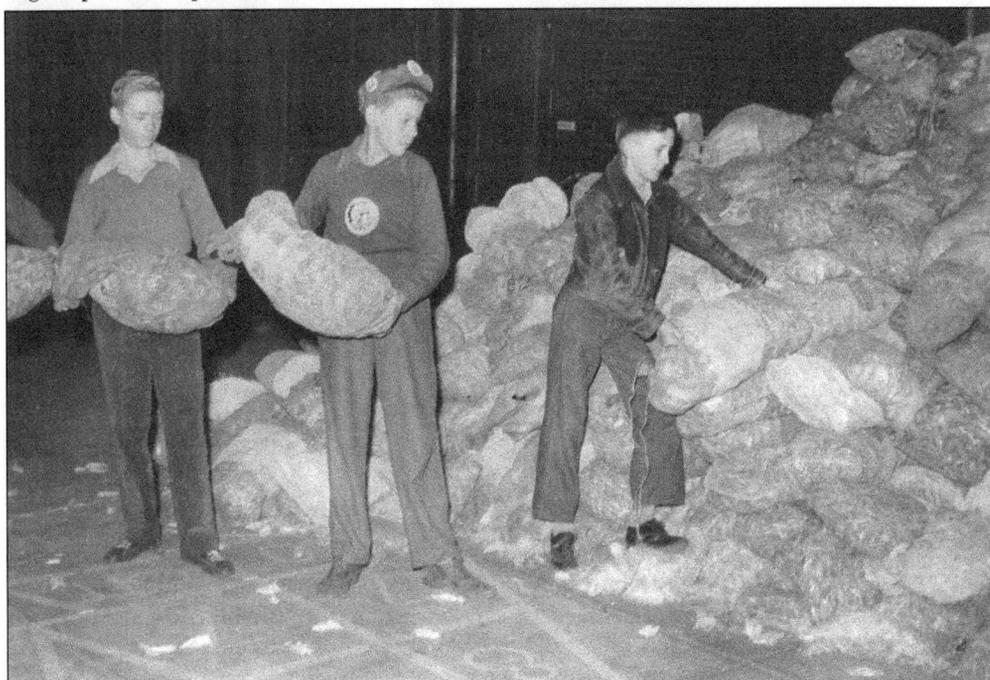

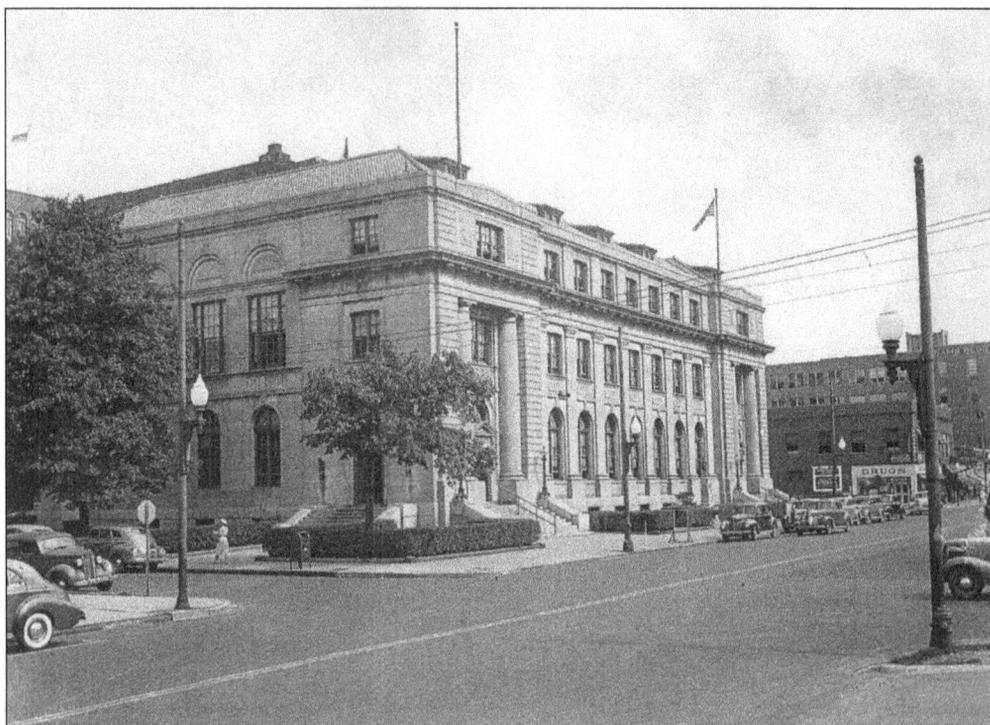

The Federal Building, at 201 North Vermilion Street, was completed in 1911. Built of solid stone, oak, bronze, and marble, it housed the federal court, federal offices, and the post office. In 1985, the post office moved to larger quarters. In 1991, $2.7 million was spent to restore the building to its original splendor. The bankruptcy court, the last in the building, vacated the premises in 2013.

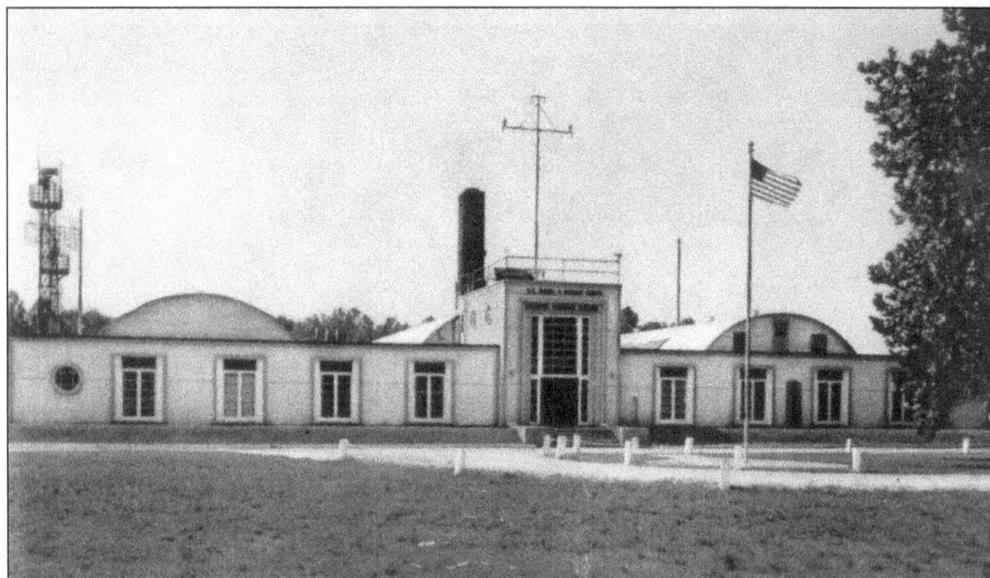

The $150,000 Danville Naval Reserve Armory, on Lake Vermilion, was constructed in 1948 by the Mayfair Construction Company of Chicago. In addition to administrative offices, it also included a drill hall, several classrooms, machine and carpentry shops, a radar room, radio receiving and sending rooms, and lounges for officers, petty officers, and enlisted men.

Lincoln Park's Friendly Town, a scale model of a city, was designed to teach children personal, bicycle, pedestrian, and fire safety. The program was geared for children who had completed kindergarten or first grade. Begun in 1970 and taught by local police officers, this safety program was ended in 2002 due to budget cuts.

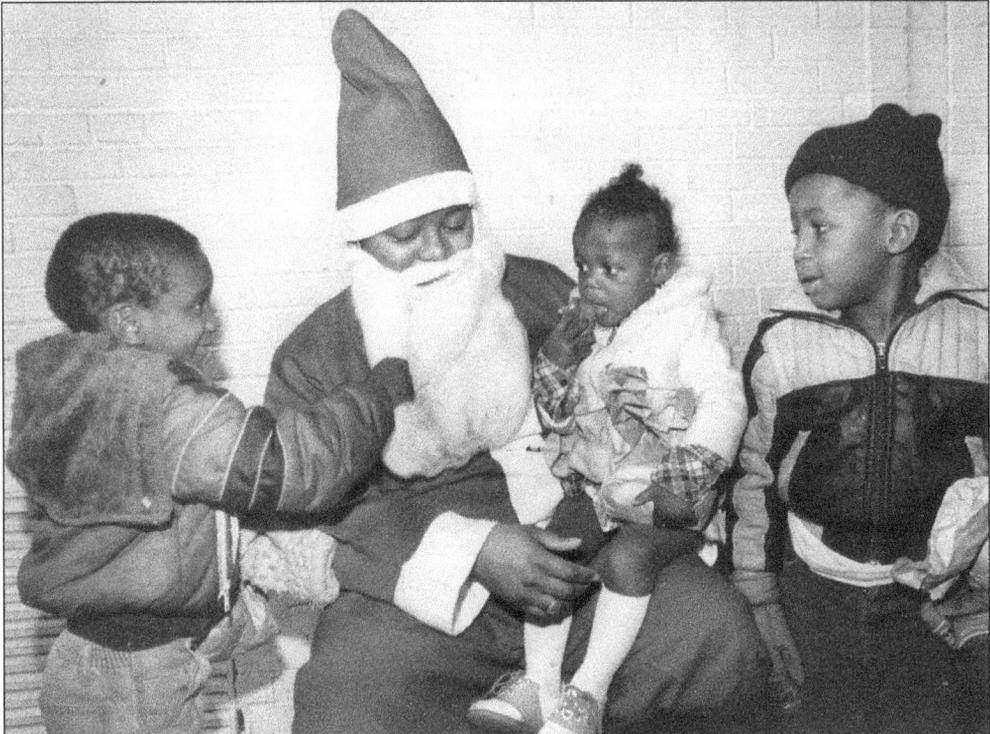

Roger Lillard plays Santa Claus for the Danville Housing Authority's annual Christmas party in 1983. From left to right are Jamall Forthenberry, age 5, Ajninea Patterson, age 1, and Damien Forthenberry, age 5.

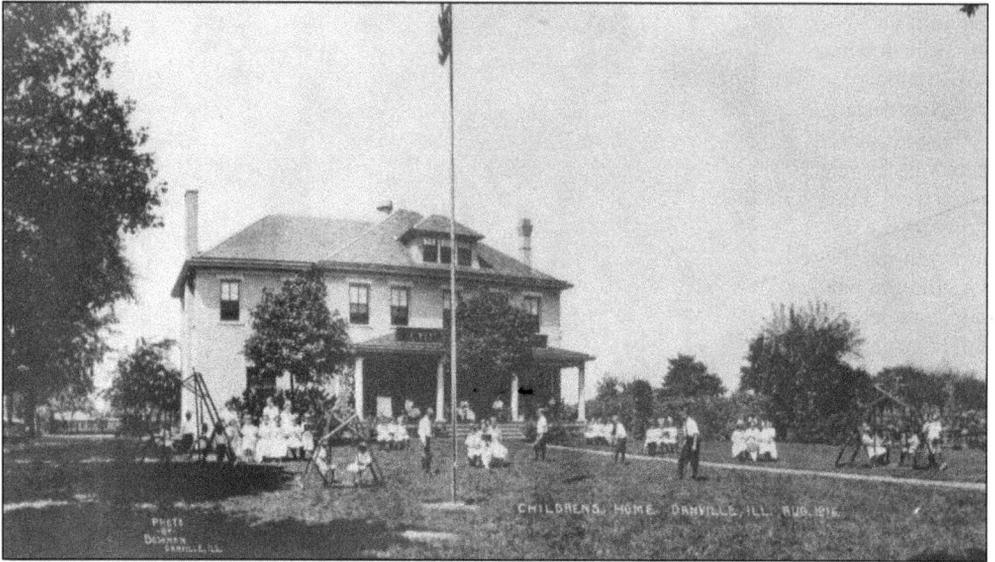

The Children's Home began with 11 civic-minded women, and officers were elected in January 1894. This photograph shows the home just prior to remodeling and improvements made in 1917. This building, containing a full basement, three floors, and attic sleeping space, provided for orphan children in the county until 1920, when an additional building was constructed north of the house. The residential housing program closed in 1973.

The Vermilion County Tuberculosis Hospital, nestled between the Children's Home and Lake View Memorial Hospital, was opened in November 1940. By 1966, only half of the hospital's 61 beds were in use, and the last patient left in 1967. A portion of the building was razed in 1984, and the balance was removed in 2004 to make way for patient parking.

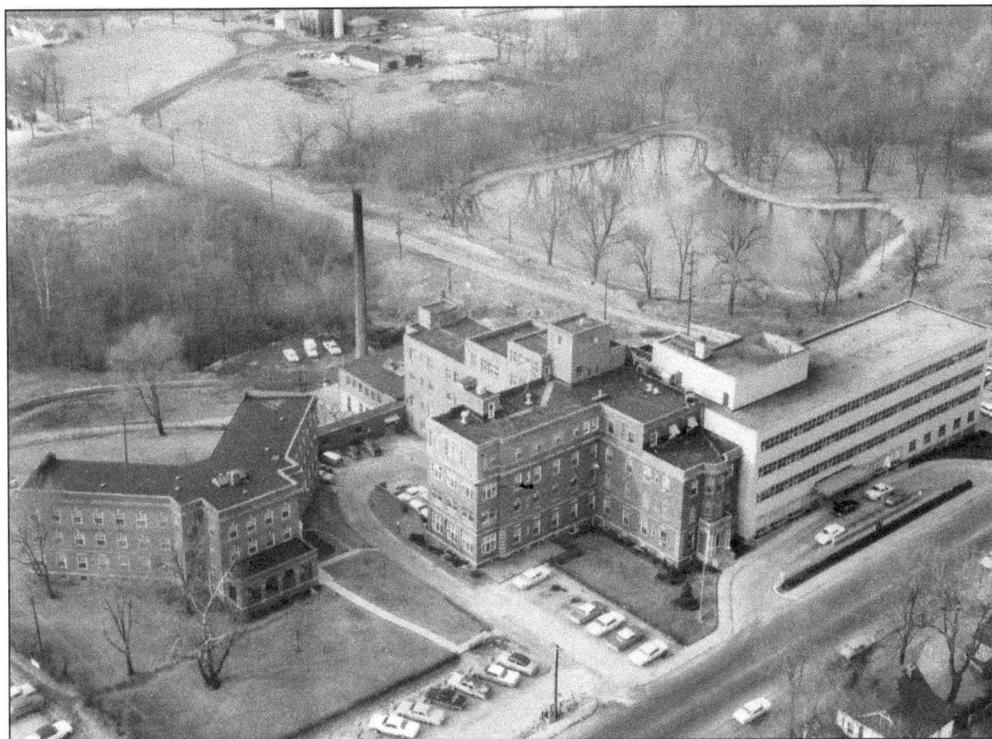

This aerial view shows Lake View Hospital in 1965. The newest portion was completed in 1959 and stands north of the Minta Harrison Wing, which was opened in 1915. To the left of the photograph is the student nurses' wing. The Minta Harrison portion and the student housing were demolished in 1976 and 1984, respectively, to make room for hospital expansion.

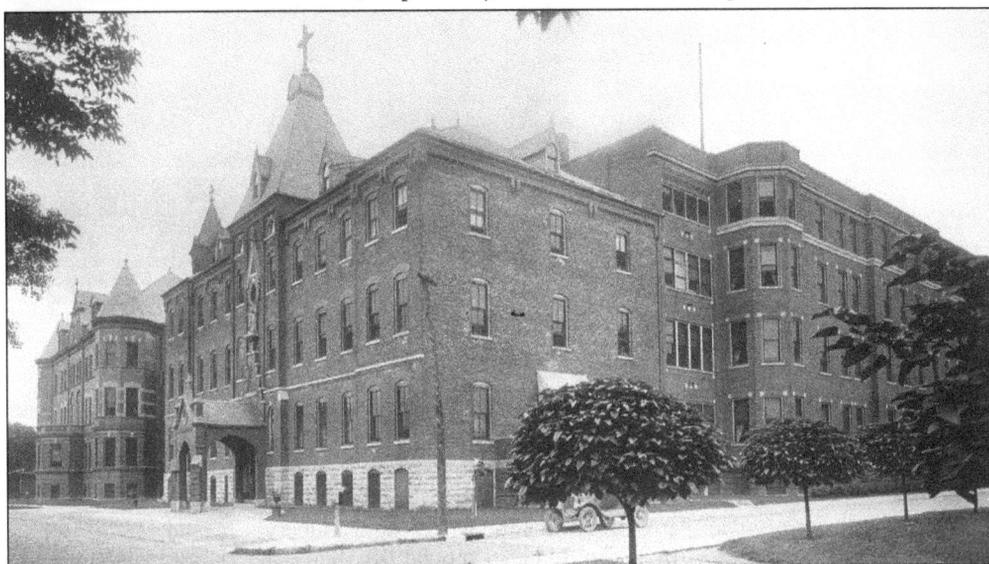

St. Elizabeth Hospital built its first structure in 1888. A wing was added in 1903, and fourth and fifth floors were erected in 1929. An $8.6-million addition was added in 1983, and, in 1994, the old chapel, the east and south wings, and the nurses' residence were razed. In 2004, the Sager Campus was closed. The building was demolished in 2006.

The National Home for Disabled Volunteer Soldiers opened for use in 1898. The total campus was 324.56 acres. The cost of the buildings, the land, and permanent improvements was $1,195,617. This view shows the fountain with hospital buildings in the background.

The Vermilion County Poor Farm began in 1866 when county supervisors paid $12,000 for 70 acres on the north side of Catlin Tilton Road. In about 1910, the brick County Home building was constructed on the south side of the road. In 1946, it was converted into the tax-supported County Nursing Home. When the new, 249-bed Vermilion Manor Nursing Home was built, the building was used for various county offices until it was razed in 1996. The site is now occupied by Southwest Elementary School.

Six

THOSE WE REMEMBER

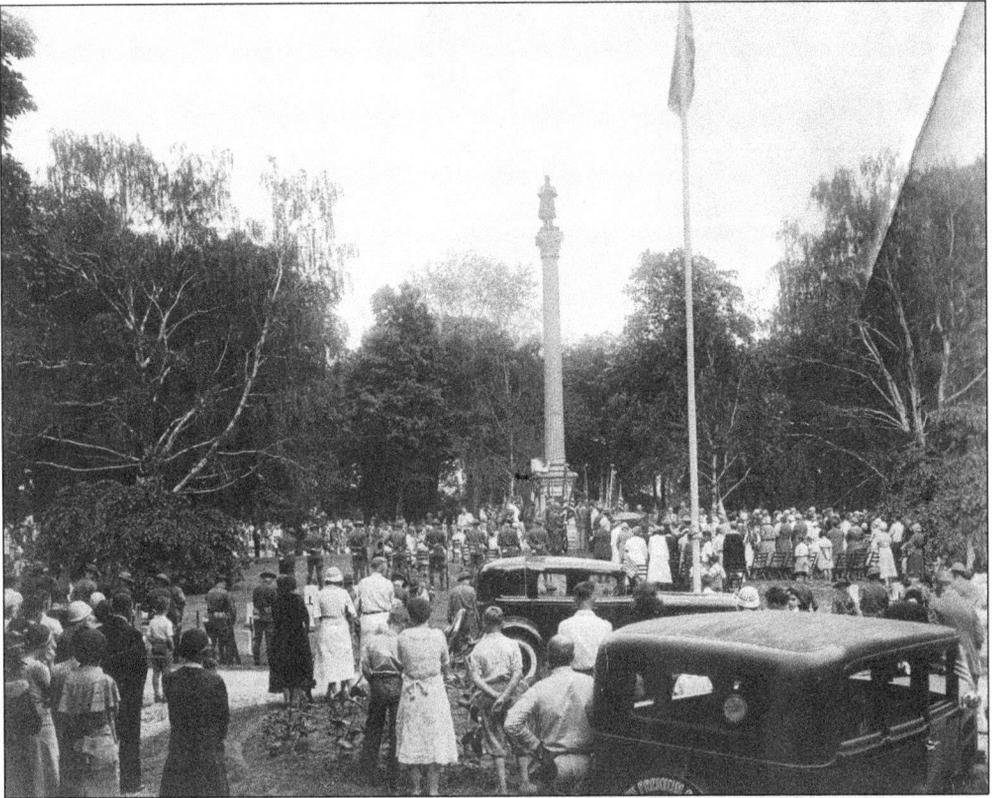

The Soldiers' Monument in Spring Hill Cemetery was dedicated on July 4, 1901, to honor local Civil War veterans. Designed by Capt. Nehemiah C. Hinsdale, the pedestal is of Barre granite and is 50 feet high, topped by a 7-foot-tall bronze soldier on guard, with his gun at parade rest. Soldiers' Circle was the site of many early Memorial Day programs. Today, 476 veterans rest in the circle, representing five wars.

The Minuteman statue in front of the federal courthouse was dedicated on September 3, 1915, by the Governor Bradford Chapter of the Daughters of the American Revolution to honor the 14 soldiers of the Revolutionary War who died in Vermilion County. The sculpture cost $9,000 when it was built and is the work of sculptor Daniel Chester French.

The Soldiers' Monument at the Veterans Administration Cemetery, at 1900 East Main Street, was dedicated on May 30, 1917. The statue was designed by William Clark Noble and portrays a young Civil War soldier. The cost of the statue was $6,000.

The Lincoln marker at the corner of Main Street and Logan Avenue was erected in 1921 to commemorate Abraham Lincoln's travels on the Eighth Judicial Circuit. Schoolchildren collected pennies to pay for the sign, which was erected by the Governor Bradford Chapter of the Daughters of the American Revolution. The arch was removed when Logan Avenue was widened.

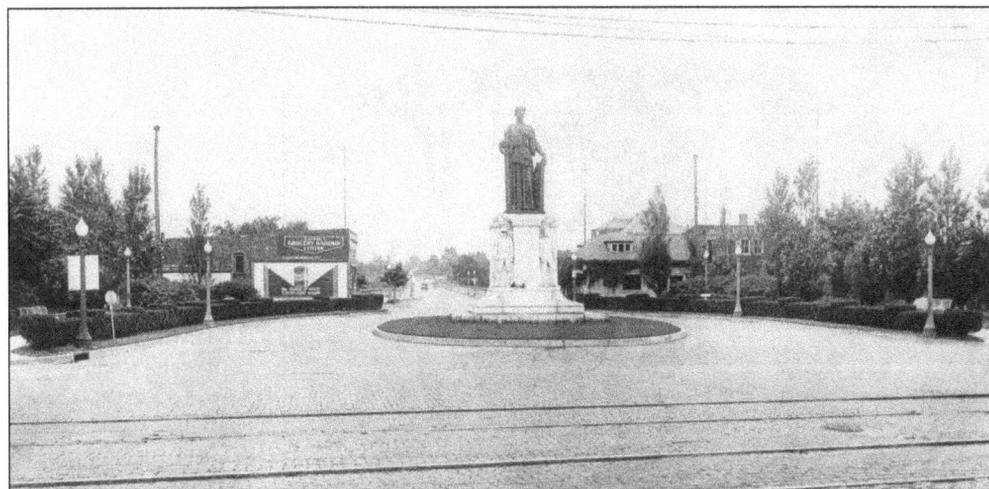

The World War I Victory Monument, at the corner of Main and Gilbert Streets, was dedicated on November 11, 1922, to honor the 54 county men who died in the war. The bronze Lady Liberty, sculpted by Loredo Taft, is 13 feet tall. Figures on the monument represent the Army, Navy, Marines, and Red Cross Nursing Corps. The cost was $50,000. It originally sat in the center of the street, as seen here, but it was moved to the southwest corner in 1955 for safety reasons.

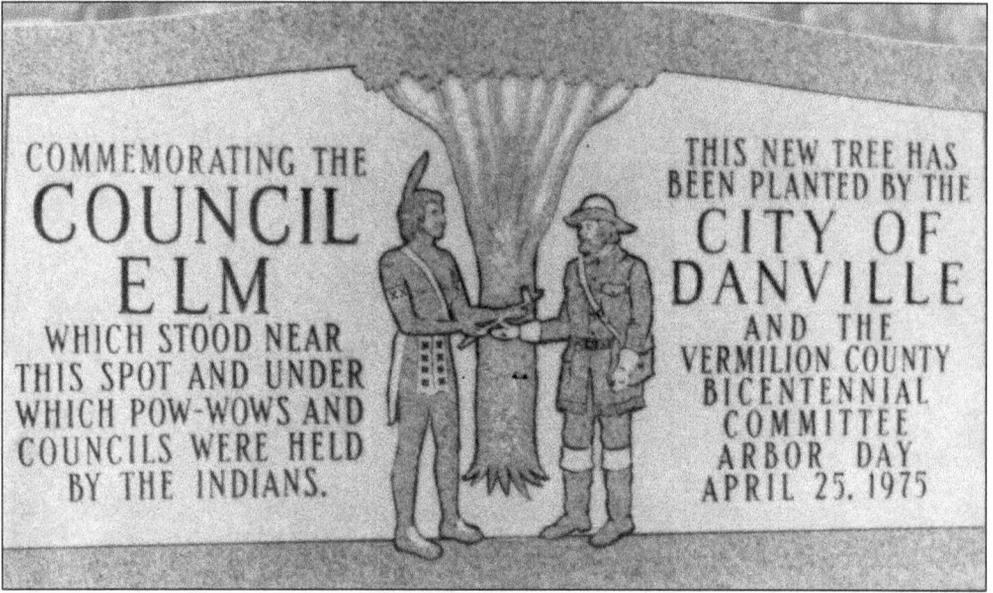

COMMEMORATING THE
COUNCIL
ELM
WHICH STOOD NEAR
THIS SPOT AND UNDER
WHICH POW-WOWS AND
COUNCILS WERE HELD
BY THE INDIANS.

THIS NEW TREE HAS
BEEN PLANTED BY THE
CITY OF
DANVILLE
AND THE
VERMILION COUNTY
BICENTENNIAL
COMMITTEE
ARBOR DAY
APRIL 25, 1975

The Council Elm marker in Ellsworth Park marks the site of early Native American and political powwows held under its branches. The first tree died a natural death, and a new tree was planted in 1975 when the current memorial was dedicated.

The metal gazebo on the southeast corner of Main Street and South Logan Avenue is near the site of Dan Beckwith's trading post. Beckwith, Danville's namesake, came to the county in 1825. The seven sides of the gazebo represent love, dedication, work, perseverance, humility, loyalty, and commitment.

The Korean-Vietnam Memorial, at the corner of Hazel and Williams Streets, was dedicated on May 31, 1986, to all men and women who served in those wars from Vermilion County. The monument cost $80,000, of which $35,000 came from the collection of aluminum cans. One side depicts a Korean War soldier battling the bitter cold, and the other side shows Vietnam War soldiers wading through rice paddies.

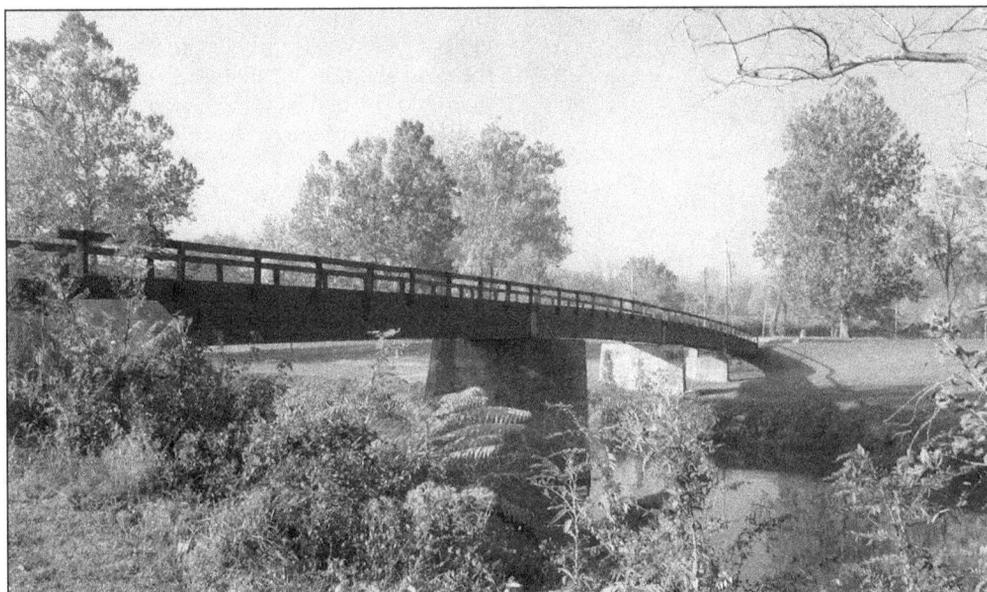

The Robert Wurtsbaugh Memorial Footbridge is located in Ellsworth Park. Dedicated on May 30, 1989, the wooden bridge over the North Fork River is named in honor of Wurtsbaugh, the first Korean War casualty from Vermilion County. He was killed in Korea in 1950.

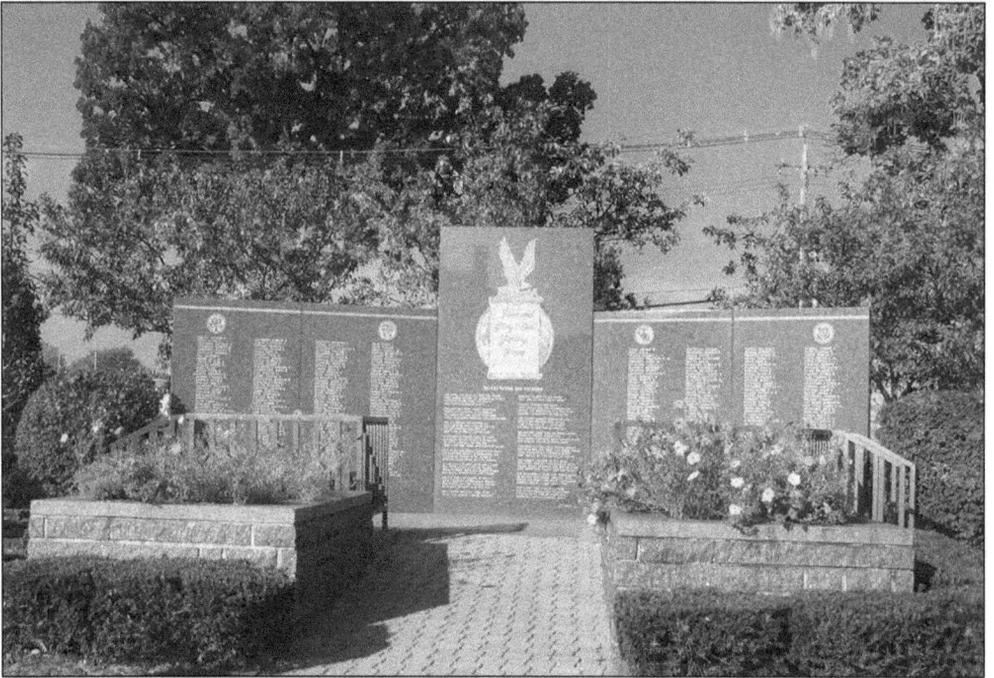

The Vermilion County World War II Memorial was dedicated on December 7, 1991. More than 8,000 men and women from the county served in the war. More than 360 veterans paid the supreme sacrifice. The monument is in the 400 block of Hazel Street and consists of three granite tablets. The names and hometowns of the dead and missing are inscribed on the right and the left, with the center section containing a tribute to the veterans.

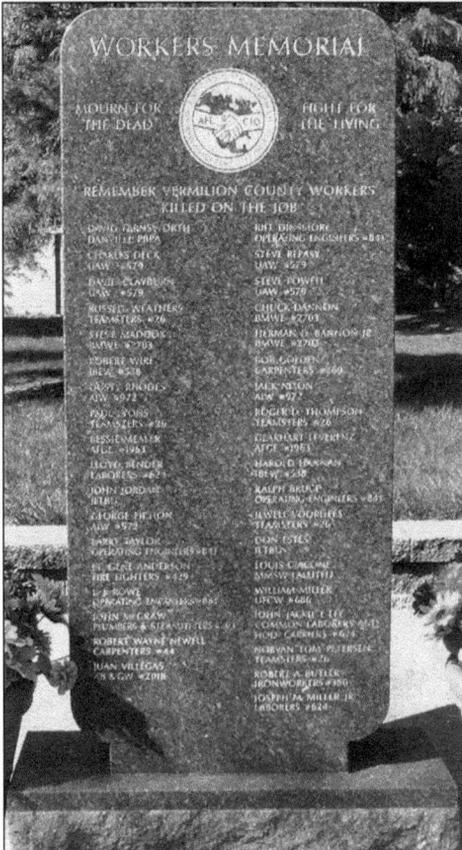

The Vermilion County Workers Memorial, on Hazel Street adjacent to the World War II monument, honors those who have been killed on the job. The front side honors AFL-CIO workers, and the reverse side honors those who were not union members. The monument was completed in 1993. The words on the front read, "Mourn for the Dead, Fight for the Living."

SINCE BEFORE THE FOUNDING OF OUR REPUBLIC AND THROUGHOUT OUR HISTORY, AMERICAN WOMEN HAVE FOUGHT FOR FREEDOM SELFLESSLY AND WITH LITTLE OR NO RECOGNITION FOR THEIR CONTRIBUTIONS.

The Vermilion County Women's Memorial was dedicated on November 11, 1995. The marker, situated on the corner of Hazel and Madison Streets, cost about $70,000, of which $50,000 was raised through aluminum can recycling. The drive for the monument was spearheaded by Harold Leisch and Harold "Sparky" Songer. Almost 500,000 women across the country served during World War II. More than 50,000 participated in the Korean War, as well as 10,000 in Vietnam. Women cared for the wounded, performed behind-the-lines jobs to free men for the front ranks, drove trucks, flew planes, and finished all the other tasks required to complete the job, both in the military and at home. The panel depicts women in an office, holding a wounded soldier, sitting in a cockpit, and saluting. The site is enhanced with benches and a sundial. It commemorates the women who have served in the nation's wars throughout the years.

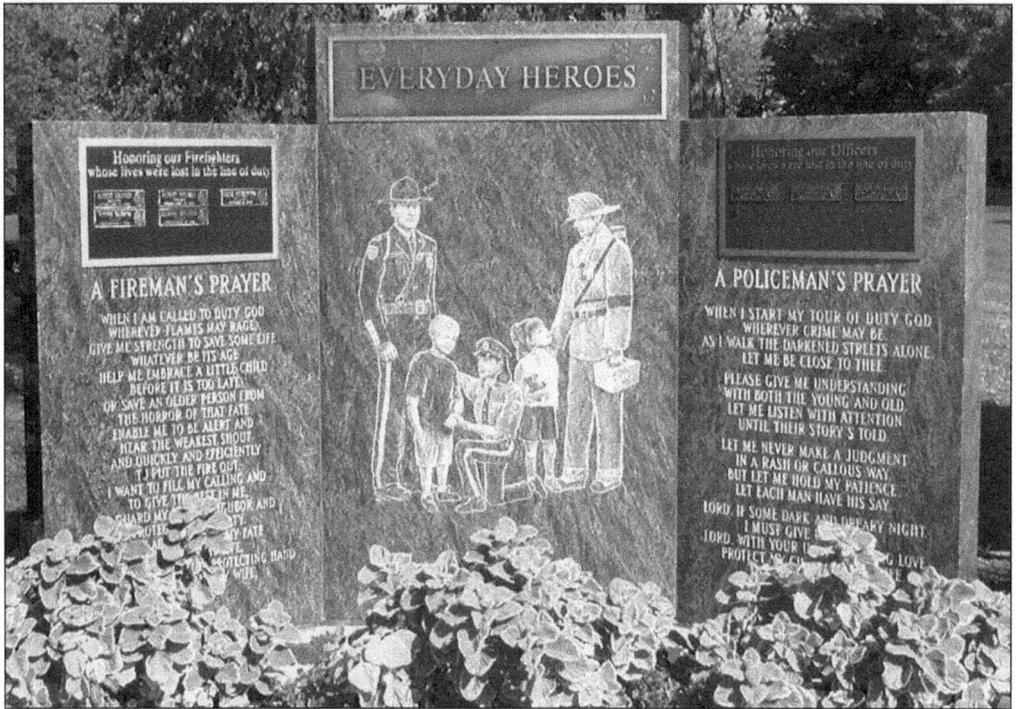

The Everyday Heroes of Public Service Monument is situated at Sunset Memorial Park. Dedicated on September 11, 2002, the granite memorial is dedicated to firefighters and law enforcement personnel. The monument was constructed by the Darby family, the owners of Sunset Funeral Home and Cremation Center and Sunset Memorial Park.

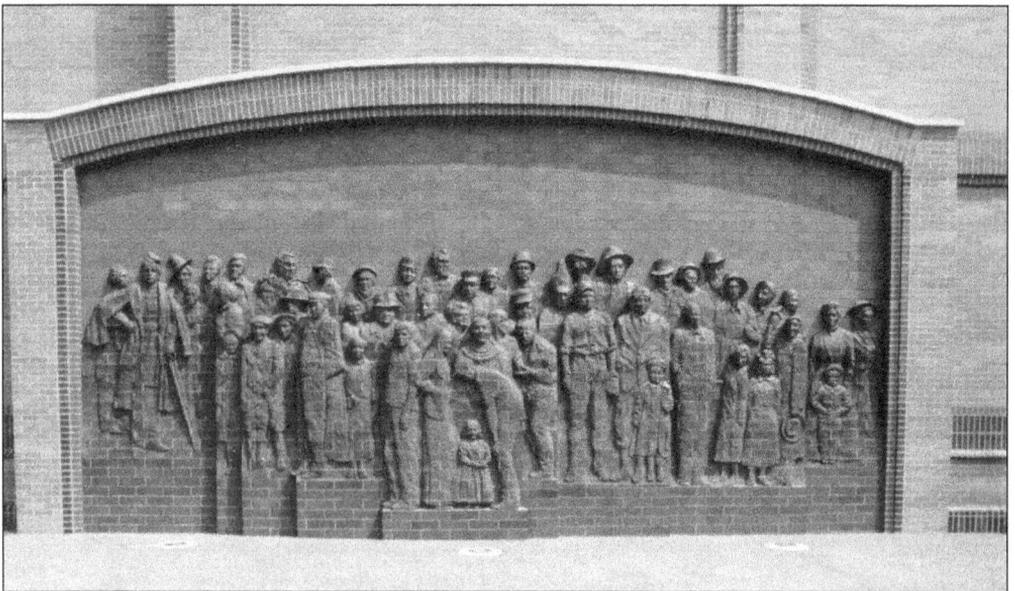

The Temple Plaza, on the northwest corner of North and Vermilion Streets, is the home of Danville USA. The 30-foot-wide brick sculpture was dedicated in August 2003. The brick mural was created by Donna Dobberfuhl, a San Antonio artist. The $60,000 relief showcases both the unnamed and the famous who have shaped Danville's history over the years.

ABOUT THE VERMILION COUNTY MUSEUM SOCIETY

The Vermilion County Museum Society is a 501(c)(3) nonprofit corporation established in 1964. It is not supported by taxes. The society maintains the Fithian Home, the Lamon House, the Museum Center, Mann's Chapel, and the Pioneer Cemetery at the Salt Kettle Rest Area. Its dual mission is preservation and education pertaining to local history.

One can walk in Lincoln's footsteps when visiting the bedroom where he stayed in the historic Dr. William H. Fithian home, which is listed in the National Register of Historic Places. The grandeur of a bygone era is shown in the renovated 1855 residence of this early pioneer physician, politician, and Lincoln client. See the desk where Lincoln and his partner worked and discussed legal problems. Visit the 1930s recreated street scene, and walk into the coal mine tunnel. Pause a moment in the atrium and have a photograph taken with a young Abraham Lincoln, cast in bronze. There is an attraction or special event for everyone at the museum.

To obtain information on hours of operation or special programs, call 217-442-2922 or visit www.vermilioncountymuseum.org.

Vermilion County Museum

Visit us at
arcadiapublishing.com